GRUPPÉ ON PAINTING

GRUPPÉ ON PAINTING

DIRECT TECHNIQUES IN OIL

BY EMILE A. GRUPPÉ

Edited by Charles Movalli and John Lavin

WATSON-GUPTILL PUBLICATIONS/New York

PITMAN PUBLISHING/London

Copyright © 1976 by Watson-Guptill Publications

First Published 1976 in the United States and Canada by Watson-Guptill Publications
a division of Billboard Publications, Inc.
1515 Broadway, New York, N.Y. 10036

Published in Great Britain by Pitman Publishing Ltd.
39 Parker Street, London WC2B 5PB
ISBN 0-273-00120-5

Library of Congress Cataloging in Publication Data
Gruppé, Emile A. 1896-
 Gruppé on painting
 Bibliography: p.
 Includes index.
 1. Painting—Technique. I. Title.
ND1500.G73 1976 751.4'5 75-40291
ISBN 0-8230-2157-2

Manufactured in U.S.A.

First Printing, 1976
Second Printing, 1977
Third Printing, 1979

This book is dedicated to my wife, Dorothy.

Contents

ACKNOWLEDGMENTS

I would like to thank John Lavin, who originated the idea for this book; Don Holden, who encouraged its development; and Charles Movalli, who organized the project and brought it to a successful conclusion.

Introduction

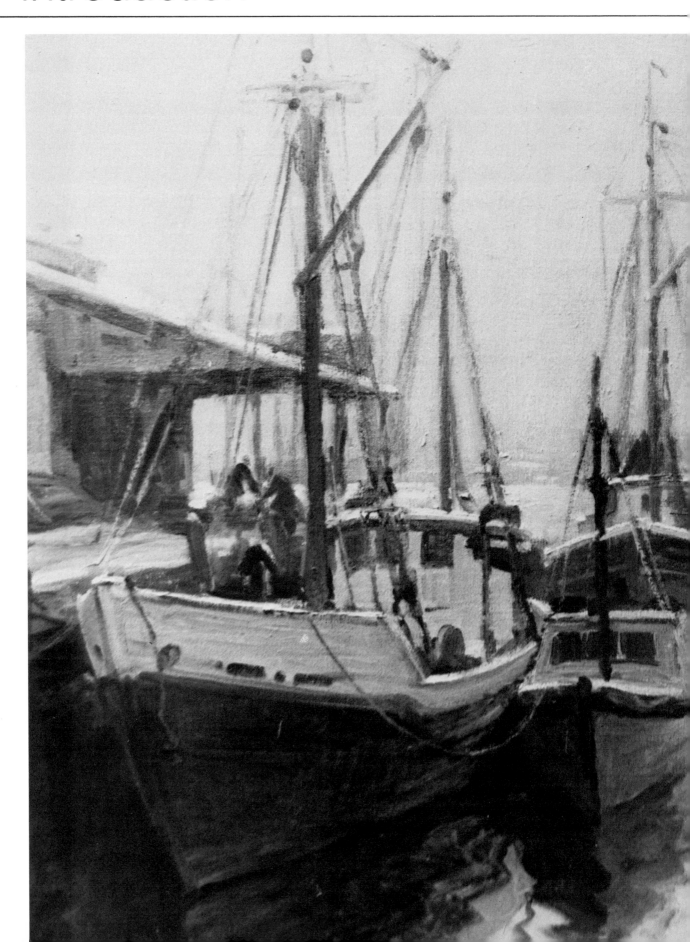

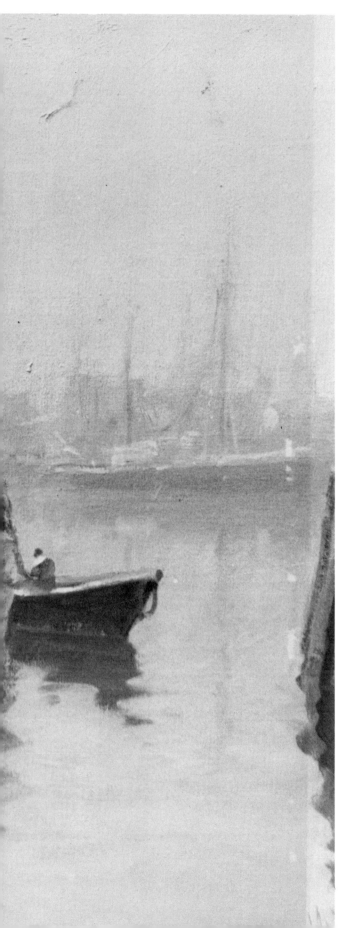

If you paint the same subject all the time, you'll soon go crazy. The best painters have always been General Practitioners. They would paint everything: surf, snow, trees, buildings, boats. They knew that everything in art helps everything else. Learn to paint snow, and you'll know how to paint foam, white boats, and white houses.

But you can't do much indoors. You have to go to nature to learn and to get your inspiration. Outside, you see and feel the character of your subject. It's an open book—all you have to do is learn how to read. And the amount of material is endless. I've been to some spots countless times. But each time I arrive on the site, I see something different, something I hadn't noticed before. It's as if it were all brand new.

Plates 1–4 should show you what I mean. They were all done on the same wharf in Gloucester, Massachusetts. In Plate 1, I was interested in the foggy day and the hazy distance; there were no really strong lights or darks. In Plate 2, on the other hand, I was struck by the brilliance of the day—the sun casts a glare over the reflections, and the boats actually throw shadows on the water. In Plate 3, I studied the cluster of boats; I was interested in the shapes of the masts against the sky. And in Plate 4, I decided to walk onto the wharf rather than look across at it, and so got a chance to paint the boats close up.

The same principle is at work in Plates 5 and 6. Here I was struck by how different the same building can look at two different times of the year. Can you feel how each painting has a different mood? Plate 5 was done in the summer and is masculine in character—there are lots of big trees, large forms, and strong areas of dark. Plate 6, on the other hand, was done in the early spring. I wanted a feeling of delicacy to go with the delicate colors of the season, so I kept all my trees lacy and thin. The picture has a feminine quality. It's the same church—but it said something different to me on each day.

The Effect

Since I'm interested in catching the mood of a day or subject, I'm committed to finishing the picture as much as possible *on the spot*. I've known many painters who would do small sketches outdoors and then blow them up in the studio. But in almost every case,

Plate 1. Foggy Day. Oil on canvas, 25″ x 30″.

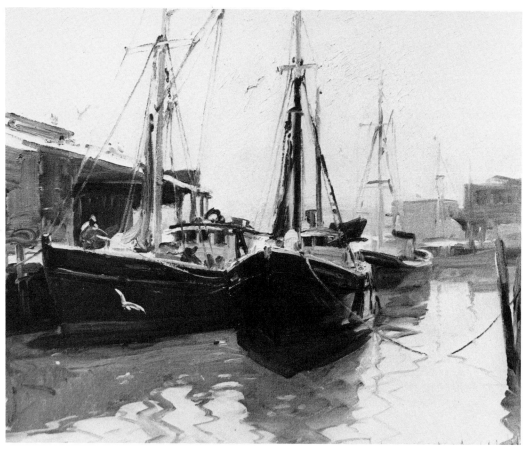

Plate 2. Reflections and Shadows. Oil on canvas, 25"x 30".

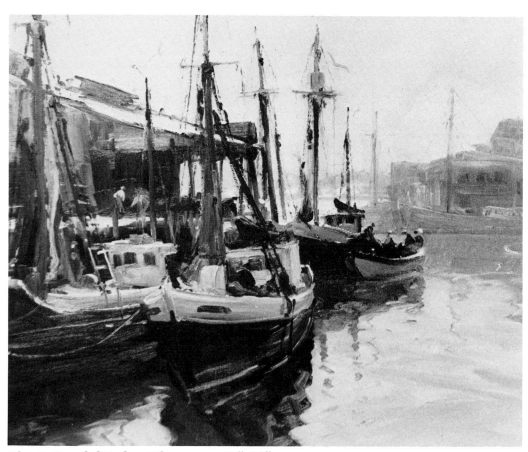

Plate 3. Crowded Harbor. Oil on canvas, 25"x 30".

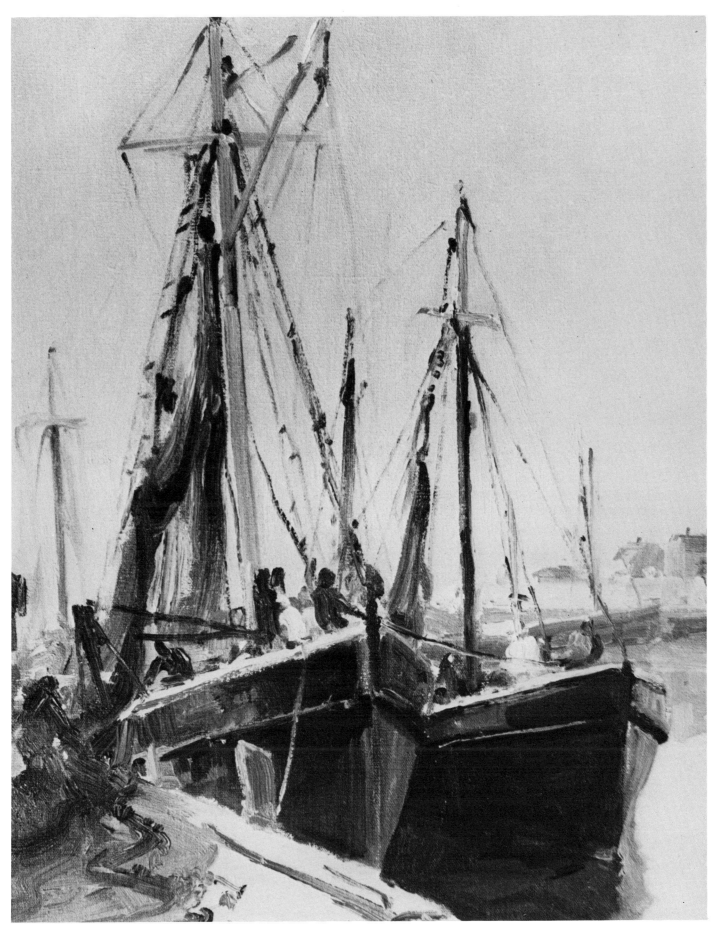

Plate 4. In Port. *Oil on canvas, 24″ x 20″.*

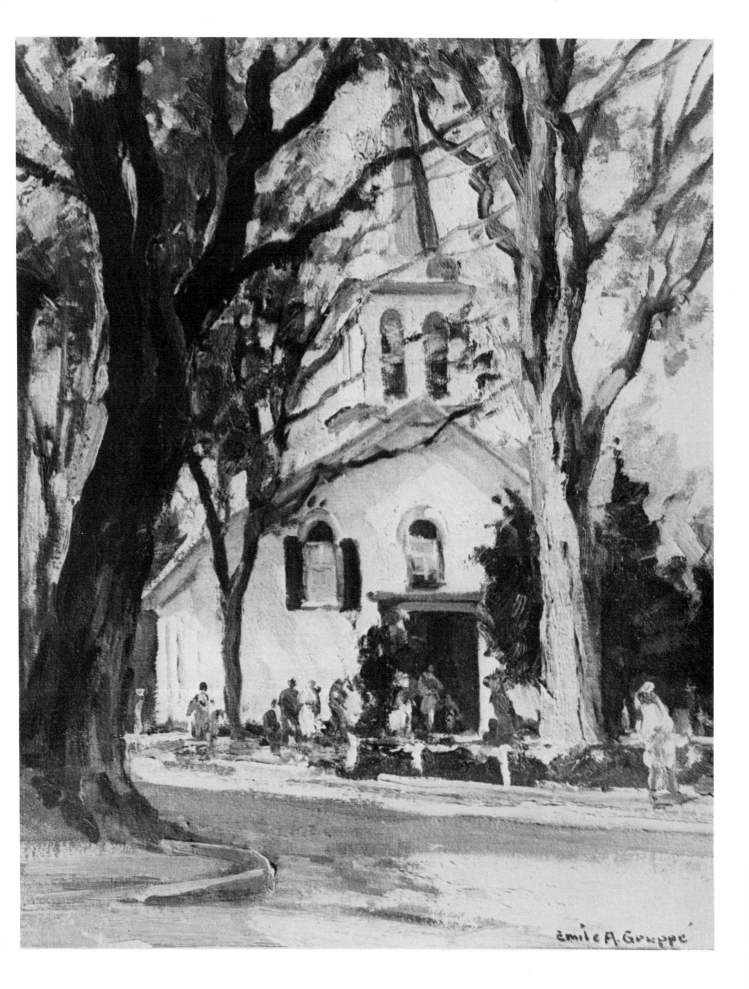

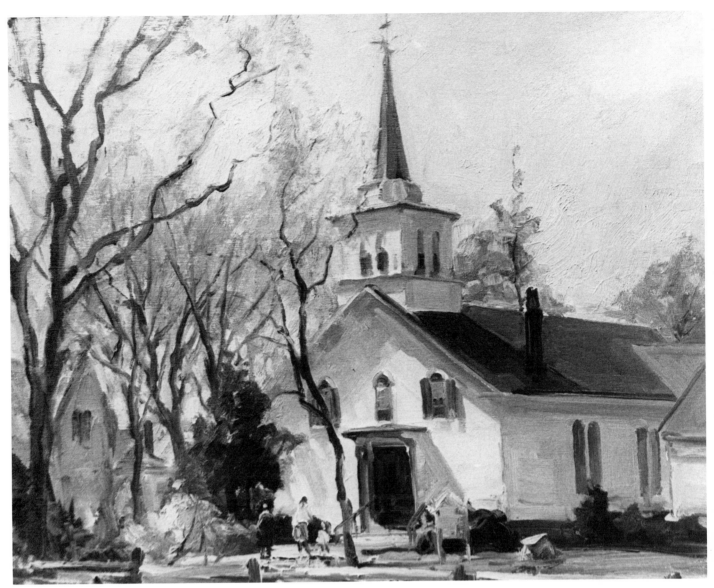

Plate 5. Village Church. *(Left) Oil on canvas, 16″x 20″. In late summer, the dark shapes around the church have a "masculine" character. I enlarged the doors and windows of the church because they were especially interesting. I also made the figures big, so you could see them and thus get a sense of the life of the village.*

Plate 6. Spring. *(Above) Oil on canvas, 25″x 30″. In the spring, the delicacy of the light-colored foliage gives the scene a "feminine" look. Again, I've added a few figures. Without them, the place would look deserted.*

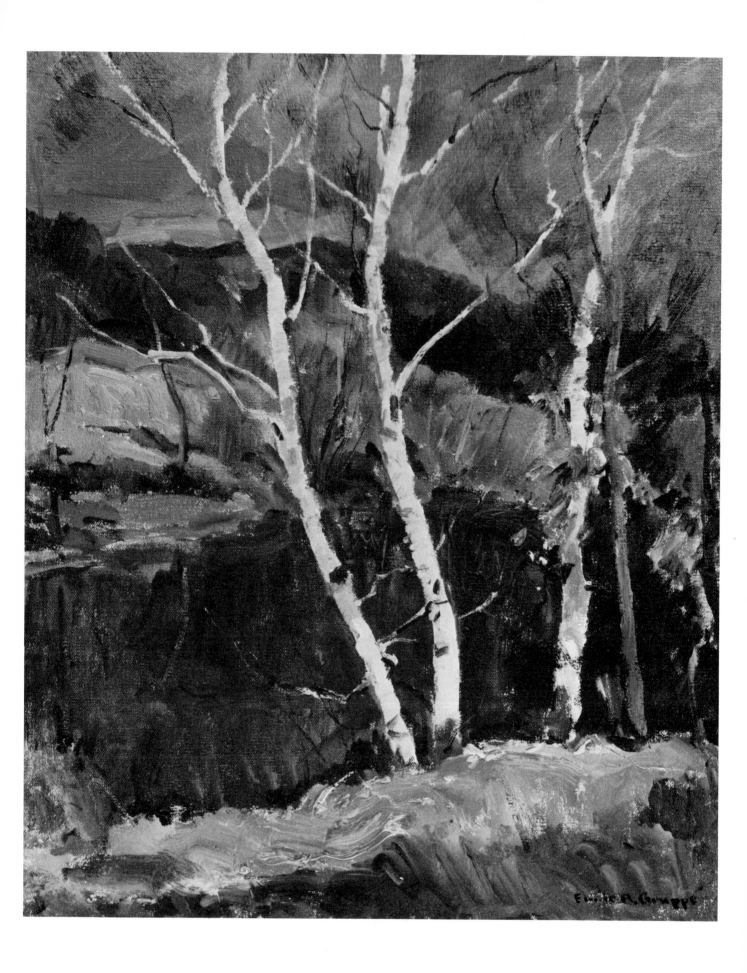

I always liked the sketch better than the finished painting—it had more life to it; you could sense the spontaneous reaction of the artist to his subject. I've always liked Plate 7 for that reason. It started raining shortly after I had begun to paint it; but I was working fast and caught the dramatic quality I wanted before I had to pack up. There's no monkeying around in a picture like this. No tricks: just a search for the essentials.

The Essential Element

The problem is knowing what you want to say in a picture and then picking just those elements that help you say it. I remember a picture by Harvey Dunn, the great illustrator, of a farmer and his horse. They were both skin and bones—but I particularly remember the *hat* the farmer had on his head. It was a funny shape, twisted and pulled, and looked like he had sat on it before putting it on. That hat told more about the man's life and the life of the pioneer than a hundred motion pictures about the Old West!

The Plan of the Book

Although the most important thing is to know *why* you want to paint a particular scene, some of the information I've picked up in my sixty years of outdoor work may help you to paint more quickly and surely. In the following chapters, I first suggest a way of drawing that will help you when you paint. Then I discuss my palette, my view of nature, and my color theories. After that, we look at the individual aspects of the harbor scene and the landscape. It's an arbitrary way of doing things, but one that's convenient. Then I devote a chapter to the most important subject of all: design. This is really the heart of the book, and I hope our study of a number of finished designs will help you solve some of your own problems. If a picture is well planned at the beginning, it will paint itself. Finally, I examine my method of painting in more detail, explaining my approach through words and a series of step-by-step demonstrations.

Variety

I've illustrated the following chapters with as many examples of finished paintings as possible—and I've tried to get as much variety into them as I can. You don't want all your pictures to look alike. And if you learn to respond to the scene, they won't. Remember, above all, that detail, the hard facts of the subject, isn't what makes a painting. What counts are those particular elements that appeal to you. When you think in these terms, you'll soon realize you don't need much to make a strong pictorial statement.

Your Own Feelings Come First

Above all, I want you to respect your own feelings and attitudes towards a subject. I discuss technique in the following chapters, but I don't want you to become obsessed by it. I can remember an incident that occurred in Woodstock towards the end of my student days. I tried to copy one of the local men—just back from Paris and full of "broken color" theories. He was building all his pictures on the interaction of purple, green, and orange. The instructor gave a critique every week and an assistant would group all the paintings together, all the same error in a bunch so the teacher would have an easier time. In the middle, the assistant would hang the picture he thought the week's best. Well, that day, my broken color piece was hung in the place of honor, and the crowd was buzzing. Everyone wondered what the instructor would say. He walked back and forth, back and forth, and finally he said, "There's someone here who thinks he's pretty darn clever." Then he began to lambast me! "Tricks, tricks, tricks," he said. "Painting isn't tricks. It isn't aping someone else's style. There's no place in art for sleight of hand." I never forgot that speech. And neither should you!

Plate 7. Dramatic Evening. Oil on canvas, 20″x 24″. A sketch is often more interesting than a finished picture. Here, everything is kept very simple. The long foreground shadow suggests the mountain I'm standing on and, by lowering the value of the area, keeps it from competing with the light trees. Block it out and see what happens.

1 Materials and Equipment

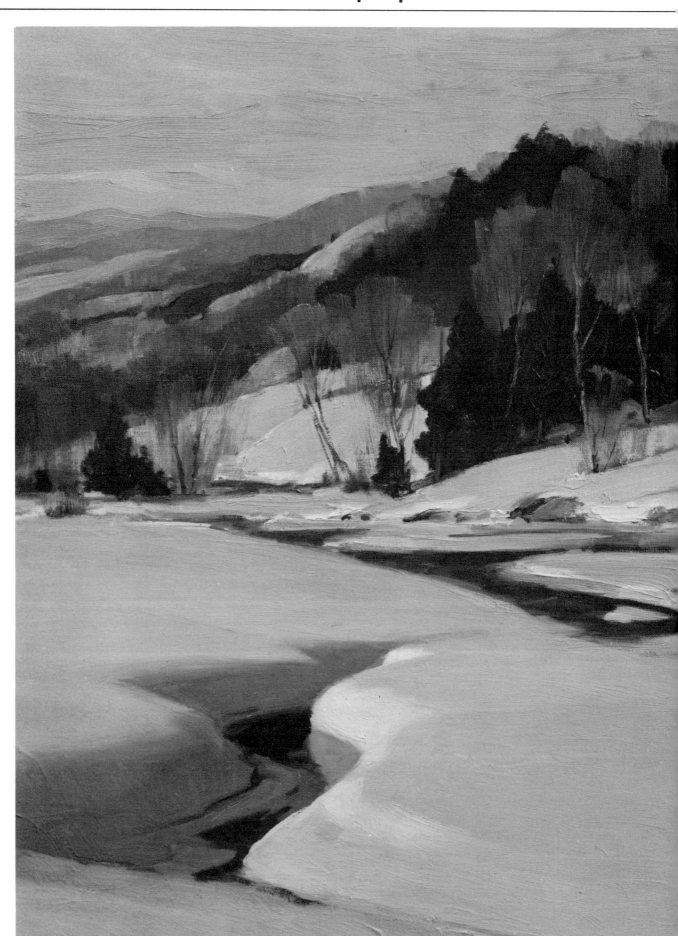

Before we begin our discussion of painting, let's talk about a few practical matters. Here are some of the materials I recommend you buy.

Easels

The Gloucester or Anderson easel is perfect for outdoor painting. It collapses into a small package and you can carry it on a strap over your shoulder. When open, its legs have a wide spread, so it stands steady in the wind. You can move the legs up and down, a feature that lets you set the easel up almost anywhere (Figure 1). In addition, it has an extra leg that can be strapped on when you're working on especially rough and uneven terrain. On a very windy day, I attach this leg horizontally to the back of the easel and pile rocks on top of it. That, and the weight of the paintbox, makes it very steady.

When you use the Anderson easel, you keep your paints, palette, rags, and brushes in a separate paintbox. The standard size box is 16″ x 20″—and that's adequate. I use one that's specially made for me and is 20″ x 24″. In Figure 2, you can see the materials stacked after a day of painting. The box holds everything conveniently and the easel is compactly folded and tied up.

Medium

My medium is a mixture of one part stand oil to five parts turpentine. Stand oil is linseed oil that's been bleached, dried, and thickened by exposure to ultraviolet rays—like those of the sun. Since it's pre-dried, it will dry very fast when used in the pigment; it takes the place of the varnish some people like to add to the medium. Since it's bleached, it won't have linseed oil's tendency to go back to its original yellow hue.

If you do detect a little yellowing in your picture, just put it in the sun for fifteen minutes. The color will come back. Many artists bleach a painting this way before sending it to a show; it restores snap to the highlights. Of course, sometimes a little yellowing can give a picture a nice mellow quality—it depends on what you like.

Plate 8. Melting Snow. Oil on canvas, 30″x 36″. By keeping the distance simple, I emphasize the interesting foreground pattern of snow, ice, and dark water. That's my subject.

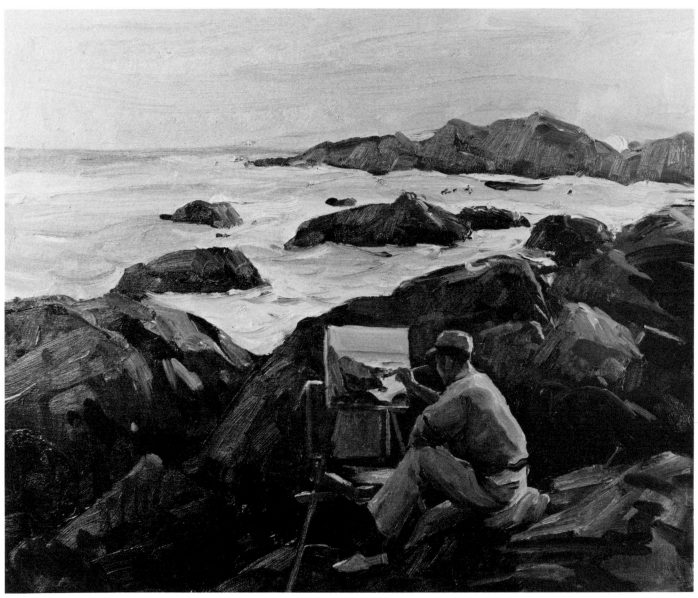

Figure 1. *Here's a painting I did of a good friend of mine, crouched among the rocks in Gloucester. The Anderson easel can go almost anywhere!*

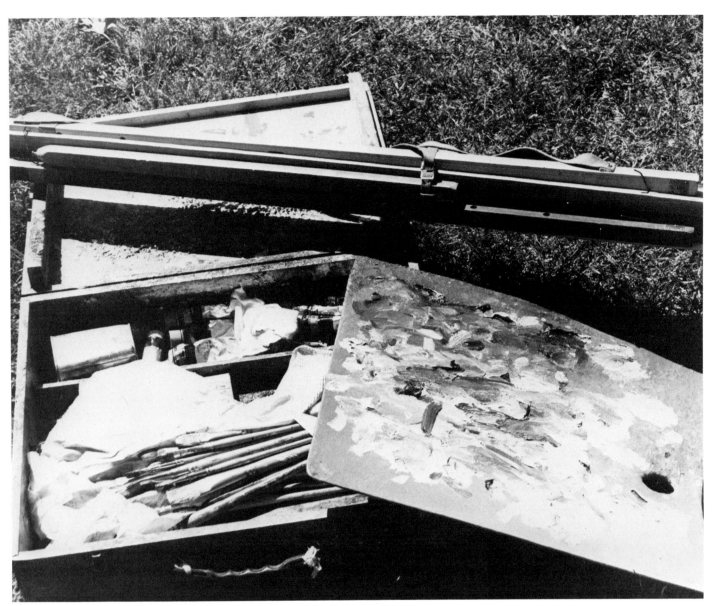

Figure 2. *This is the complete outfit: my palette and painting equipment are in the box—and the Anderson easel is packed and tied.*

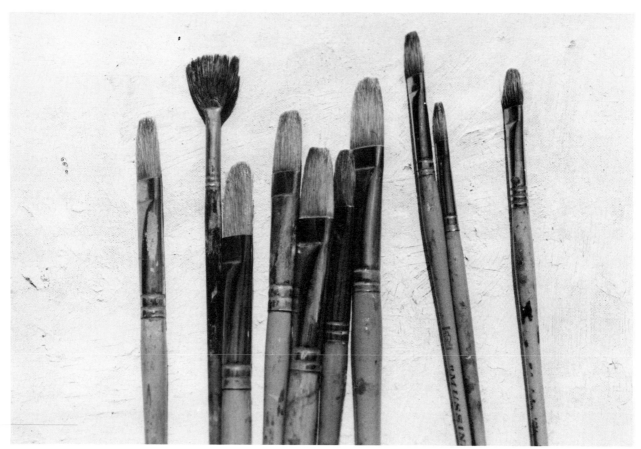

Figure 3. *My brushes are long-bristled and can hold a lot of paint.*

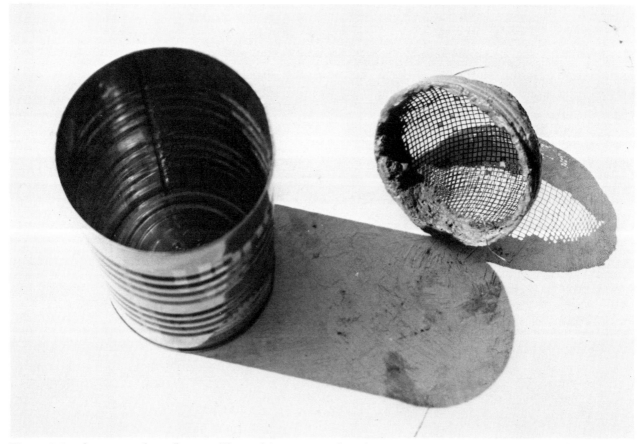

Figure 4. *Put the sieve in the coffee can, fill it with kerosene, and you've got a convenient way to clean your brushes.*

Palette Knife

I mainly use a palette knife for scraping. Sometimes, it helps bring out the edge of a rock, and it can be used to pull together an area that seems too broken up. It's a good tool for experimenting with colors, since you can tip color into color and mix them quickly. There's also a determined quality to the stroke that I like. But it creates a lot of paint ridges, and dirt can accumulate in them. I've seen old palette knife pictures of mine that were covered with dust—they looked like a batik! Also, if you use a palette knife too much, it can make your work look stiff. You aren't able to get subtle effects. I've always felt that a brush can do everything a palette knife can.

Brushes

I use *flats*—long-bristled brushes—sizes one to twelve, for most of my painting. The *brights*—short-bristled brushes—are good for portrait painting; you can get short, sharp strokes that help delineate the planes of the face. And sables are useful if you're doing the kind of work the old French painters did—those small pictures with detailed heads the size of a walnut.

But the flat is the brush for the landscape painter. Its long bristles pick up the paint and let you put down big, broad strokes. Remember: *use as big a brush as you can!* Figure 3 shows a sample collection of my brushes. Note the fan-shaped brush on the far left. I use that to suggest the lacy branches of a tree and to rough up the grass in my landscape, so it doesn't look too well-mown.

It's a good idea to soak a new brush in kerosene—the paint won't accumulate in the ferrule so readily. I also use kerosene to clean my brushes. It keeps them moist—unlike turpentine, which dries far too quickly. I simply swish them around in a can with a sieve attached to the top (Figure 4). If you're not go-ing to use the brushes every day, you should wash them with Ivory soap after cleaning them. That way, they won't dry up on you.

If a brush does go stiff, add a cup of soap—not detergent!—to half a cup of boiling water. I use Fels Naptha. Be sure to take the boiling water off the stove before putting in the brush. Wash it again with kerosene and the paint should come out. Then clean the brush with clear water and lay it on a table to dry. After about a day, you'll be able to use it again.

Canvases

Begin with small canvas panels—8″ x 10″ and 12″ x 16″. You'll be able to cover them easily. Later, as you gain in experience, you can try a number of larger canvases. I tend to like the squarer sizes—16″ x 20″ and 20″ x 24″. The 18″ x 24″ size strikes me as too oblong. It dictates to you. But with a square canvas, you can emphasize either height or width—it's up to you.

The kind of painting I do assumes that you work on a white, untoned canvas. The white helps give luminosity of tone. It shines through the underpainting and the thinner glazes of color. One of the nicest grounds to work on is the surface of an old painting, sanded down and covered with the purest white lead. A canvas like that always has an interesting texture.

Mirrors

The last piece of equipment I mention is probably one of the most important: a mirror. As you paint, you get used to mistakes, but seeing the picture in reverse gives you a fresh eye. Errors jump out at you. And it's a good way to check for balance. In my studio, I have *three* mirrors: one in back of me, one to my right, and one to my left.

2 Drawing and Values

Plate 9. Drying Sail: Foggy Day. *Oil on canvas, 25″ x 30″. On a foggy day, values are close together.*

Before we look at my palette and my color theories, let's talk about drawing. Leonardo da Vinci, the greatest draftsman of them all, complained: "I never learned to draw well enough." To paint a good picture, you have to be able to draw, for the preliminary charcoal drawing on the canvas is the most important part of the work. Remember: if you get that going properly, the picture will almost paint itself.

Drawing What You See

The most important thing to remember is that you should try to *draw what you see.* Don't think you're doing a "horse," or a "tree," or a "boat." As soon as you start thinking about the subject, as such, you'll get lost in drawing what you *think* it looks like. Think of a *shape,* first—then you won't get into trouble. I once had a very talented student who had spent much of his time in Europe. Instead of drawing Gloucester boats as they were, he'd always draw them like the Breton boats he was familiar with. That's how he saw them. I had to make him stop and really look.

So begin by observing the direction of the lines of your subject, without worrying about what the subject is. Look at Figure 5. I've marked the important lines. When you're drawing such a scene, you should ask yourself: at what angle does line A meet line B? How much does line C diverge from line D? Where does line E intersect line I? What's the difference in direction between line E and line G? Where does line H fall on line E? What is the relationship between the spaces marked 1, 2, and 3? Which is the biggest? Which the smallest?

When you draw and paint, you're always dealing with *relationships.* The student too often draws each line separately; he forgets that he can't draw one line without figuring out how it relates to another. It isn't a question of how long an individual line is, but how it compares with every other line. Is it longer, shorter, more curved, more horizontal or vertical? A person who can draw a good horse should be able to draw a good cow: he draws each *as he sees it.* Once you've gotten to the point where you can draw what a thing looks like, you can begin to *interpret* it. You can begin to draw your feelings about it.

Perspective

If you take my advice and look for the relationships between lines, it will help you with a subject that seems to cause all kinds of confusion to the student:

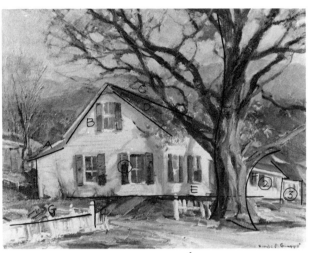

Figure 5. You draw an object by comparing the directions of the lines that give it character.

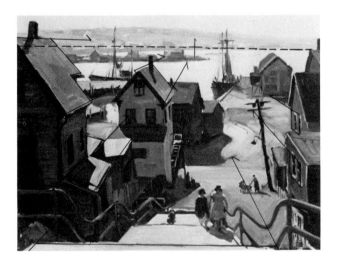

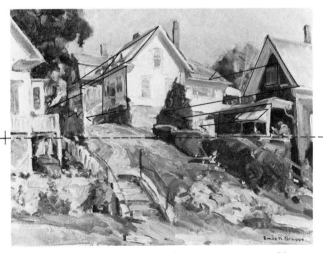

Figure 6 and 7. In Figures 6 and 7 the superimposed lines show you how objects in perspective recede to a vanishing point (the cross marks). (Figure 6 courtesy of the Cape Ann Savings Bank, Gloucester, Massachusetts.)

Figure 8. Drawing with a pen, you tend to see too many edges.

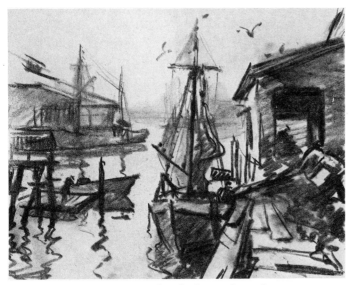

Figure 9. Drawing with soft charcoal, you learn to see in terms of shape and mass.

perspective. In Figures 6 and 7, I've tried to indicate how perspective works in two different cases: looking up and looking down on a group of buildings. The dotted line marks your eye level, and is called the horizon line. The cross marks on both pictures represent the vanishing point. As you can see, all the parallel lines converge on this vanishing point. Now it's possible to develop elaborate theories about perspective. They get more and more confusing and students become obsessed with finding horizon lines and locating vanishing points. But the mechanics of the subject are really of little importance. Again, the trick is simply to compare the lines of the buildings in front of you—see how they angle and *draw them as you see them*. If you do that, you'll get the perspective reasonably correct. Knowing about vanishing points helps; it tells you what to look for. But that's all. Besides, you don't want to get your perspective so perfect that your drawing looks like an architectural rendering. You should try to get the feeling of recession towards a vanishing point without worrying about pinpoint accuracy.

Painterly Drawing

When I refer to "lines," I'm using the word as a convenience, indicating the borders between various masses. On his deathbed, Renoir declared that there was no such thing as an edge, or line, in nature. And that is really the key to drawing in a painterly way. You want to be able to draw quickly, in a manner that gets at the essentials and that's concerned with the design possibilities of a subject: its shape, contour, and value. You don't want to be concerned with the individual details of a subject.

To give you a clearer idea of what I mean, look at Figures 8 and 9. Which looks the most "realistic"? Of course, Figure 9 does. Yet, invariably, a student will begin drawing in the manner of Figure 8; that is, he'll see things in terms of *lines* rather than in terms of *masses*. This could be the result of years of writing with a hard pencil—or playing with coloring books. But whatever it is, the student wants to outline everything and then fill in the spaces.

This is just the wrong way for an oil painter to draw. The most noticeable thing about oil painting is the fluidity of the medium. It's natural with oil paint to brush in large areas rather than to draw a lot of lines and details. And since conditions are constantly changing outdoors, we can take advantage of oil's fluidity to put down the big facts first—while things remain fairly static—and then worry about lines and details later. That's why I want you to draw in a broad manner—a manner that matches your medium.

Values

It's also a fact that we just don't see nature in bits and pieces. We see it as a number of large areas of value—that is, of large masses of light and dark. Only when we consciously *focus* on one spot, do we see an edge.

Values can be defined as the relative lightness or darkness of a color; it's how a scene would look if you took a black-and-white photograph of it. Figure 10 shows you a value scale, from the darkest dark to the lightest light. In Figure 11, I've tried to indicate how the scale appears in nature—in this case, a stand of maple trees that I painted on a misty morning in Vermont. The mistiness of the day exaggerated what would happen anyway. The strongest darks are in the foreground trees; as more atmosphere comes between us and the distant objects, their value becomes lighter.

A correct sense of values is one of the most important of the painter's skills. My earliest instructor used to sit with me for hours, after the day's work, going over my painting and pointing out where an area was too dark or too light. I'd have a spot in the sky, for example—maybe a part of the underpainting that I didn't cover—and he'd point to it and ask: "What's that, an eagle?" So I became a tiger for values. In fact, I decided one day to test myself. I wanted to see if, by looking hard enough, I could determine where two nearly identical values came together. I chose the forest and the side of a barn—in the moonlight! I finally did see the border—but only with the beat of my heart: when the blood was pumped into my eyes, I could see. Then it would disappear! Of course, you don't have to worry about values *that* close together; I just mention them to you to show how infinite the variations can be.

For a lot of people, the fact of color gets in the way of their seeing values. They see a red barn and then paint it a red of the same value, whether the building's near them or a mile away. They don't realize that seeing the fact that the building is red is, really, the least important thing for you to do. What counts is seeing the *value relationship* between colors. If the value of the color is right, then almost any color you use will look right.

That's why I want you to practice drawing in the manner of Figure 9—a "value drawing." Don't use a pencil or pen; that only encourages you to waste time with detail. Instead, get a soft charcoal; it fills in large areas quickly and blends easily, so you can lose as many edges as possible. The pen and pencil cut things up too much, leaving you with pieces rather than a big statement. In Figure 12, you can see how a line compares to a quick, swinging stroke of the charcoal.

Figure 10. The Value Scale.

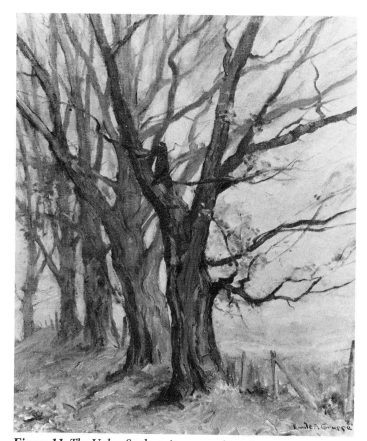

Figure 11. The Value Scale as it appears in nature.

Figure 12. Compare a hard line to the breadth and subtlety of soft charcoal.

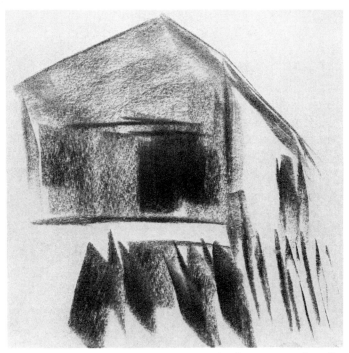

Figure 13. Areas of value suggest the dimensions of an object.

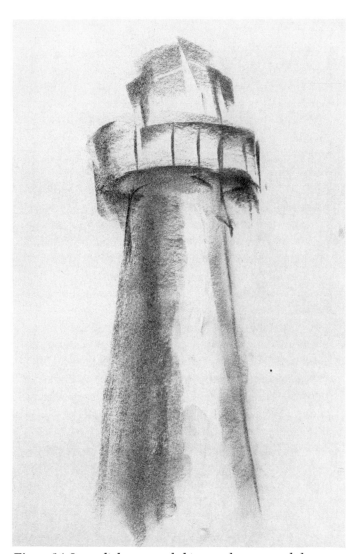

Figure 14. In sunlight, a round object undergoes a subtle series of value changes.

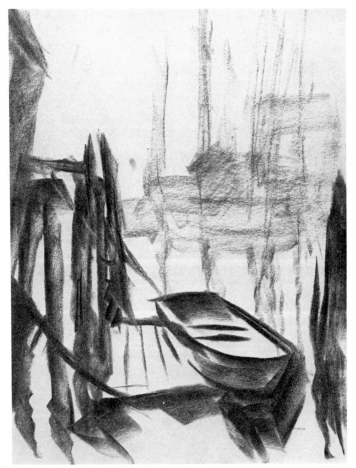

Figure 15. If you squint your eyes, you'll see that objects fall into large patterns of light and dark.

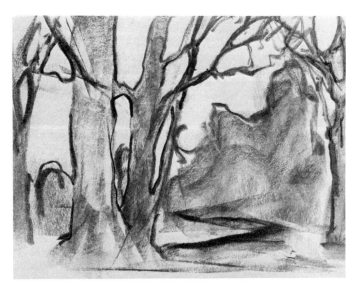

Figure 16. If you get the big pattern right, details aren't really necessary.

The Third Dimension

I've suggested that values have a part to play in separating your foreground from your distance and giving a three-dimensional look to your picture. In the same way, values help give your objects a three-dimensional shape.

Everything in nature is defined by light and shadow. On a gray day, to be sure, you won't get much "modeling," but on a sunny day, you need to look for the dark and light areas. Figure 13 is a very simple charcoal sketch of a building. Its form is defined by the relationship between the dark and the light areas—*not* by drawing edges and lines. The effect of light on a curved surface is even more noticeable. In Figure 14, the light hits the right side of the lighthouse. As it curves away from the source of light, it gets darker. But notice on the far left side, it lightens again: light is reflected into it from the sky. The darkest value occurs just before the lighthouse curves away from us.

Pattern

As you draw, look for the way objects come together—how they link up and what kind of pattern they make. Squint at the scene and the details will disappear; you'll just see the interesting masses. Figures 15 and 16 indicate what I mean. In Figure 15, squinting makes wharf, pilings, float, and boat all come together into one dark shape, a shape that outlines the sunlit areas. So I drew that characteristic shape without worrying about details. Figure 16 shows a group of trees handled in a similar manner. You know they're trees without seeing detail.

Go outdoors and do some sketches like these, concentrating on the forms and drawing them so that they make interesting shapes on your page—shapes that your eye enjoys looking at.

Drawing and Feeling

When you draw, try to isolate the main characteristic of your subject. What kind of a *feeling* does it give you? I'm not talking about anything mysterious. Look at Figure 17, for example. I've drawn a collection of concave and convex lines. Now, do these lines *suggest* anything to you? In Figure 18, I've taken the convex lines and drawn some mountains. I've spent no time on detail: I'm after the feeling of the earth bulging up, of mountain piling on mountain as you look towards the distant peak. Once I have that *feeling*, I can add all the detail I want. But if I haven't got the bulging, rounded, massive feeling of the

Figure 17. Try to feel the different qualities suggested by CONVEX *and* CONCAVE *lines.*

Figure 18. CONVEX *shapes suggest the massive bulge of the earth.*

earth, then all the detail in the world won't do me any good.

Similarly in Figure 19, I've taken the concave motif and used it to suggest the ocean. The concave lines of the net, the boat, and the distant ship all suggest the bobbing, constantly moving nature of the ocean itself. These shapes alone give you the sensation; I don't even have to indicate the troughs and peaks of the water! By accentuating the essential and characteristic nature of a subject, I've freed myself from the necessity of doing the relatively unimportant details.

In Figure 20, I've combined the two lines: you have the bulging, convex lines of the tops of the trees—lines that suggest growth—and the delicate, convex, reaching lines of the branches. The two lines, played off against one another, define the nature of the trees. I don't have to draw every leaf or indentation in the bark. I've given you my *impression* of the tree. The power of suggestion—the painter's best friend—is enough to suggest the rest.

Design

Look for the way things fall into large light and dark masses, and draw those masses. As an exercise, I think you should often try drawing with the *side* of your charcoal. Such drawings can be very effective—and you won't be able to do detail, even if you wanted to. Look for the broad design. In Figure 21, for example, I've tried to suggest a landscape, stressing the water rather than the trees. I'm after an interesting balance of light and dark, and of horizontal, vertical, and diagonal elements. A drawing of this kind is interesting, even when you turn it upside down. That's the mark of a good design: it shows that you've been thinking about the way the shapes look rather than simply trying to copy what's in front of you. Since the sketch emphasizes the water, it naturally takes a horizontal shape—it's a horizontal idea. Similarly, Figure 22—a study of a tree and its branches—falls easily into a vertical shape.

Pages from a Sketchbook

You should keep a sketchbook and use it to record things that interest you. Draw in a variety of manners and give your hand plenty of practice. In the three sample sketches shown here, you can see how I used different methods to achieve different ends. Figure 23 is done mainly in outline: I wanted to make a close study of the way the tree branches grew. I wasn't relating it to a background. Figure 24 is a subtle value study of a beech tree in the snow; I was especially interested in the way the shadows fell across the tree's

smooth, curved surface. And Figure 25 is a bold study of the big light and dark pattern created by the strongly lit sugar house and the distant mass of trees.

The Value Range

Before moving on to a discussion of color, I should say a few words about how the value range functions in a group of finished paintings. There are a variety of tonal effects you can get in a picture, each of which has its own appeal. I'm mentioning them, so you can look for them when you go outdoors.

On a foggy day, for example, values are close together. This creates an air of mystery that people like. In Plate 9, you can see that the boat in the distance is one simple mass, light in tone. The heavy atmosphere reduces the boat and sails to the same value. Many people, painting a scene like this, would paint the hull of the distant boat darker than the sail. That's because they *know* one is darker than the other. And they paint what they *know* rather than what they *see*. They don't compare. In a picture like this one, you lose the whole effect if you don't keep all your dark values in the foreground, close to the viewer. That's where they belong. And they make the distant boat seem even farther back, by way of contrast.

In Plates 10 and 11, I'm working on a sunny day, but the tonal effects are completely different. I'm in the sun in Plate 10, looking *towards* the deep woods. The beech tree gets a full blast of light and is high in value. The evergreens in the background, however, are in shadow and look very dark. This gives me strong light and dark patterns to work with, and, as a result, the picture has a lot of spunk; it hits hard and has plenty of impact. Plate 11, on the other hand, was painted *inside* the deep woods. The value scale is entirely different. The light doesn't hit the subject full-force; it filters down through the trees, like the light in a cathedral. There are no really strong darks and no really bright lights—except where you can glimpse the sky now and then through a skyhole in the trees. The appeal of a painting like Plate 11 is completely different from that of Plate 10. Now, I'm interested in subtle shifts in value between the pines overhead, the trunk of the tree, and the snow. Both pictures are good, but I have a special fondness for the sensitive painting in Plate 12. I've had the picture for years—and plan to keep it.

Relating Value to Value

Another important thing to remember about the values in a picture is that they help to identify one an-

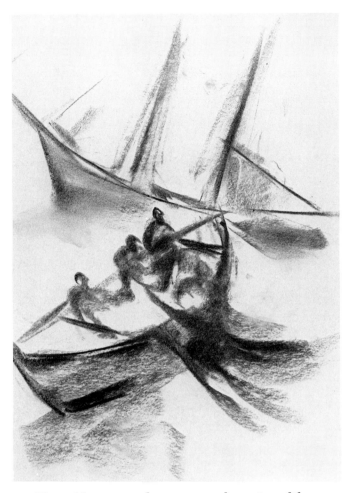

Figure 19. CONCAVE *shapes suggest the motion of the sea.*

Figure 20. CONVEX *and* CONCAVE *lines together give character to a tree.*

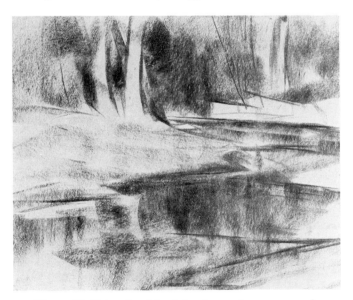

Figure 21. *Using the side of the charcoal, you can make broad studies of a subject's design possibilities.*

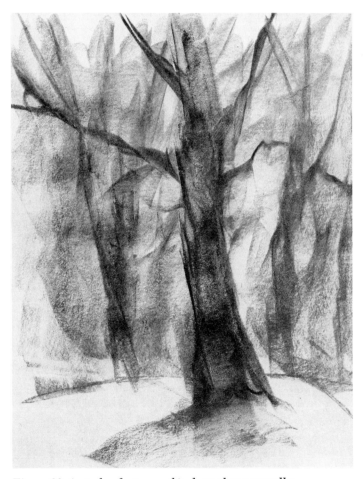

Figure 22. *A study of a tree and its branches naturally takes a vertical shape.*

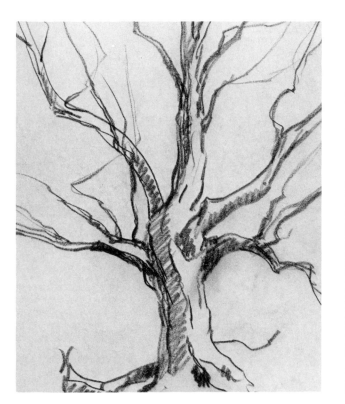

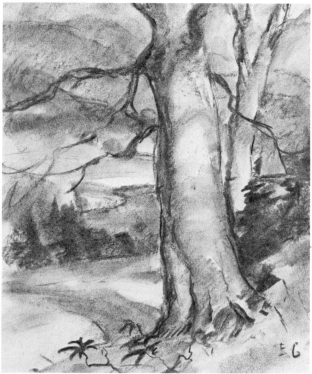

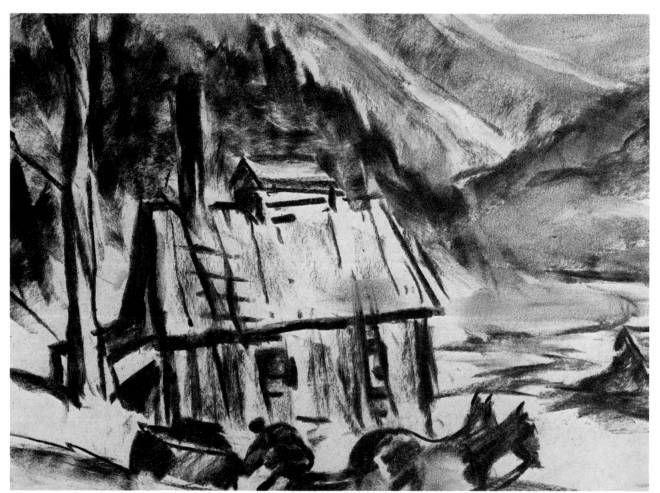

Figures 23, 24, and 25. Three pages from a sketchbook. Different methods are used to achieve different effects.

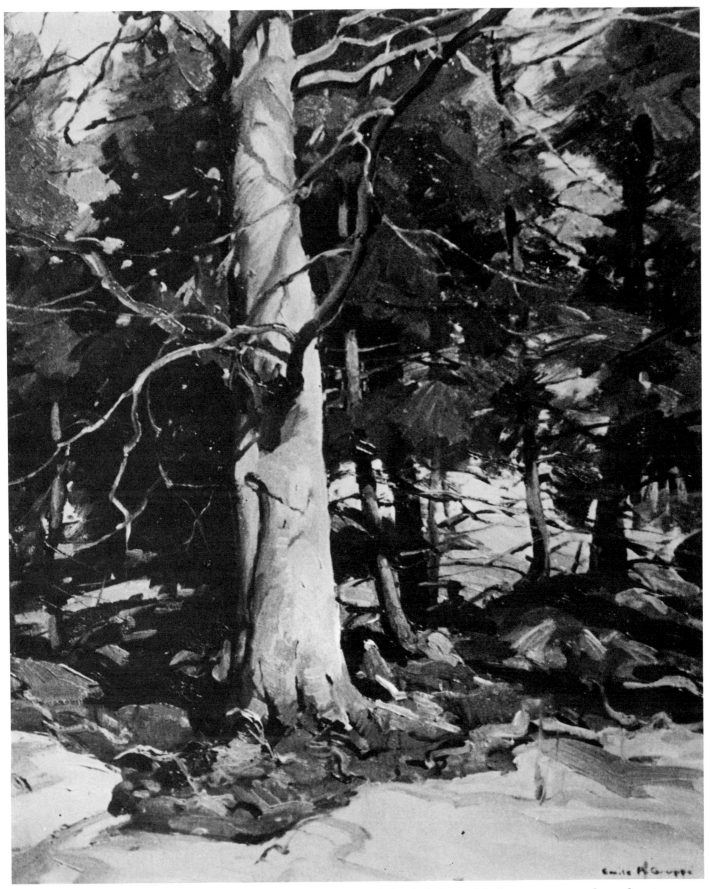

Plate 10. Melting Snow, Vermont. *Oil on canvas, 36"x 30". In sunlight, the lights and darks are strong—you have almost the full value range.*

other. You can see what I mean in Plates 12 and 13. There was no birch tree at the spot shown in Plate 12. So why did I put that small one in? Well, cover it with your finger and see what happens. I need the white spot to tell the viewer just how dark all my darks are. In addition, the eye likes to see a pure white in a picture—it completes the value scale and gives the viewer a satisfied feeling.

In Plate 13, the same principle is at work, only in reverse. What counts here are the dark shadows at the base of the principal group of birches. Those darks not only help focus your attention, but they also tell you just how light the trees are. Again, put your hand over the darks and see what happens. When you remove your hand, the trees jump out at you. The deep dark tells the viewer that the light parts are in strong sunlight.

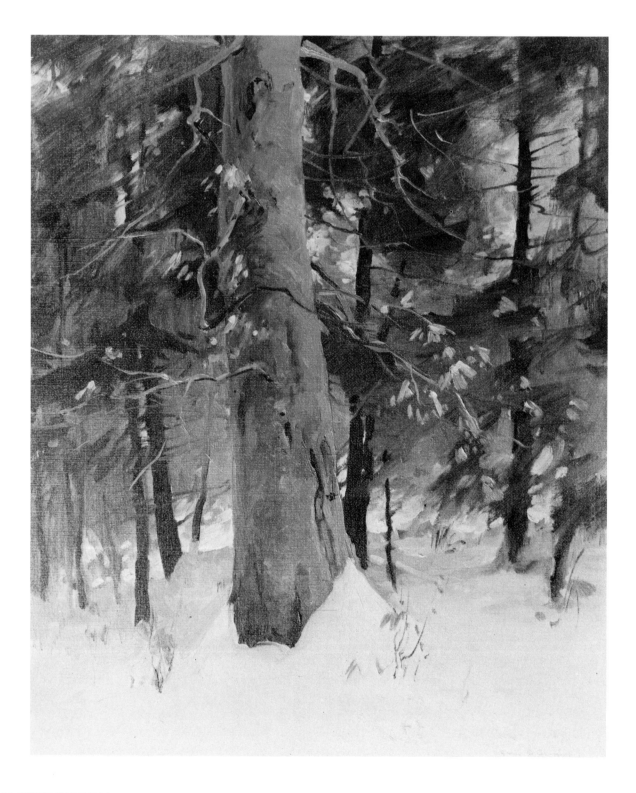

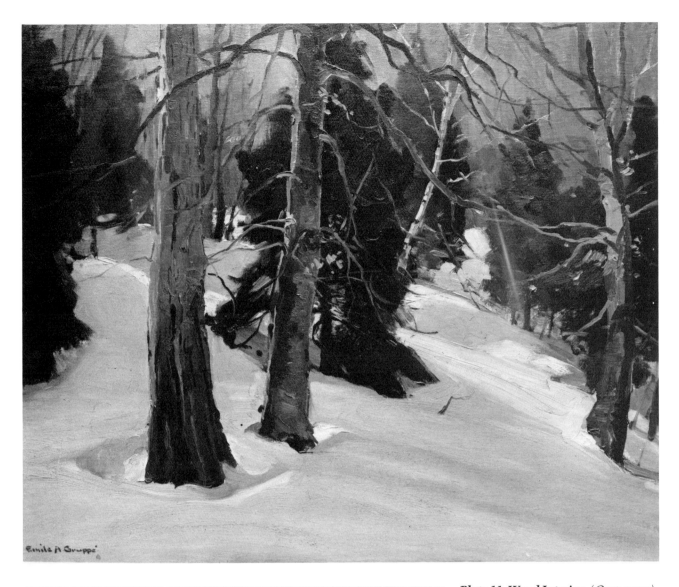

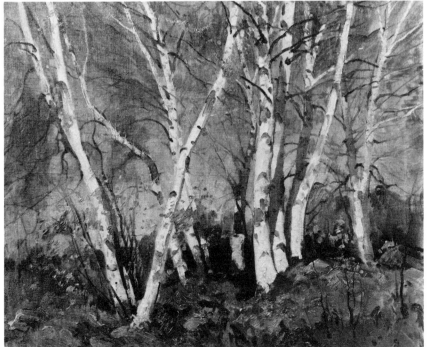

Plate 11. Wood Interior. (Opp. page) Oil on canvas, 25″x 30″. Inside the woods, the light is diffused and the values are close together.

Plate 12. Windblown Snow. (Above) Oil on canvas, 25″x 30″. The light birch tells you how dark the other trees are.

Plate 13. Screen of Birches. (Left) Oil on canvas, 25″x 30″. The dark shadows tell the viewer that the birches are in strong sunlight.

3 Color

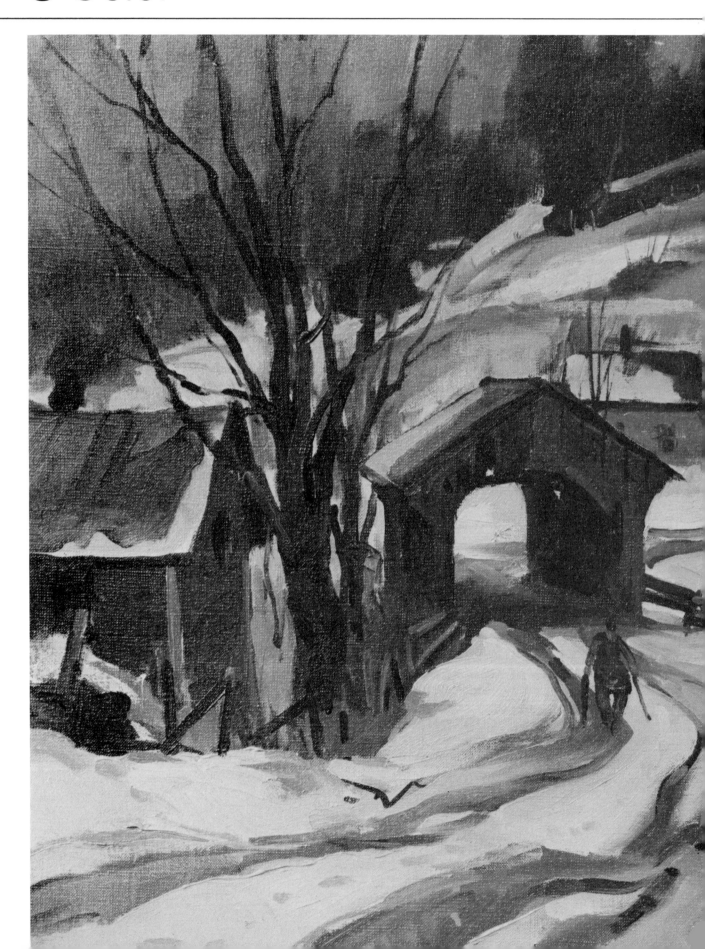

As you probably learned in grade school, the three basic, "primary" colors are red, yellow, and blue. Yellow is a "warm" color—that is, we associate it with the sun, fire, and similar warm sensations. Blue is a "cool" color—we associate it with water, shadows, and other cool sensations. A cool color can have a warmish tinge, and vice versa. Red, everyone used to tell me, was also a warm color. But I never believed it, and I still don't. As I see it, red is a *modifier*, lying between the cool and warm extremes. You can warm a cool color by adding red and you can cool a warm color by also adding red. Think of red as moderating between brilliancy and shadow.

The eye has three kinds of cones: one that sees red, one that sees blue, and one that sees yellow. Blue and yellow are the most easily seen colors in nature. For some reason, they seem to travel more quickly to the eye. Red isn't so easy to see. In fact, you have to use a lot of red in a picture if you want the viewer to see it at all. So when I paint, I try to get a little red into everything. The eye seems to like it. And it accords with the facts of nature: all three of the primaries appear in every object in sunlight. A blue object, for example, may reflect mainly blue rays—but there will be red and yellow ones present in varying degrees. Prevailing conditions—sun, atmosphere, and the texture of the object—will make one or possibly two colors predominate. But the third is always there.

Plate 14. Melting Snow. Oil on canvas, 20″ x 24″. I've kept the sky dark so that the light snow will have a chance to register. In reality, the distant mountain was straight, but I slanted it so that it leads the eye towards the bridge and the large tree—my subject. The road leads the eye in the same direction. The old man gives scale and life to the scene: see how vacant the painting looks if you cover him with your finger.

Palette

There's no manufactured paint that's a *pure* red, or yellow, or blue. In order to get a variety of warm and cool mixes, I've reduced my palette to a basic minimum: the three primaries, each in a warm and cool version (Figure 26). After you've practiced with this palette, you'll discover that you can mix almost any color with it. I add a cadmium orange to the palette for convenience. I could mix it, but I use a lot of it and it's easier to put it out. I also use zinc white. The complete palette encompasses the full value range—lemon yellow is my lightest value and the two blues, my darkest. To lower the value of yellow, I add red or blue. To raise the value of blue or red, I add yellow.

Temperature	Colors	Characteristics
Warms	Cadmium yellow deep	A warm, orangey yellow
	Cadmium lemon yellow	A cool, bluish yellow
Modifiers	Cadmium red deep	A warm, yellowish red
	Rose madder deep	A cool, bluish red
Cools	Pthalocyanine blue	A warm, yellowish blue
	Ultramarine blue	A strong, cool blue

Figure 26. This is my basic palette.

Color Characteristics

The cadmiums are, of course, the most brilliant colors available so I like to use a lot of them. As for the rose madder deep, it's similar to alizarin crimson, but more mellow. Alizarin is really a nasty color—it's a dye that gets into everything and never seems to dry. It gets stronger with the passage of time, finally bleeding through all the other colors. I remember a famous sunset painter who used a lot of it; his pictures have gotten redder and redder with time, and they now all have a crimson glow to them. Madder deep doesn't have any of these drawbacks.

Thalo blue is a fairly recent replacement for Prussian blue—a replacement that was badly needed, since Prussian blue tends to get darker and darker as it ages. I know one landscape painter who used it—and whose delicately mixed greens have now all turned black. Remember to be careful with thalo, or it will get into all your colors.

I use zinc white because it's fairly weak. it isn't like titanium, a white that swallows color up. You can cover a bright red house with one coat of titanium; it's what they use in commercial housepaint. With zinc white, however, you can see your color; and since the white is fairly transparent, your pictures don't get the bluish cast that results from a strong white. I remember accidently getting a case of titanium years ago and using it, unknowingly, for a number of months. My work turned blue—and for a while I was afraid I was going color blind! Then I discovered the mistake. Zinc white is also a safe white. Beware of lead white: it can be poisonous. I knew a painter who used lead white and always cleaned his brushes with soap and water, rubbing them on the palm of his hand. The lead worked into his system and he turned the color of gun powder! For the last four years of his life, he didn't touch oil paints at all; he just worked in pastel.

You should also notice that I don't have any earth colors on my palette. They're too opaque and they have a tendency to strike through all the other colors. When you put an ochre down, for example, that's all it ever is: ochre. It's lifeless, dead. I admit that I carry a tube of raw umber in my paint box; but I've rarely had reason to use it.

I don't use black either. Again, it's too much one thing: black. And it's usually too dark. A spot of black in a picture jumps out at you. It doesn't stay behind the frame and so destroys all atmosphere.

How to Use the Palette

The following diagram indicates how I lay out my palette; the positioning of the pigment is designed to make the color-mixing all that much easier. With this palette, I not only have the primaries, but I can mix the complements (purple, orange, and green), and I can create my own umbers—umbers that have more snap than the ones out of the tube because they're created from a combination of different colors. That gives them added vitality.

The umbers and the greens are especially important when using my palette, because when you first work with it there's a tendency to have your picture go too blue. The purple is substituted for black, and if you don't get your greens and umbers working

quickly, you'll go color blind. You won't realize how cool your picture is getting.

I usually whip the zinc white before using it by adding some medium and swirling it around with my palette knife. This isn't necessary if the tube has plenty of oil in it, but sometimes it comes out hard and you have to do something to keep from *fighting* it. Otherwise, you'd have to break the white down before you could get any color into it. And in breaking it down, you overmix your colors. The idea is to *touch* color into your white and then apply it, with as little mixing as possible. The less mixing, the more vibrant your color.

Complements

I noted that I could mix the complements with my palette. You can get the complement of each primary by mixing the other two. The complement of red is green (blue & yellow); of blue is orange (red & yellow); and of yellow is purple (red & blue). The complement relationship is an extremely important one, for the complements have interesting proper-

ties: (1) they accent one another when placed side by side, and (2) they modify one another when mixed.

If you place a red next to a green, the red looks redder and the green, greener. But if you have a strong green and you want to make it less pronounced, don't add black: run some red into it. That's a more lively way of achieving your end. The more red you add, the more the green will be tempered. A red building in shadow, for example, will have a lot of green in it.

In my opinion, you're really painting when you create all your neutral colors by cutting complement into complement. As an exercise, you should try to mix a variety of neutral tones with the complements, adding white to the mix so you can see the color. Have the mixture favor either the warm or cool side of the spectrum. Then see if you can get a perfect neutral, carefully balancing your red and green, or blue and orange, or yellow and purple so that no one color predominates. An exercise of this sort will give you a feeling for what your palette can do. And it will be very useful when you go outdoors.

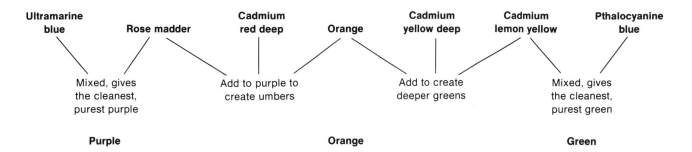

Figure 27. Here you can see how I lay out my colors on the palette and also how I mix their complements.

Color in Nature

Before we can use the colors on our palette, we have to have some understanding of how nature works. The most important consideration for the outdoor painter is light—we're always after the fleeting effect, always trying to capture the quality of a particular day. In order to do this, you have to know what to look for when you go out. I'll tell you some of the facts I've noticed over the years, and maybe they'll help you *look* at the scene in front of you.

I plan to keep my remarks fairly general. But at the end of the chapter, there's a series of full-color reproductions. They'll give you specific examples of how I apply my theories.

The Sky

The sky is the source of light in the painting—and, as a rule, it will usually be the lightest part of the picture. There are times when you may want to make the sky dark. In Plate 14, for example, I wanted to emphasize the light-colored snow. So I kept the sky relatively dark. That way, the snow registers. Usually, however, the rule holds true—even though the value relationship in the picture may be a very subtle one. In Plate 15, for example, I've painted an overcast day; the clouds act like a lampshade, diffusing the light over the whole scene. But despite the fact that the water is very light, the sky is still lighter. Turn the picture upside down: you won't be distracted by the subject matter and you'll see that the water is just a hair darker than the sky. It's subtle difference but one that's essential if you want the picture to ring true.

Gradation of Color in the Sky

As a rule of thumb, remember that when you look directly into the sun, the sky has a lot of yellow in it. Yellow, as we've already noted, is a warm color. As we move away from the sun, the warmth will become less noticeable; we get more of the natural blue of the sky. "Cool" color begins to appear. With paint, it's always easier to make a warm color cool than it is to make a cool one warm. So always put down your warm sky color *first*. If, for example, you're looking directly into the sun, you can begin the sky with plenty of lemon yellow and white. Now don't be afraid to use the yellow. If you use too much white, the sky will look chalky and unconvincing. After you have the yellow down, you can run blue or whatever color you want over it.

You'll be surprised how *little* cool color is necessary to make the sky look natural. Students almost always use too much blue! They kill the sunlight effect. It's the warm color that counts; the less blue you use, the better. I knew one fine painter who made all his skies green. And then there was a student of mine: I told her to use yellow in her sky. Not knowing any better, she put the color on almost pure out of the tube. Well, the effect was tremendous! I ran over to her and told her to stop. She was finished; if she could do as well five years from now, she'd be lucky. She was proof of the old saying that every student paints a masterpiece sometime during his years of study; only in most cases he doesn't know it. There is no one around to tell him—and he keeps working till he spoils it!

If you turn ninety degrees, so that the sun is at your side, the sky won't be as warm. We introduce red, the palette's general modifier, to lower the sky's intensity and value and so end up with an orangey underpainting. If you turn another ninety degrees, so that the sun is in back of you, the sky will be even less warm; in fact, it will have a strong reddish tinge. Remember: the farther you get from the sun, the more the yellow drops out of the sky. The blue in the sky is similarly affected. As you look towards the sun, the sun gives the blue of the sky a greenish cast. Looking away from the sun, the blue is affected by the red and looks purplish.

Not only is there a yellow-orange-red gradation as you move horizontally away from the sun, but there's also a vertical gradation of the sky from the zenith to the horizon. The zenith will usually be an intense blue, with a lot of red in it. As you move towards the horizon, the blue gets less intense and warmer—it changes to a green and then to a purple at the horizon, where the atmosphere is condensed and acts like a cloud. The sky actually goes through the whole spectrum: purple, blue, blue-green, green, yellow-green, orange-green, orange-red, red, red-purple, and blue-purple. So the horizon may sometimes be relatively dark—though, of course, never as dark as the zenith.

If you want to give the viewer a sense of the sky's arch, then accentuate the dark blue of the zenith. A number of years back, I saw a fine book on lighthouses. The artist wanted to emphasize the *height* of his subject. He did this by lowering the horizon and including a lot of the blue of the zenith, right at the top of the picture. You felt as if you were looking straight up at the towers, since only by looking straight up could you have seen that dark color. It was a good trick and made the lighthouses rise high into the sky.

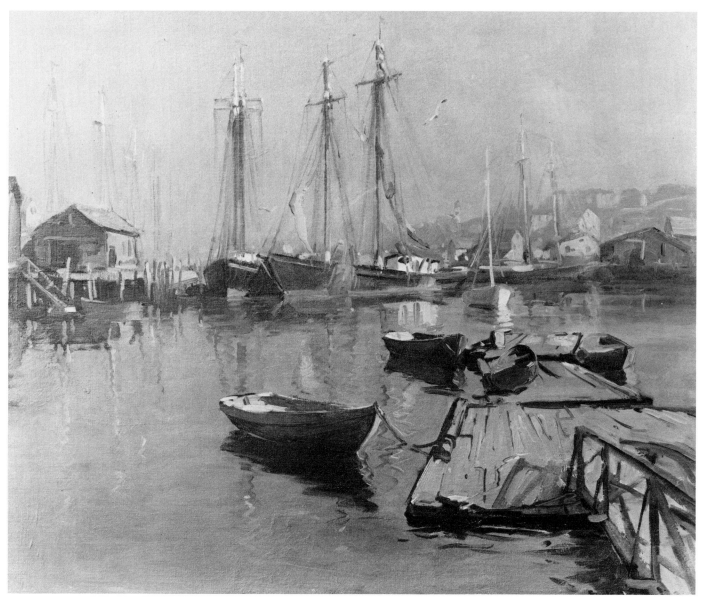

Plate 15. Reflections. Oil on canvas, 25″ x 30″. Even on a gray day, the sky is the lightest large area in the picture. This was a strange day: overcast, but with a strong light source. I was reminded of an eclipse. The strong white spots are very important. They lead your eye from highlight to highlight, and thus through the painting.

Cloudless Skies: Hazy and Dry

I like days that have lots of "atmosphere." Moisture is suspended in the air, diffusing the rays of the sun and throwing a veil over the distance. Plate 16 shows just such a day: the distance blends together and is very light in value. A background like that gives a picture the strong three-dimensional quality that I like. I find that even when painting Vermont, I make use of such hazy distances—even though, to be truthful, the state has very little atmosphere and the distant mountains usually look as hard as nails.

When you look into the sun on a hazy day, the particles of moisture in the air each pick up the sun's light. So the whole sky lights up, and yellow, the sun color, predominates. Again, the trick on such a day is to get that strong warm color down first; then you can run cool color over it.

On a clear, *dry* day, there's still plenty of warmth in the sky, but there also tends to be more cool color. In Plate 17, you can see how the sky has more gradation from top to bottom; the sky in Plate 16 is much flatter. You can also notice how much sharper everything is on a clear day; compare the distance in Plate 17 to that in Plate 16. Remember, when you paint a day like this, to put the cool color in the sky—and

then leave it alone! Don't go over and over it. If you do, the warm underpainting will begin to mix with the cool color—and all you'll have will be a dull gray. In order to work together, the warm and cool tones have to retain some of their identity. That way, the sky has vitality.

Partly Cloudy Days

On cloudy days, you have a great chance to use the cloud-forms to enhance your composition. The clouds quickly come and go, depending on the air temperature and currents. So you should keep your eyes open and get the ones you like down on canvas—note the essentials and develop them later at your leisure.

In Plate 18, I painted a sky-piece. The clouds were what interested me so I devoted most of the canvas to them. You can see how the clouds fall into the picture—I like to angle them, thus avoiding a static, layered sky with row after row of parallel cloud-forms.

Notice particularly how the clouds are formed. Directly overhead, the clouds show mainly their shadowed undersides, and these areas have a semi-circular shape. As you go into the distance, you see more and more of the sides and tops of the clouds, and less of the bases. Since the sunlit sides of the clouds become more visible, the clouds overhead tend to appear darker, while the ones towards the middle-distance are brighter. This not only is a natural fact, but it's also very useful to the painter—we want to keep our brightest clouds fairly low in the sky, near the center of interest. In Plate 18, for example, the clouds get brighter as they near the sail, with the sail itself being the brightest element in the picture. If the large cloud in the upper left-hand corner were as bright as the lower clouds, your eye would jump back and forth between them. It wouldn't know which was supposed to be the more important. As a general rule: try to keep bright clouds away from the frame.

Variety

You should remember that I'm talking about skies in general and that you must go outside and make your own observations. There are no rules for painting. There must be at least a hundred different kinds of blue sky. And no day is like any other. Some days, the sky will be very orange; others, very red. So it's important to keep your eyes open and see what's in front of you. I've seen days when, looking directly into the sun, the horizon turns a vivid lemon yellow. It doesn't always happen. But the important thing is to look, so you'll see it when it does.

Plate 16. The Draggers. Oil on canvas, 25"x 30". On an "atmospheric" day, the moisture in the air blurs the distance. This painting is simply a study of fishing boats. Notice that I've kept the boats relatively small, so that there's lots of air around them. That gives the viewer room to breathe.

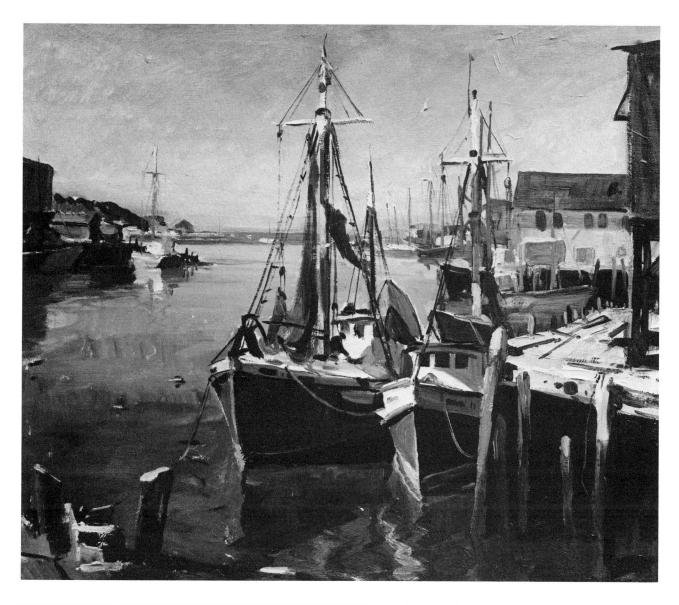

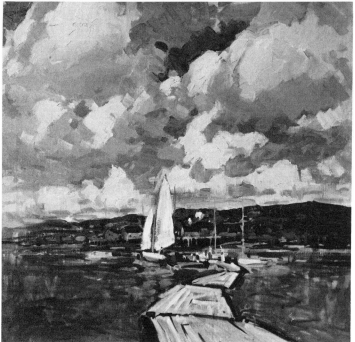

Plate 17. Clear Day. (Above) Oil on canvas, 25"x 30". On a clear day, things seen in the distance are sharp and the sky is clearly graded from the horizon to the zenith. Notice how crisp everything is. I've used the strong lights and darks carefully, placing them side by side so they accent one another.

Plate 18. Cumulus Clouds. (Left) Oil on canvas, 30"x 32". Clouds diminish in size and show less of their undersides as they go away from us. The clouds and wharf are both angled to lead the eye to the strongly lit sail. The sail catches the viewer's attention and holds sky, hills, and ocean together.

Color and Light

Now that we've discussed the sky, we can take a look at how it affects the landscape. You should understand that outdoors the colors of objects are always changing. An object has no one color and there are no formulas for painting it.

Local Color

The *local color* of an object is its color when there's no strong light upon it. On an overcast day, for example, you have no strong light source and no strong shadows. You only have local color to play with (Plate 19).

Many students paint as if every day were a gray day. They paint every tree green, every barn red, and so on, without thinking about the nature of the day itself. So let's see what happens to local color on a clear, sunny day. On such a day, the sky becomes a dual source of light for our landscape: there's the sun giving off warm color, and the blue sky giving off cool color. The local color of objects will be affected by one of these two light sources. Objects that face *towards* the sun will become warmer in tone. Green grass becomes yellow-green; a yellow-green becomes yellow; a red-purple becomes orange. Areas turned *away* from the sun—the shadow side of objects—will pick up the blue of the sky and become very cool. There's no way for warm color to get to them.

This leads us to what is probably the single most important fact to remember when painting outdoors: in order to get a feeling of sunlight in your pictures, you have to paint in terms of warm and cool. You need that contrast. Given the limitations of oil paint, you can only capture this contrast by exaggerating certain aspects of nature. If you want warm color to register, you have to play it against cool color. Now, many painters make their sunlit areas warm, but then they make their shadows warm, too—they paint them brownish. There's no contrast, no interplay of color, and the picture loses vitality. Whenever I see someone painting that way, I assume he's done a lot of indoor work; indoors, the shadows *do* tend to be warm since there's no sky to reflect cool color into them. Of course, people will always like brownish pictures: they're almost monotones and so are very easy to understand. As soon as you begin to use color, however, you make demands on the viewer.

I learned the importance of contrasting warm and cool color after years of experience. But there were two incidents that played a particularly important

part in getting me to open my eyes. I was in my 'teens in Woodstock, doing a big willow tree and a pump. I used mostly browns in those days—earth colors—and thought I was doing a darn good job. The instructor came by, looked at my picture, and put one stroke of blue on the top of my tree. "Sky color," he said, and walked away. Well, I was furious. That was the only blue spot in the whole picture. "Some lesson," I thought! But as I calmed down, I saw that it *was* a good lesson. It showed me that I wasn't really painting the color of nature—I wasn't looking. The blue sky did affect the color of my tree, but with all the browns I had on my palette, I didn't see it.

The second incident occurred a few years later when *I* was doing the teaching. I still had a fairly subdued palette and was taking out a woman student who couldn't draw at all. I could see that at a glance. But, as she worked, I was amazed at her color. She threw deep blues into her shadows, and used orange with blue running through it for the sky. The drawing was completely off, but with all that color, you didn't notice the drawing. I was so excited by what she was doing that the next day I went out and painted five pictures using her method: less drawing and more color. Of course, I didn't charge her for her lesson. In fact, I tried to trade pictures with her, but couldn't talk her into it.

So remember that everyone can see the contrast of light and dark, but you have to learn to *feel* warm and cool. That's why it took painters so long to discover the fact. It went largely unnoticed until the Impressionists came along. For a while, try painting highlights warm and shadows cool, even if you don't see them that way. Eventually you will. And, as a help to strong contrast, keep the areas separated. Don't, for example, introduce a warm yellow into a shadow.

Atmospheric Perspective

The color of an object is also affected by its closeness to us. The farther away it is, the more the moisture of the atmosphere interferes with the color waves that come to the eye. We noted earlier that the veils of air tend to make things lighter in value. But far objects will also tend to get an increasingly blue tone.

Yellow is the first color to fade as objects move into the distance. A rock that appears orange in the foreground will look red in the middle-distance and purple in the background. Remember: yellow is bread and butter color—it's right at the end of your nose. Anything yellow will come forward and attract the viewer's attention. You could really say that *all the power in a painting comes from how you handle*

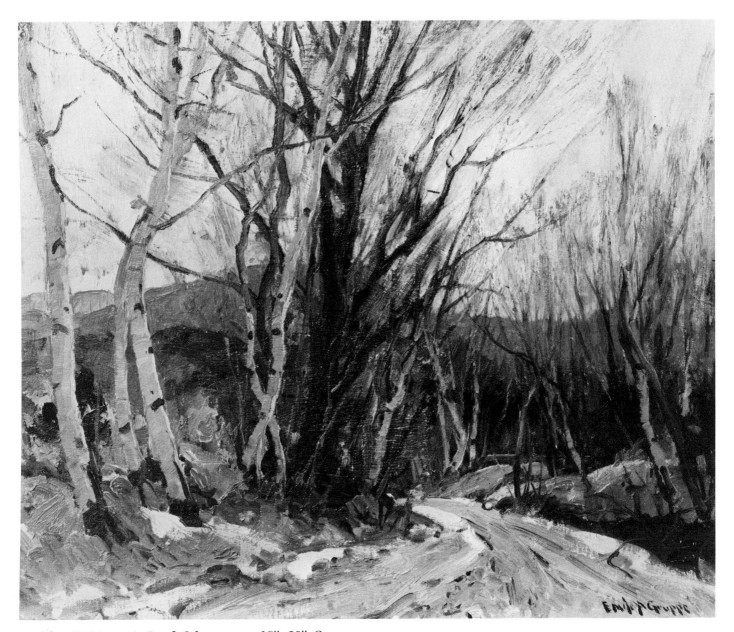

Plate 19. Mountain Road. Oil on canvas, 25"x 30". On a
gray day, there are no sharp lights and darks to work with.
Instead, I make my picture out of the interesting pattern of
branches against the light sky. Sometimes, you can arbi-
trarily introduce a few highlights into a picture like this—
just to suggest where a shaft of light may have broken
through a cloud. A few such touches will give the design
real snap.

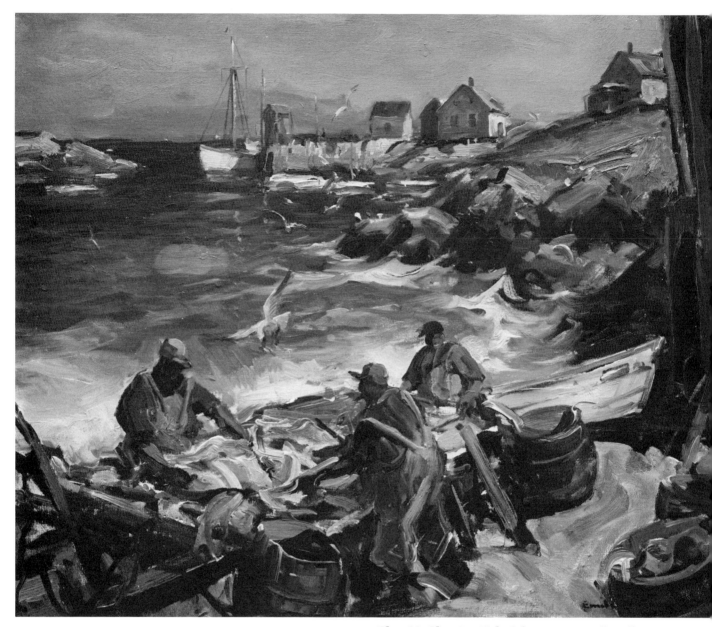

Plate 20. Cleaning Fish. Oil on canvas, 30" x 36". Most pictures need a strong foreground, middle-distance, and distance. In this picture, the darks are kept in the foreground, with the busy workmen. None of the shadows in the distance are as dark as the shadows in the foreground. Notice how the seagulls, the breaking waves, and the whirling brushstrokes all add to the activity of the scene.

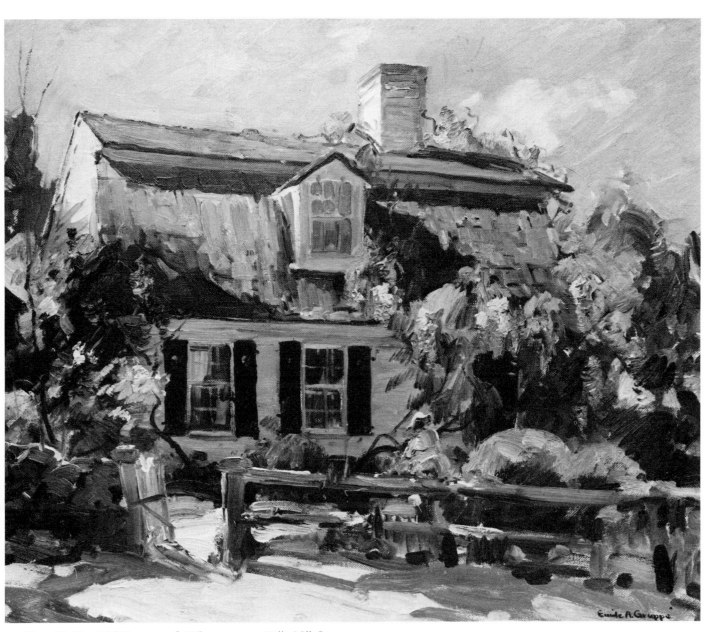

Plate 21. The Old Homestead. *Oil on canvas, 25"x 30". I painted this picture using only a small area of light on the side of the house. Many people would have waited and painted it when the front was in full sunlight. That's the postcard view of the subject. But this particular light attracted me because all the colors of the surrounding trees and flowers bounced back into the shadow side of the building. That was my subject: the interplay of the different colors.*

your yellow. If you misplace it, you can destroy a picture's three-dimensional quality.

An instructor of mine once said that you're painting when you show each foot of recession back into the canvas. That's an ideal attitude. But if you understand the nature of atmospheric perspective, you can use color and value to establish your foreground, middleground, and distance (Plate 20). It stands to reason that the colors in the foreground will be the least affected by the veils of atmosphere and will therefore also be the strongest in tone. Paint your foreground strong in value and rich and warm in color and you'll give the viewer a clear idea where he stands. On a bright day, begin by using as little blue as possible in your foreground. You can always adjust it. As we noted when painting skies, it's easier to cool a warm color than it is to warm a cool one.

Reflected Light

The color of an object is also affected by the colors near it (Plate 21). Light will bounce off an orange surface, for example, and throw warm color into all the nearby objects. There's a lot of reflected light outdoors and you should try to see it—but don't overdo it! Don't put down every color shift that you see. If you do, you'll break your objects into too many areas of color. The picture would be too busy and you would confuse the viewer. Reserve is an important element of all good art.

Complements

There's also another way that the color of one object affects that of another. A color will frequently generate its own complement. If you look directly into a sunset, for example, the objects in front of you will be silhouetted against the sky. These dark objects will often take on a color that's complementary to the sky. Against a predominantly orange sky, a white house will appear purple in shadow. The same house, against a red sunset, will turn almost emerald green.

Another example of this phenomenon is the relationship between snow and the skies of winter. If you have a reddish sky, the snow will have a green tinge. If you have a greenish sky, the snow will look pink—and its *shadows* will appear blue-green! And the other seasons show similar effects. In the summer, for example, all the green in the trees makes the sky look red by contrast; in the autumn, all the red, orange, and yellow in the foliage makes the sky look green!

It also happens that a painting, dominated by one color, will cry out for the complement. Someone once asked me for a critique. He was an artist who painted all his pictures very green. Well, I simply took his picture and glazed the entire canvas with red. The painting suddenly came into balance and the eye was satisfied. With only green to look at, it was uncomfortable. The average viewer couldn't tell you *why* he was bothered—but he'd know that something was wrong.

The Old Buttonwood Tree. (Right) Oil on canvas, 30"x 36". This is a "study." I drew the tree exactly as it was—first walking around it, of course, to find its best side. Because of all the warm, reddish orange foliage, the sky tends to be a complementary greenish blue.

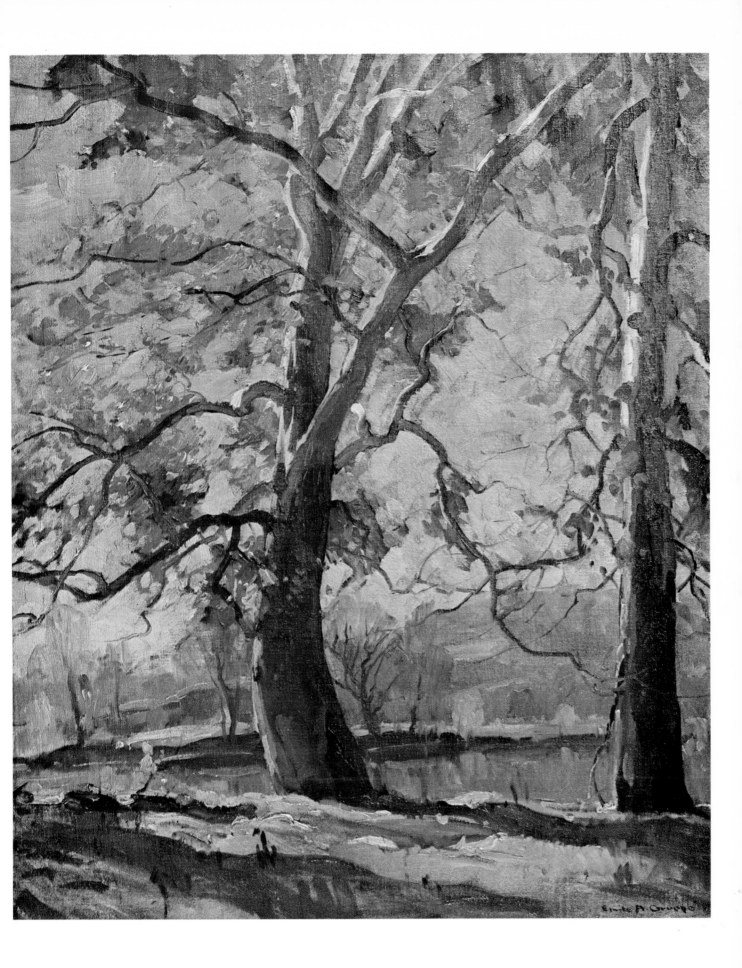

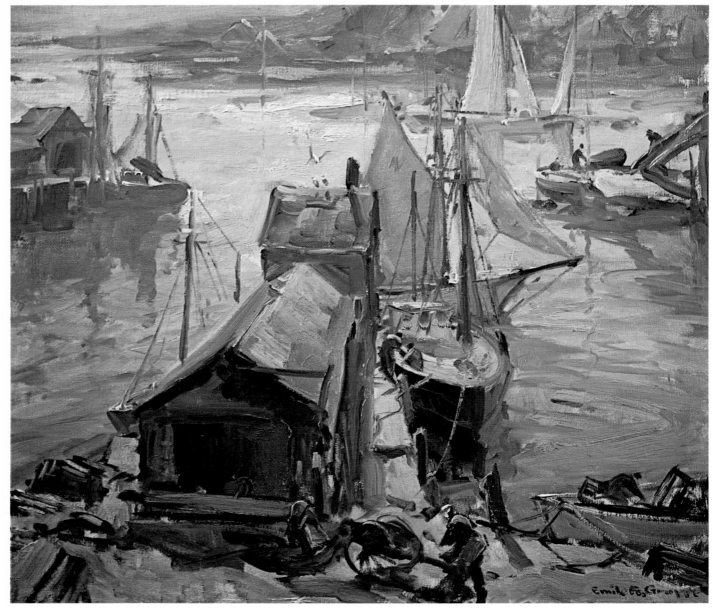

Motif No. 1. *Oil on canvas, 30" x 36". If you contrast this picture to the two preceding ones, you'll see that although a lot of sky is good in a picture, it isn't absolutely necessary. Instead of silhouetting them against the sky, I place my objects here against the light mass of water. In this case, I concentrate on the interesting patterns made by the sails and the various buildings. Notice that I've suggested the light source—directly in front of us—by the strong glare on the water.*

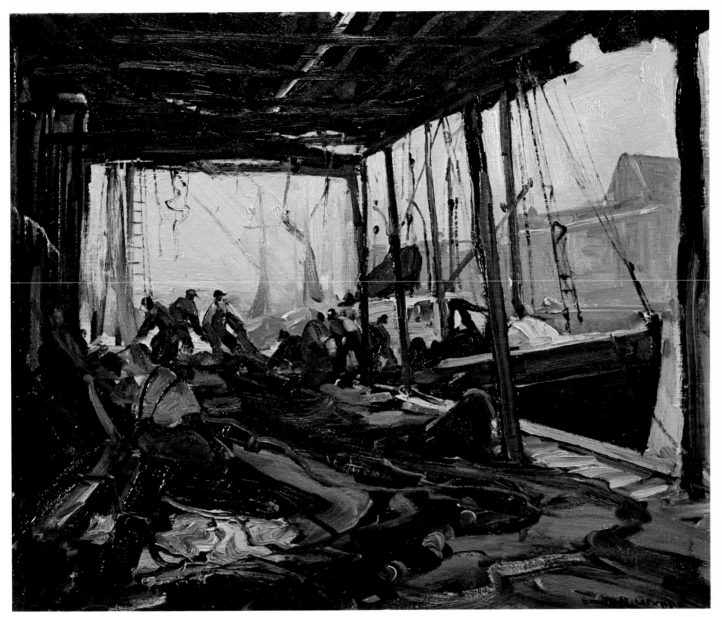

Mending Nets. *Oil on canvas, 25″x 30″. In this painting,
I've tried to make objects in shadow stay in shadow: that is,
I've kept all their values close together. Squint at the page
and you'll see how the shapes begin to merge. I've excluded
all strong warm colors. There are reddish oranges, to be
sure, but they're all tempered with the complementary
green. The only fairly warm places are under the eaves to
the far right; the sunlit wharf below throws warm color up-
ward. By keeping these shadow areas simple and cool, the
distant sunlit sky is enhanced.*

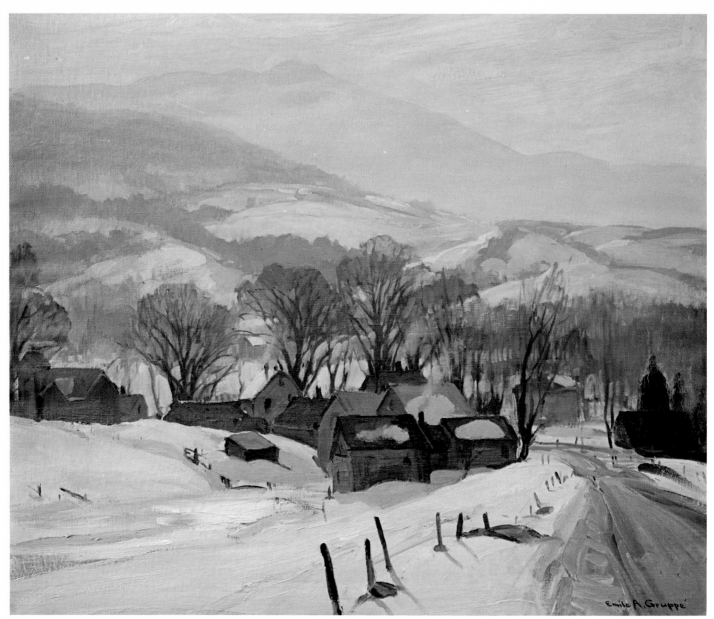

Mount Mansfield. *Oil on canvas, 30″x 36″. The buildings and trees in the middle distance form one big silhouette, broken here and there by a snow patch. These darks give you a standard so you can better judge the shift of values as you move into the distance. Notice that the glare on the river is actually brighter than the sunlit snow.*

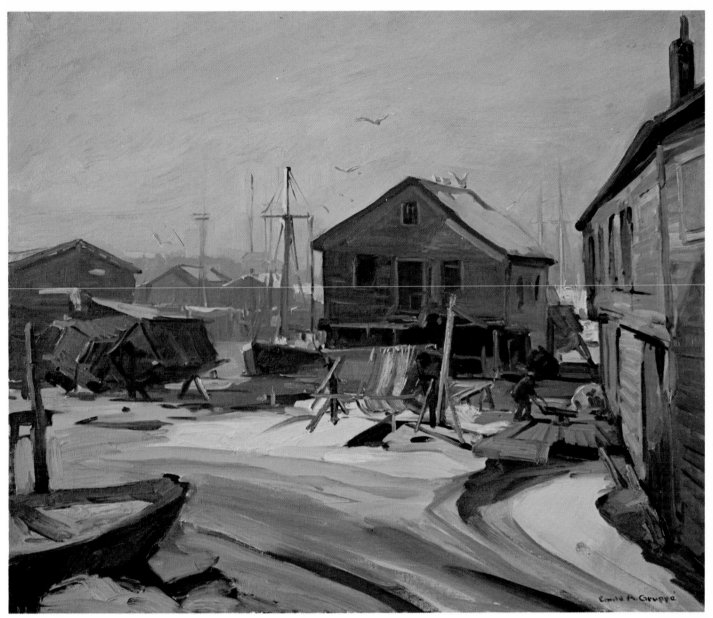

Gill-Netters. *Oil on canvas, 30″ x 36″. Here's a good example of the kind of effect that lasts for only a short time: the late evening light casts long shadows over the snow and buildings. I had about a half-hour to paint—and worked fast!*

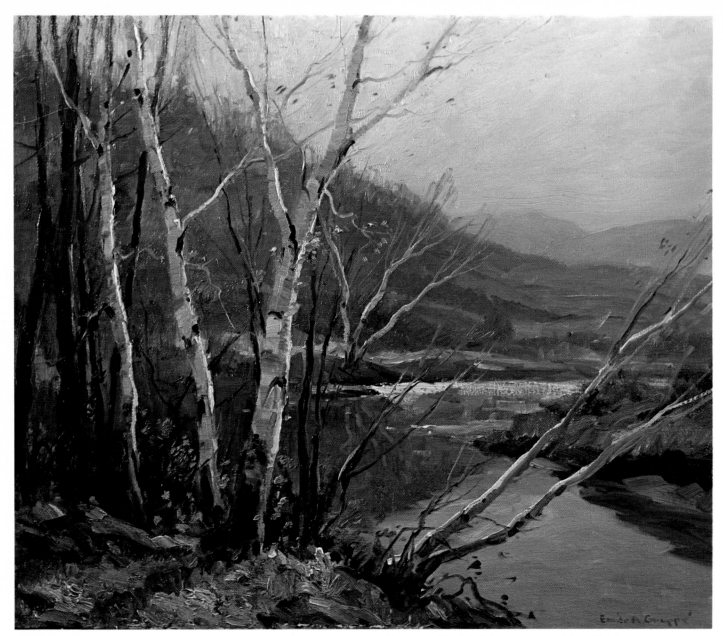

Birches. (Above) Oil on canvas, 30″x 36″. This is a misty day where the atmospheric perspective is especially obvious. Notice how much lighter and bluer the distant mountain is compared to Birches in the Fall. The bright red foliage in the foreground becomes a reddish purple in the distance. Similarly, the yellow-green grass on the right-hand bank becomes less and less yellow as you look off into the distant fields; in fact, it finally merges into the blue of the distant mountains.

Vermont. (Right) Oil on canvas, 30″x 36″. This is a picture of a very clear day; notice how sharp the distant mountains are. But atmospheric perspective still plays a part. The picture's most brilliant warm color, for example, is in the group of yellow leaves on the foreground birch. Of course, there are leaves just as brilliant on the opposite hillside. But the distance takes the yellow out of them and you see only oranges and reds.

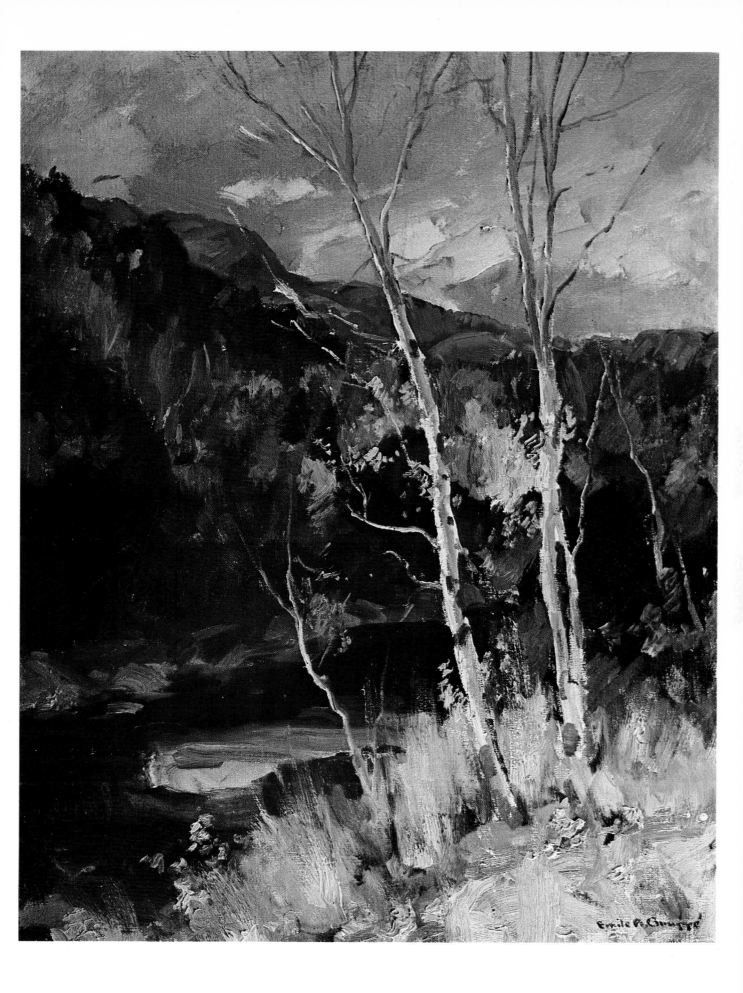

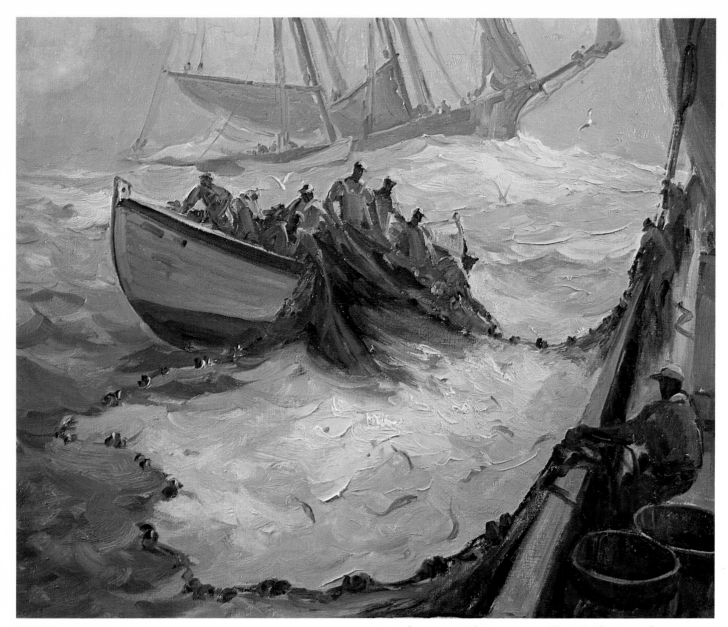

Hauling Nets. *Oil on canvas, 30" x 36". The same theory is at work in this picture. The schooner on the horizon is very cool—there's just a hint of warmth in it to suggest the sails. But look at all the warm color in the men on the boat; that makes them come forward and attracts the eye of the viewer. Fortunately for me, fishermen wear yellow oilcloth outfits when they work. I just took advantage of a sailing tradition.*

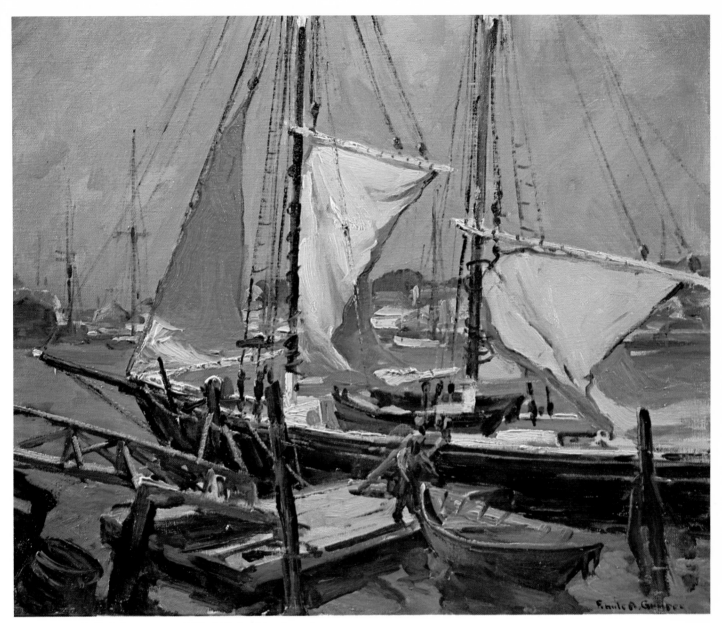

Drying Sail. *Oil on canvas, 25″ x 30″. In this plate, the same principle is at work as in the preceding picture. The sails, a warm color, are made to jump forward by being placed against a cool sky. I've suggested the glare on the sails by taking advantage of the fact that white objects reflect all the primary colors. To get a prismatic, glaring light, I underpainted with white and orange—that gives me the red and yellow primaries. Then I run a white with lemon yellow over it—the lemon yellow, being on the bluish side, completes the color range.*

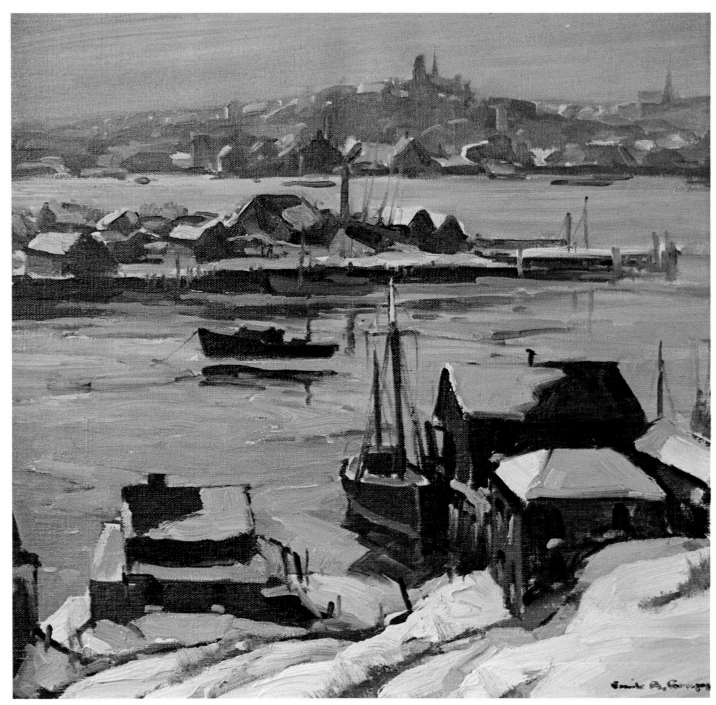

Looking over Gloucester. *Oil on canvas, 18″ x 20″. In rare cases, the harbor can be lighter than the sky. Here, there's an ice-skim on the water, which gives it a bright glare. The dark lobster boat serves as a transition: your eye moves from the foreground, to it, and then to the distance. And it breaks up what would otherwise be a large and uninteresting area of water.*

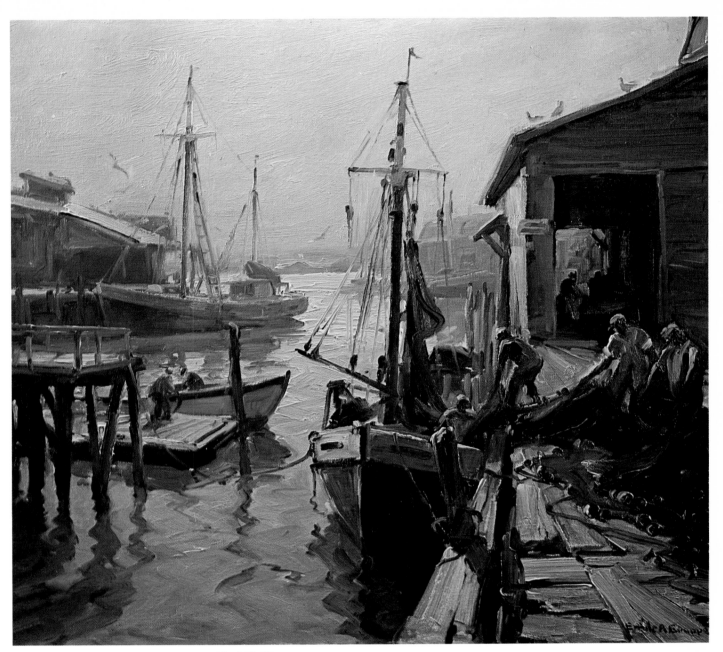

Morning Chores. Oil on canvas, 30"x 36". Here you can see reflected light at work; the warm color of the wharf reflects up onto the curving net and bounces back onto the shadow side of the building on the right, giving it a slightly warm glow. All that reflected light also keeps the building from becoming too dark. The darkest part is inside, where the light can't reach. The reflected light is especially evident directly under the eaves, where a strong orange color is reflected up off the walkway below.

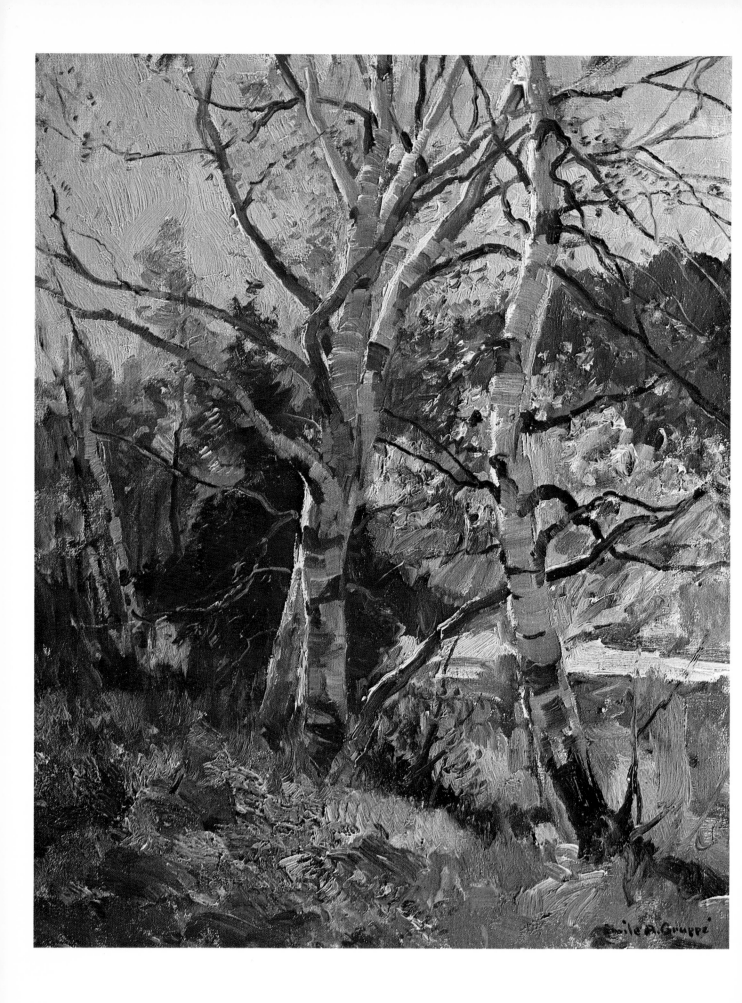

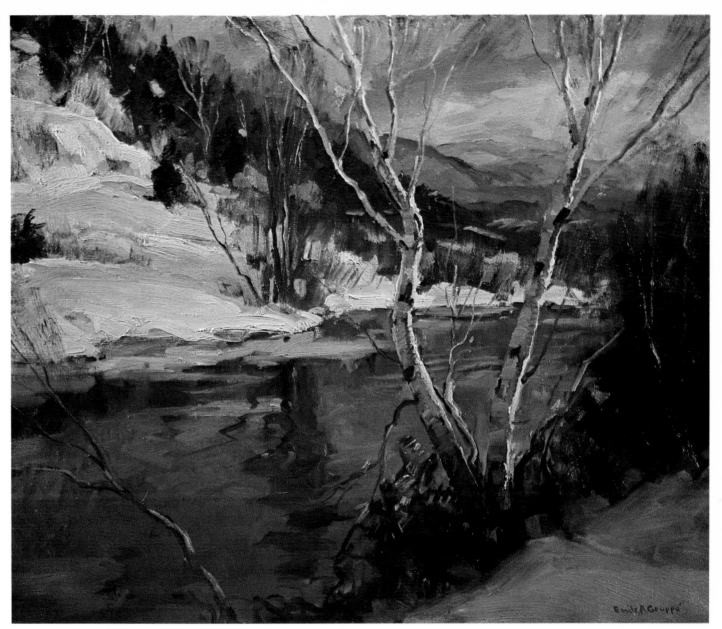

Birches in the Fall. (Left) Oil on canvas, 25″x 30″. Here the warm/cool contrast is especially important, for I want to get a strong feeling of sunlight on the distant trees. Notice the cold, bluish evergreens in the far distance. The trees in front of them are yellow and warm—and it's this contrast that makes the sunlit trees jump out at you. I've kept a lot of cool color in the foreground, too. Again, the contrast makes the sunlit trees really sing.

Birches along the River. (Above) Oil on canvas, 30″x 36″. I've used a lot of warm yellow and orange in the highlights on the snow. But in order to give the viewer a strong feeling of sunlight, it's necessary to contrast the warm with a lot of cool color. Notice that I've kept the shadows on the hill, the foreground bank, the water, and the far distance all very cold. So when I put down a warm spot, you know it's warm.

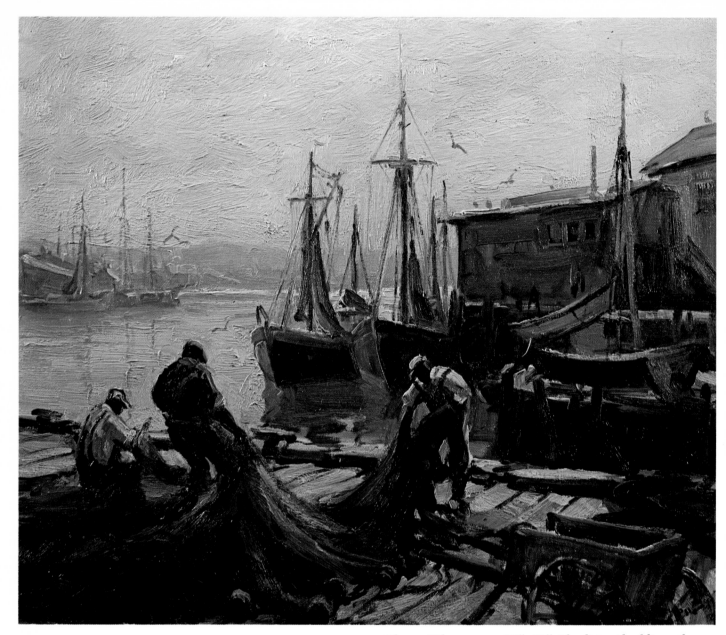

Chores. *Oil on canvas, 25″ x 30″. The distant building, silhouetted against an orange sky, takes on the complementary purple in the shadow. This purple spot accents the orange, making the sky seem much warmer and full of light. On the dock, you can see the opposite principle at work: to get a warm gray look, I paint the orange first (sun color) and then run blue over it. That gives me a nice gray effect without my having to mix what would probably be a rather dull gray color. The complements neutralize one another.*

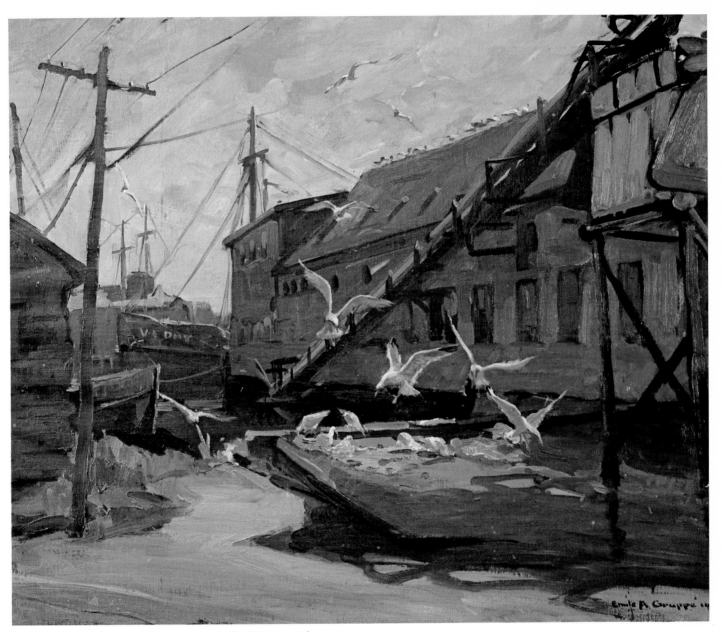

Coming for Scraps. *Oil on canvas, 30″ x 36″. Since the theme of this picture is seagulls, everything is designed to accent them. Notice that against the large dark building the gulls are light and against the light sky they are dark.*

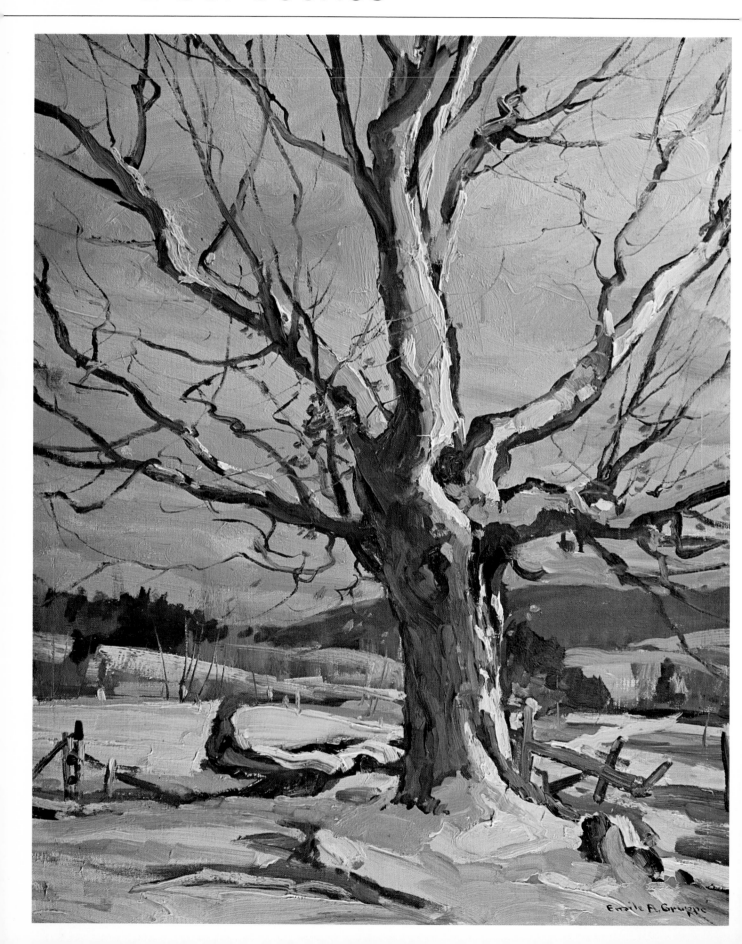

A picture first attracted me to the Gloucester wharves. I saw one of Frederick Mulhaupt's scenes in a New York gallery and decided I had to visit the town. It was a brilliant picture: a harbor in winter with broken pieces of ice in the foreground and pilings covered with snow. And it got me going because I was *interested* in water, boats, and the life of the fishermen. I'd fished in Holland as a kid and had pulled bait out of the stinking piles of clamshells that the local people used to make lime. I'd joined the U.S. Navy in World War I. The subject had a personal meaning to me, and that's one of the keys to painting any subject well. You have to *feel* it—and then use your knowledge of painting to put that feeling on canvas.

The Elements of the Harbor Scene

For the sake of convenience, I'm going to break the harbor scene down into its separate elements. It's a complicated subject, but don't let the parts confuse you. Later in the chapter, I'll try to show you ways to pull the elements together into a *unified* design. Remember, it's the overall impact of a picture that counts—not how many details you put in. I'd rather see one big effect in a painting, even if the draftsmanship is faulty, than a lot of carefully drawn flyspecks.

Simplicity

As an example of what I'm talking about, look at Plate 22. It has hardly any detail. Yet an old instructor of mine thought it was one of the best things I'd ever done. When I showed it to him, he said, "You might just become a painter some day." He felt the picture conveyed a mood. It made a *little*—some rope, a pulley, and a broken-down pier—say a *lot*.

If you knew what to put in and what to leave out, you could make a picture of a pulley alone—or of a piling. All the old pilings in a harbor tell a story. One

Windblown Snow. (Left) Oil on canvas, 30″ x 36″. This tree was painted shortly after a snowstorm. You can see the interesting pattern the snow makes as it clings to all the upright surfaces. The tree is a reddish color in the sunlight. And I've carried this red into the shadow side but have neutralized it by combining it with a lot of the complementary green. Then I've made this green effective by running the dark branches into a sky that has a lot of the complementary red in it. If the sky, too, had been green I'd have lost my effect.

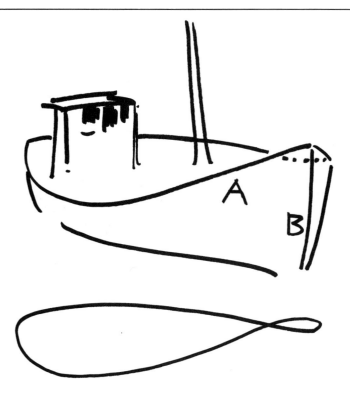

Figure 28. The figure-eight can help you draw draggers. Keep the gunwale (A) and bow (B) fairly straight, otherwise, your boat will look like a gondola.

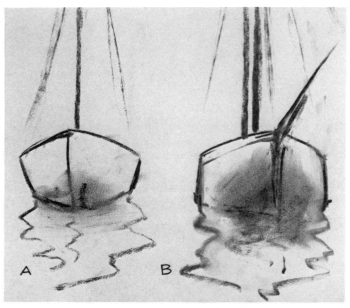

Figure 29. The boat in A cuts under too sharply. In B, you feel that the boat cuts under far beneath the water: it looks heavy and seaworthy.

Plate 22. Low Tide, Gloucester Harbor. *Oil on canvas,
25"x 30". A quiet moment in the harbor. Notice the almost
motionless reflections. I was especially interested in cap-
turing the look of the wet mud near the water. You can see
that the background buildings are suggested, rather than
painted in detail.*

has a lot of tangled ropes caught on it—and gouges where boats bump into it. There are rusty spots from mooring chains. An old spike sticks out of one side, with maybe a piece of dangling wood. You have to feel the significance of things like that. They give *character* to a subject.

Fishing Boats

Today, you don't find many sailing vessels in a busy port; the trade has been mechanized. People still like square-riggers—but stuff like that has whiskers on it. There's no one alive who can do it authentically; you end up copying old photographs. So the best thing to do is stick with what's around you *today*; paint what you see and know.

Drawing

One reason students have a hard time drawing boats is that they're distracted by all the rigging, running lights, hanging nets, and other details that obscure the hull. Try to strip all that away in your mind's eye—then you can see the hull as it is. Of course, that isn't the only problem. A worse one is that students have *preconceptions* about what a boat should look like. They think of the boats they drew as children, boats that were shaped like wooden shoes or bananas, curling up at the bow and stern. And that's how they draw them. But probably no shape could be less like that of a real ocean-going dragger; all those concave lines suggest weakness while the character of the dragger is strong and tough.

You might find a figure-eight useful in getting the general shape of the fishing boat's hull (Figure 28). Remember that the gunwhale of the boat (A) is straight as it nears the bow—it doesn't sweep up like a gondola! And the bow (B) goes into the water in a fairly straight line—it doesn't cut under sharply. Use strong lines to suggest a strong subject.

One of the hardest things to get in a boat is the feeling of its weight in the water. I want you to compare sketches A and B in Figure 29. Do you see how much heavier and more solid boat B appears? Yet most students paint boats like A—they make the sides cut under too sharply. By having them bulge *out*, you increase the boat's bulk and dignity. The viewer feels that it's *in* the water, with most of its hull below the surface. It looks sea-worthy and not like a peanut shell that could be blown away by the first gust of wind.

Cast Shadows

Where the boat snuggles against the pilings, the wharf usually casts a shadow on it. In Plate 23, you can see such shadows at work. The dock throws a

Plate 23. Evening Light. Oil on canvas, 30″ x 36″. The late afternoon light gives the scene a crisp, sharp look. Notice that the dock on the right gives you an easy path into the picture. The shadows are all kept dark and very simple.

Figure 30. Under strong sunlight, a boat will cast a shadow on the water.

Figure 31. The halftone around the mast keeps it from looking pasted onto the sky.

shadow on the light boat; and it, in turn, throws one on the dark boat next to it. I don't mention this because I'm interested in shadows as such; these shadows follow the shape of the hull and thus can be very useful in describing the *form* of the subject.

If the light is especially strong, you can look to see if the boats cast a shadow on the water. This sometimes happens on very bright days. The cast shadow will actually be *darker* than the shadow side of the boat above it; little light can get to it. It catches a lot of the blue sky, however, and is very cool. There's a cast shadow in Figure 30—but notice that it serves a purpose. It helps pull the sketch together by linking the foreground dory to the large dragger.

Masts

When we were kids, we all drew boats with the mast right in the middle—and most students still do. On a dragger, however, the mast is located about one-third of the way back from the bow—not smack against the wheelhouse. And the rigging pulls at it, giving it a slight bend. Don't draw it with a ruler.

How tall you make your masts depends on the *feeling* you want to give the viewer—not on how tall those masts are in real life. If you want a foreground boat to look close to you, make its mast tall, the viewer senses that he has to look up at it. In addition, by exaggerating the mast you give the ship a greater dignity. When I painted the famous schooner *Yankee* (Plate 24), I pulled the mast right out of the frame—and kept it thin and graceful. Take your thumb and cover the top of the mast; see how stubby the boat would look it I had kept the mast in. You'd feel as if I'd barely been able to squeeze the boat onto the canvas—and that would give you a cramped feeling. A fellow artist once criticized the way I exaggerated my masts. I'd drawn a boat way across the harbor—and its mast reached far into the sky. But when I asked him if the exaggeration was *effective*, he had to admit it was. And that's what counts—not the care you take in copying what's in front of you.

One technical trick might interest you: when you paint the mast, hold the brush between your thumb and forefinger. Place the brush on the canvas; start at the top of the mast, let it drop straight down. That way, the line won't wobble as it does when you hold the brush with the *entire hand. You don't tense up as much.*

Rigging

I'm no expert on rigging. I know the general lines, the lines you need on every boat. A captain once refused to buy a picture of mine till I'd put in the bobstay—that's the rope that runs from the mast to the

bow and keeps the mast from falling backwards. Lines like that can be seen when you're down on the wharf. And they're all that count. The rest is mongrel rigging, different with every ship. Put in the lines that help your design. Nobody will be any the wiser. I used to spend a lot of time painting an old derelict in the harbor—and it didn't have any rigging at all. Just an old frayed rope hanging from the mast. No one ever missed the pulleys and lines.

And remember: you don't have to put everything in. A few blobs for pulleys, a couple of rungs on the rope ladders—that's all the eye can see at one time. I knew a painter who had rigging everywhere; you could trace each piece of rope down to where it hooked onto the boat. But you get tired looking at pictures like that. They tell you more than you need— or want—to know!

Refraction

When you paint a mast, remember that all the rigging around it cuts down on the amount of background light that can come through to your eye. As a result, you get a halftone around the masts—*refraction* blurs the edges. Without that halftone (Figure 31), the mast looks as if it's pasted onto the sky. It's a good idea to block the mast in first and then paint the sky over it, smudging the area. (You can see how I do this in the demonstration at the end of the book.)

Smaller Craft: Dories and Seine Boats

Dories and seine boats are a study in themselves. They're not easy to draw and I had a hard time getting the hang of them. In fact, I knew a postman—a fellow who *built* dories—and I'd have him come in to tell me when I was on target. Of course, he couldn't tell me exactly what was wrong. "If I could do that," he said, "I'd be painting them myself." But he could tell me when I needed to give the subject more study.

In Figure 32, I've tried to show how the figure-eight you used to draw the dragger can also help you draw smaller boats. The dory will look different, depending on whether it's close to you, in the middle-distance, or in the background (Figure 33). Notice that the dory, when seen from above, looks almost oval. This odd shape lets the fisherman bring the gunwale down to the waterline without capsizing the boat. Then he can *slide* the catch into his dory!

Drawing these boats is one thing; using them in a composition, another. In Figure 34, for example, the most important element in the picture is the small foreground dory—it points you into the picture. It's like a finger saying, "Look, here's the subject!" In Plate 25, the smaller work boats *are* my subject. I'm trying to tell a story—so I have seine boats in the fore-

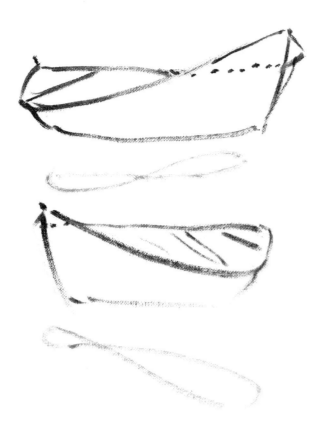

Figure 32. The figure-eight can also help you draw dories and seine boats.

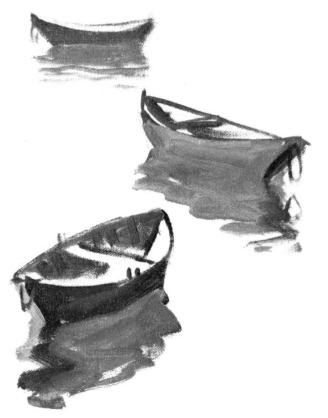

Figure 33. A dory looks different as it gets farther away from you.

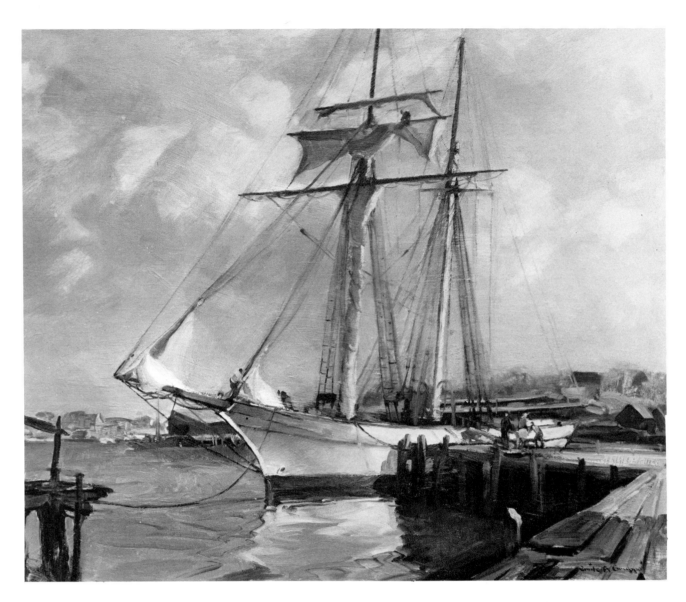

Plate 24. The Yankee. (Above) Oil on canvas, 25″ x 30″. This is a portrait of a famous boat. I've kept the sky fairly low in key so that the sunlit parts of the boat will tell. The hull of the boat is light on the side, dark where it cuts under, and then light again on the bow.

Plate 25. Seine Boats. (Right) Oil on canvas, 25″ x 30″. In contrast to the first two pictures in this chapter, a close-up study of the harbor can also make an interesting design. Notice that the nets, the men, and the ropes are all used to connect the foreground boats and keep them a single unit in the composition.

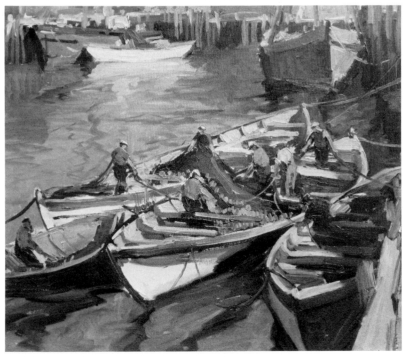

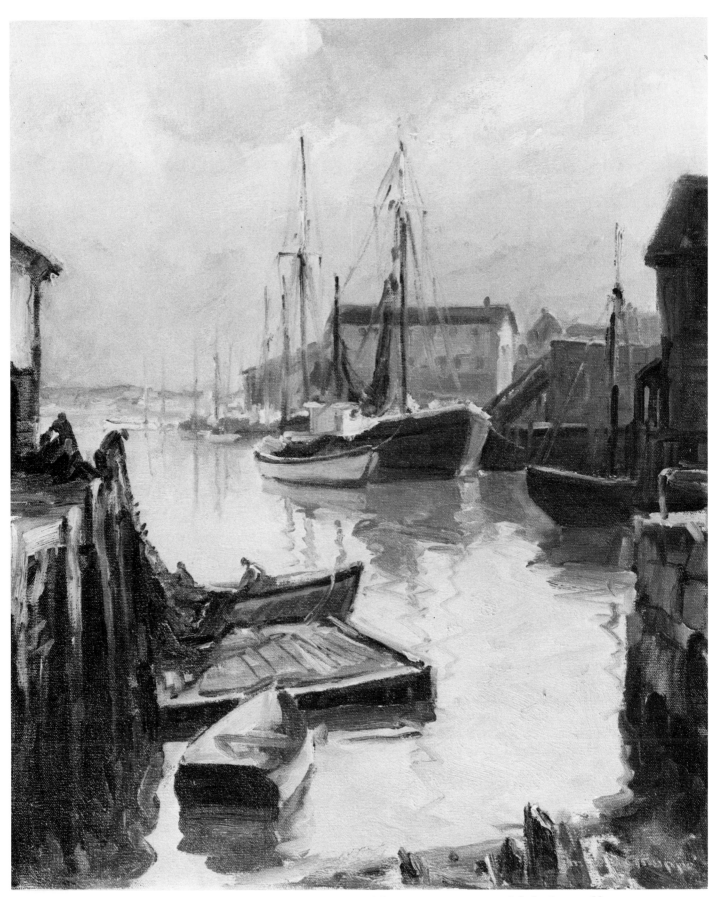

Figure 34. *The most important element in this picture is the small dory: it points you toward the background boats.*

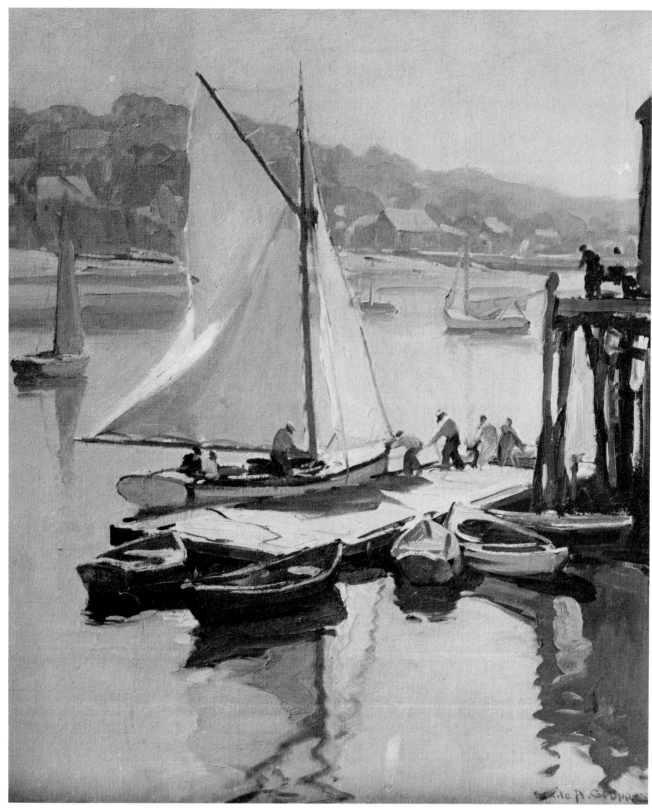

Plate 26. Sailing Party. Oil on canvas, 25″ x 30″. The eye moves up the foreground reflection, across the float, and out toward the right. The building next to the frame then pulls it back into the composition. A small boat blocks the eye from wandering into the area to the left of the sunlit sail. I've kept all my other highlights low in value so the strong light on the sail will have a chance to register.

ground, where you can see them in profile. The viewer sees how they look from a variety of angles and so gets a better understanding of their character.

Docks

The wharves of an old fishing port are usually rough and worn. This makes them interesting—and treacherous. I remember one of my students falling right through the rotten boards. She hung there by her elbows, yelling at me to catch her hat as it rolled toward the edge of the pier! So when you paint a wharf, try to get a sense of its history. Don't pretty it up—paint its rough edges, the broken boards and piles of equipment that show men have worked there.

Five Wharves

In the following five plates, you'll see how I've made use of the material on the Gloucester docks. In Plate 26, for example, I've kept the wharf to the right-hand side of the picture, but I used the long and graceful lines of the pilings to complement the elegant lines of the sailboat. The very low tide—always a good time to paint—lets you look down onto the dories, sailboats, and floats. Their shapes are more interesting than at high tide, when you can only see them in profile.

In Plate 27, I've tried for just the opposite effect; there's nothing graceful about these pilings. They're old and weatherbeaten. But they form a fine dark mass, against which I silhouette my white boat. Notice how the pilings disappear as they go down into shadow; you want to keep your shadow area simple, with little emphasis on the pilings within it. Sometimes you can see the distant ocean through the pilings. But don't break the area up too much: you'll confuse the viewer. In Plate 27, the background water appears in only a few places, and these are all towards the end of the dock. Refraction affects these small areas, so that they're not as bright as the open water.

In Plate 28, I've suggested the material of the dock in a very sketchy way. You know there's equipment there. But you don't know just what it is—and don't really care. What interests you is the white boat and the hoist directly over it. If I'd carefully drawn all the stuff on the dock, you'd spend all your time looking at it—and that's just what I don't want!

Although you can barely notice it, the top of the wharf is slightly convex in shape—this gives it an added strength. The docks are ramshackle; but you don't want to give the impression that they'll fall down at any minute. Weak, concave lines would do just that.

I've drawn a lot of pilings in Plate 28, but they have variety. Whatever you do, don't make them look like a picket fence. Have some pilings stand alone, some in groups of two or three. Vary the space between the different groups. Lash some together. Keep the pilings thin and never straight—and don't forget about perspective. Notice the difference in size between the pilings in the right foreground, those in the left foreground, and those just behind the white boat. They get smaller as they go away from us.

Plate 29 shows the harbor in winter. This time, I use the strong inward slant of the dock on the left to pull the viewer into the picture. Since it's kept in shadow, the dock remains a subsidiary part of the design—and the eye moves to the sunlit boats and wharf to the right. The nice darks and big shapes on the left-hand dock give the viewer a strong sense of foreground—he knows where he stands. Then I *contrast* these shapes to the simpler, smaller, and brighter forms in the distance.

Having looked up, down, and across at wharves, in Plate 30 we're right on one. I've kept the composition simple—that's one reason I've always liked this picture. The net is the subject; the way it curves and moves across the wharf. Remember, you may be down near the harbor, but you don't *have* to paint boats!

Mud

One advantage to painting at low tide is that you can make use of the foreground mud. In Figure 35, for example, the mud blocks the lower left-hand corner and keeps the viewer's eye in the picture. The pilings sticking up on the right serve a similar purpose. The dark pilings, the spots of junk, and the broken lobster pot slats all give the picture a strong foreground. And that, in turn, throws the boats back into the middle-distance. The contrast enhances the picture's three-dimensional quality.

Buildings

Every building has a story to tell: the sag in the roof, the broken sashes, some displaced bricks or clapboards—interest and appeal are a result of the character picked up over the years. Feel that part of a building and don't just draw architecture.

There's no particular merit in drawing wharf buildings just as they appear. All through this chapter, I've tried to suggest that you have to pick and choose; you have to throw out what you don't want and emphasize what you like. In Plate 31, for example, the small building on the left is turned so that you see most of one side—and only a small part of the other. By featuring one side, I've made the building

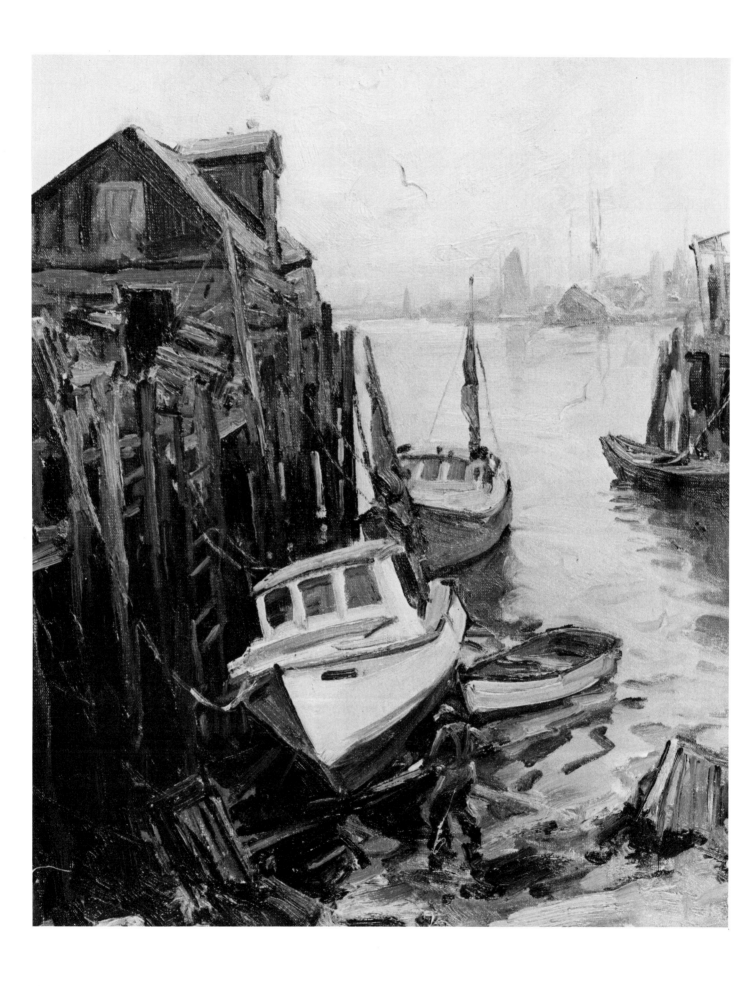

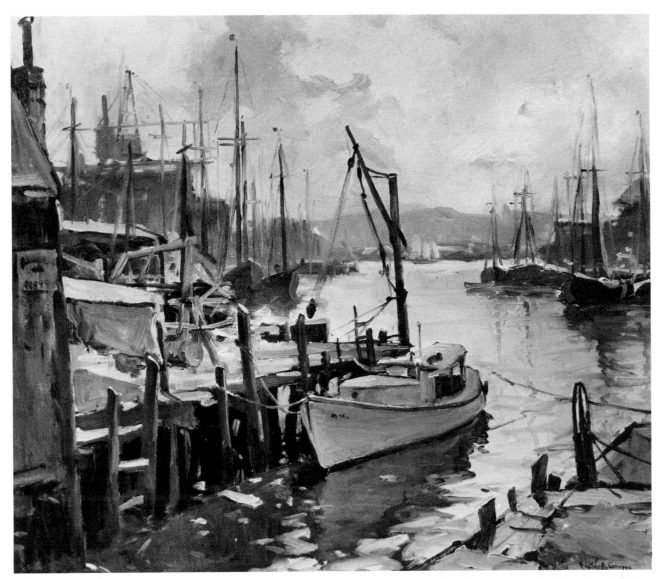

*Plate 27. **The White Boat.*** *(Left) Oil on canvas, 20"x 16".*
This is a quick sketch—the roughness of the paint matches
the roughness of the subject: an old dock and the messy
foreground mud. The clean white boat further accentuates
the surrounding junk. Notice that I've varied my spaces by
keeping one boat to the right of center and the other boat
slightly to the left of center.

*Plate 28. **Crowded Harbor, Morning Light.*** *(Above) Oil on*
canvas, 30"x 36". Again, I've gotten a strong atmospheric
effect by keeping the foreground dark and hazing out the
distance. All the distant masts suggest a busy port, but I
haven't bothered to draw each and every boat!

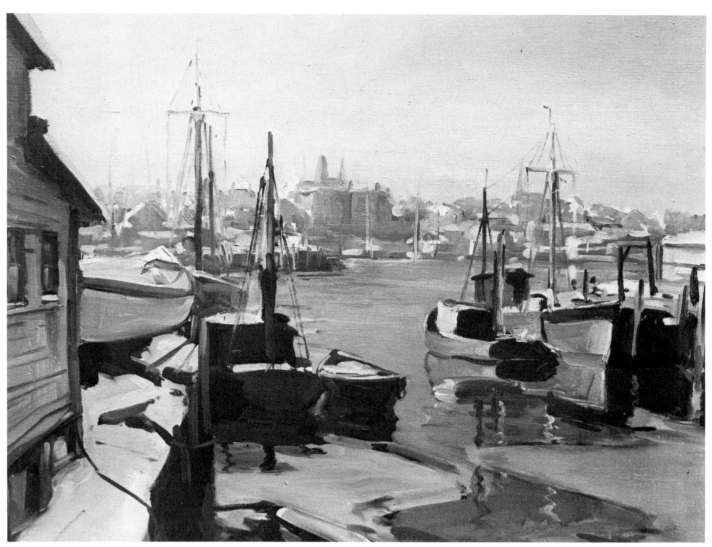

Plate 29. March Thaw. (Above) Oil on canvas, 25"x 30". By keeping the large area on the left in shadow, I emphasize the light on the right-hand boats and in the far distance. The ice in the foreground breaks up the water and makes a pattern that snakes the eye into the picture. I've tried to capture the stillness of a March evening. There aren't even seagulls or men in the picture. Everything is quiet.

Plate 30. Nets. (Right) Oil on canvas, 20"x 16". This painting was done very quickly. I was interested in the overall pattern made by the net and the figures—and didn't spend time putting in a lot of detail. The farther you stand from a picture of this sort, the more finished it looks.

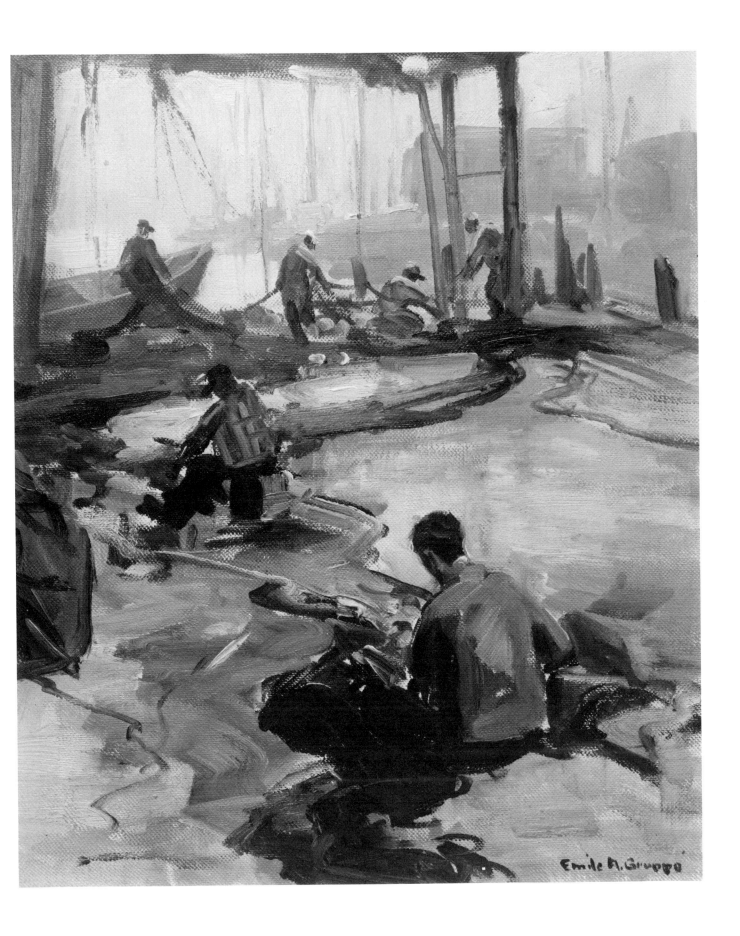

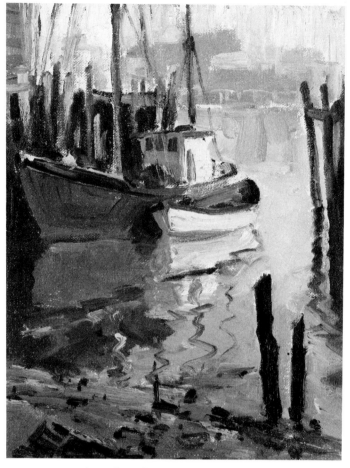

Figure 35. *Mud can be a useful compositional device, blocking a corner and keeping the viewer's eye in the picture.*

understandable. If both sides had been about the same size, the viewer wouldn't know what I was trying to say.

Also notice in Plate 31 that I've made use of perspective. On the far left, there's the edge of a large building. I've angled the top and bottom so it directs the eye into the picture. In addition, the building connects you to the scene; you feel as if you're standing somewhere in its cast shadow. Cover the building up, and you can see that the picture seems farther away from you. You're not as involved in it.

Architectural Details

In Plate 31, you can also see that I've worked for the big mass of the buildings and haven't broken them up with a lot of doors and windows. Consider such details as spots of color and don't draw them too carefully. Ask yourself: can a man in the picture go through the doors? Keep your windows near the eaves; that keeps them from being isolated and attracting attention. And don't worry about the materials that make up a building. A few clapboard shadows, one or two shingles on a roof—that's all the eye needs to understand what it's looking at. Forget about details and think in terms of building a paint texture, a texture that suggests shingles and tarpaper roofing. Make the paint do the work. You can always indicate boards by a change of color and value; that's more suggestive than a series of carefully drawn lines—and more natural.

Transitions

Notice the men and work gear I've put at the base of the building in Plate 31. These are important transitional elements. If they weren't there, the building would meet the wharf at a right angle, and the sharpness of that angle would catch the viewer's attention. He'd be distracted from the real center of interest: the boat at the dock. The angle is softened, and, of course, the man adds a sign of life to the wharf.

Distant Buildings

In the background of Plate 31, you can see a busy scene: docks, boats, and warehouses. The less you have happening in these distant buildings, the better; a lot of windows and doors would attract too much attention, ruining any sense of atmosphere.

Rather than paint each background building individually, squint your eyes and pick out the big masses. Look for groups of buildings and block them in. If you see a big area of brick buildings, put down a reddish tone, in the proper value. If you get the value

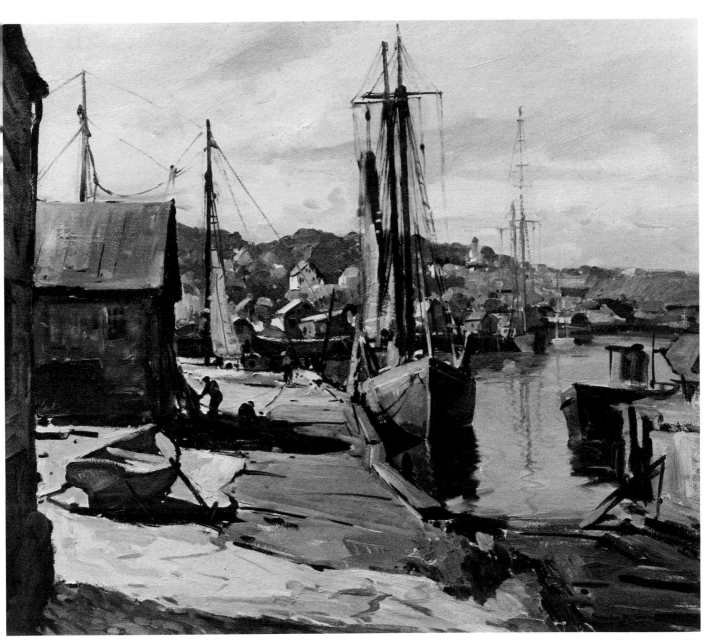

Plate 31. Gloucester Docks. Oil on canvas, 30"x 36". I've tried to give the scene a certain dignity by keeping my masts tall—both in the foreground and in the distance. Notice that I've varied the distances between my vertical lines. The mood is enhanced by the number of large, simple masses. The dory to the left points toward the center of interest.

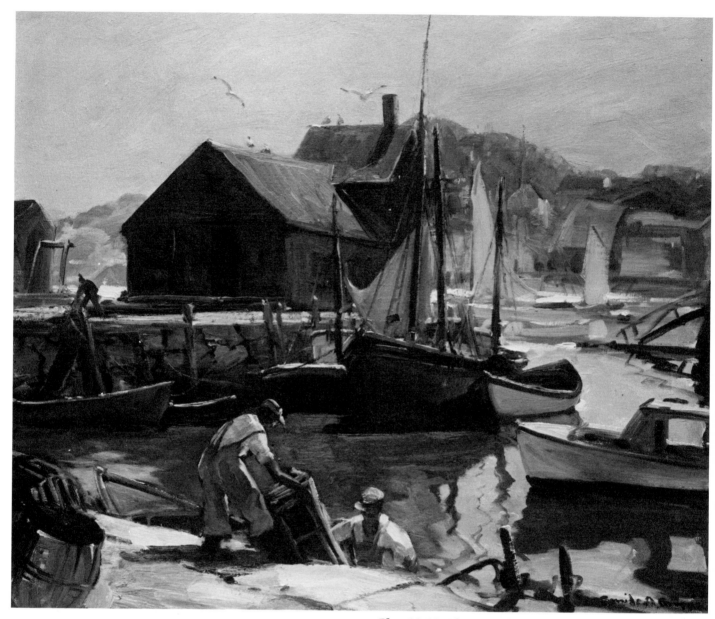

Plate 32. Motif No. 1. *Oil on canvas, 25″ x 30″. This is a noon picture; you can see how the light falls on the top surfaces of boats and piers. It throws a strong glare on the water. The design is built like a triangle—all the elements work toward the center, where the chimney of the Motif and the mast form the highest points.*

right, the buildings will stay back. In Plate 31, I've defined only four background buildings; they have recognizable doors, windows, and roof-lines. But that's all the detail I need. The eye sees these few *characteristic* shapes and imagines that it's looking at a whole town.

The broad, dark mass of trees sets off the buildings and keeps the area from becoming too busy. I haven't drawn individual trees—just a few simple areas of value. Remember that the farther you are from masses of foliage, the rounder the shape they make against the sky. You can't see the irregularities when you're far away.

Morning, Noon, and Evening

As an experiment, try comparing the background in Plate 31 with those in Plates 32 and 23. In Plate 31, the morning light hits the side of the distant houses, giving them a shape without making them stand out too strongly. In Plate 32, the noon light pours down on top of everything, weakening all contrasts. The sky is very light and only the roofs catch the sun. The whole background has a washed-out look—an interesting and delicate effect. In Plate 23, twilight is approaching and the sun is low in the sky. It hits the sides of the buildings with a blast of light. The sun is near the horizon and the sky is dark, so the buildings look strong and bright. Notice that the tree area—a simple mass in all the pictures—is darkest in Plate 23. The late afternoon light strengthens contrasts and makes the picture more dramatic.

Workmen

In a harbor scene, workmen are essential. But make sure they're there for a purpose. One of the greatest compliments I ever got was when Gordon Grant told me my figures looked as if they belonged in the picture. The trick is to have them doing something; don't just draw stick figures, standing straight and looking like they stepped out of a bandbox. They should look shopworn.

A good way to draw these figures is to begin with a triangle. One part of the triangle will be the figure's back; the other, his arm. You can make him bend to the left or right, depending on where you place the dot for his head (Figure 36). Place one foot under his head, to keep him balanced. The other can be used to indicate whatever action you want. As you establish the pose, try to *feel* the effort of the figure as he bends, tugs, and pushes.

Try not to make the heads of your figures too big. All you need is a little dot; the smaller the head, the bigger the torsos and the stronger the men will look.

Figure 36. A simple triangle can help you draw dock workers.

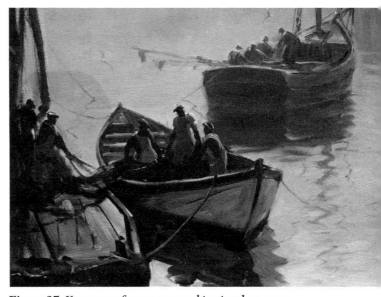

Figure 37. Keep your figures grouped in simple masses.

Figure 38. Get variety in the grouping and positions of your seagulls.

Figure 39. As a reflection catches the sides of larger ripples, it twists and turns more.

Keep the faces dark—the men are red and suntanned from working outdoors all the time. And when you block them in, try to see them as a single mass. Interconnect them with shadows, nets, anything that will keep them from being isolated figures (Figure 37). Vary the directions of the heads and bodies so as to add interest to the group. And remember to make them bigger as they near you. In Plate 32, for example, the men in the foreground are large and detailed. To the left on the distant wharf, there's a small figure; I've kept him just a simple silhouette. These figures give scale to the painting.

Seagulls

Some painters hate to put seagulls in a picture—they think it's "corny." And I'll admit that you can overdo it. But the important thing to remember is that a busy seaport is full of gulls; if you don't put them in, the place looks deserted—like Fifth Avenue without people. As they dive and bank, they add to the feeling of activity. So don't be afraid of them. Simply cross two curved lines and you've got their shape. Then you can make them more realistic by turning the tips of the wings either up or down (Figure 38).

Put the gulls in groups. Vary both their direction within the group and the patterns of the groups themselves. For example, if you have four or five gulls on one side of a boat, just put one or two on the other side. And keep them away from the masts; they don't get near for fear of being caught in the rigging. They're likely to be anywhere else—on dragger doors, on top of pilings, and especially on top of roofs. They help add interest to a straight roof-line. But remember to keep their bodies off the roof itself. They're standing up there, but you can't see their legs.

Above all, have the gulls *do* something. Have them banking to the right or left. If you make them all straight, the viewer feels as if they're flying directly at him, and he'll be scared to death. I remember a bad winter in Gloucester—the harbor was frozen and no one was fishing. The seagulls were slowly starving to death. I brought a carton full of stale bread and threw it onto the ice. Every gull in the area made a bee-line right for me! I can't explain the feeling I had: it looked as if they planned to eat me up. Remember my experience—and get plenty of variety in the way your gulls move.

The Surface of the Water

Now that we've talked about the solid elements of our subject, let's turn our attention to the constantly

changing water. The main thing to remember about water is that it acts like a mirror. It reflects whatever is over it, absorbing some light in the process. Because of this absorption of light, you'll find the surface of the water is usually *darker* than the sky. I've seen a Winslow Homer where the sea is lighter; but that rarely happens. After all, the sky is the source of light and *should* be the lightest part of the picture.

Since the water acts as a mirror, paint it only after you've established the note of the sky. I don't mean finish painting the sky before you move on—almost every student makes that mistake. You want to have room to maneuver; you can tune the sky in as you develop the whole picture. Just put down enough color to tell you where you're going with the sky and then work these colors into the water.

Be sure to add some green. I discovered how green the ocean is only after I began to winter in Florida. Down there, the tendency is exaggerated; it can be more easily seen and understood. When you're not sure of the exact color of the water, you can't go wrong by adding green. It always makes things look realistic and *wet*. The harbor demonstration in Chapter 7 will show you how to develop your sky and water, step-by-step.

How Reflections Behave

We've all seen days when the reflections in the harbor were perfect—there wasn't a ripple in the water. But that doesn't happen very often. The place is busy. Boats are moving up and down as men jump in and out of them, haul nets from them, or load them with lobster pots and bait. Seagulls land and break the surface of the water. Outgoing boats send their wakes into the inner harbor. And the water hits and bounces off countless pilings. As a result, you have a series of ripples, each like those from a stone dropped in a lake; the radiating circles cut back and forth across one another.

Remember that as the ripples come nearer to you they seem to get larger—since you look *down* on them, they also appear more circular. A reflection, as it moves forward, catches the edges of these widening circles. It's a haphazard affair; the only thing you can be sure of is that the reflections will zigzag more as the circles come near to you and show their shape more clearly (Figure 39). These reflections help attach the boat to the water. Make them *bigger* than the objects themselves. In Figure 40, you can see how the large reflection adds dignity to the objects. I once had a student who made her reflections three times the size of the actual boats—and the effect wasn't at all bad!

Figure 40. *Ripples and reflections interact inside a busy harbor.*

Figure 41. This is a monotonous design; all the shapes are the same and therefore uninteresting.

Figure 42. Here, I've rearranged the shapes so they'll be more varied and interesting.

A Summary

Figure 40 summarizes a lot of facts about the painting of water. You can see that the foreground water is darker than the water in the distance. The background reflects the light sky above it; the foreground reflects the dark sky overhead. As the water comes nearer, I paint it with a larger stroke—that puts it in perspective. In the immediate foreground, I cross-hatch my strokes and I use rough figure-eights. I do anything that will put action into the stroke and give the water a rhythmic, animated look.

You can see that dark ripples cut across the water in the center of the sketch. In cross-section, these ripples are shaped like little cones. Instead of reflecting the light sky above them, their angled sides catch a reflection from the dark sky in front of them. It's very important, though, that you don't make these ripples too dark. If you do, you'll ruin the effect. I've exaggerated them in the illustration as much as I dare— the value change is subtle and has to be right on the nose if you want the effect to work.

I've run a few of these dark ripples across the lighter reflection of the sail. That emphasizes the surface of the water. But don't overdo it! Sometimes you put in one ripple and then like it so much that you add a dozen. Take a tip from Renoir. In one of his paintings of the Seine, a rough day is suggested by just three dark streaks in the background. The power of suggestion is so strong that those three ripples tell the whole story. Any more would have confused what he had to say.

Composing with Boats

I want to end this chapter by discussing a few ways to use the elements of the harbor in a unified composition. I should say at the beginning that what you decide to paint is always a personal matter. I can't give you advice on that. Just remember that the questions to ask yourself are: What impresses me most about this subject? The way the nets hang from the mast? The angle of the boats as they lie against one another? A group of men working on the dock? The masses of seagulls looking for food? It's all up to you.

Once you've decided on a subject, squint your eyes at it. Try to see it as a simple light and dark pattern of interesting shapes. Then take the charcoal and use your first lines to place your center of interest. If you want to keep a mast in the picture and have a lot of reflections in the foreground, then place the mast and reflections first; draw the boat to fit them. Otherwise, you'll do what a lot of students do: draw the boat so big that there's no room for anything else.

Interesting Shapes

Look at the shapes in Figure 41. Forget about their being boats. Turn the picture upside-down, if that helps. You can see that the forms all look alike. The masts are the same height; the cabins are the same size; and the crossbars are at the same place on each mast. The masts themselves come right down on the bow, so that along with the bows and reflections they make straight lines up and down the whole picture. The composition is monotonous.

Now boats at the wharf often look just this way. If you're only interested in copying a scene, line-for-line, you'll end up with a picture that's as boring as Figure 41. I once had to auction a painting like that for a local art association. I decided that the only way to sell it was by naming it "The Three Sisters." The title made *some* sense of the design. But you don't want to paint pictures that have to be explained by their titles.

In Figure 42, I've tried to show one way you can rearrange the scene and make it into a more satisfactory composition. One boat's bigger than the other—the viewer knows which one I'm emphasizing. The other boat is in profile and is pushed back a little. I've varied the size of the wheelhouses, the height of the masts, and the length of the reflections. The masts lean in different directions and the third boat has been eliminated. It didn't add anything to the story. On the right, a piling balances the larger mass. The picture now has variety and a certain amount of interest.

Leading the Eye

In Figure 43, you can see how I've arranged the boats in a way that leads the eye into the picture. The dory is at one angle, the neighboring boat at a slightly different angle, and the dragger at still another angle. I've kept the sketch simple so that you can see how the light and dark pattern connects the various parts of the composition. No matter how many details or how much color I may add to this sketch, I don't want to lose this simple pattern. It's interesting, easy to look at, and quickly understood by the eye.

That's what counts. You should always be prepared to make boats and buildings bigger or smaller, longer or narrower—whatever fits your particular theme. Plate 33, for example, is a painting of *Old Salter,* a huge three-master. I remember painting it again and again one summer—with the sails up, with the sails down, in sunny weather and in fog. I tried it in all sorts of ways because it was an interesting ship. Here, I want to emphasize the size of the boat—so

Figure 43. *The shapes of the boats lead the eye into the picture.*

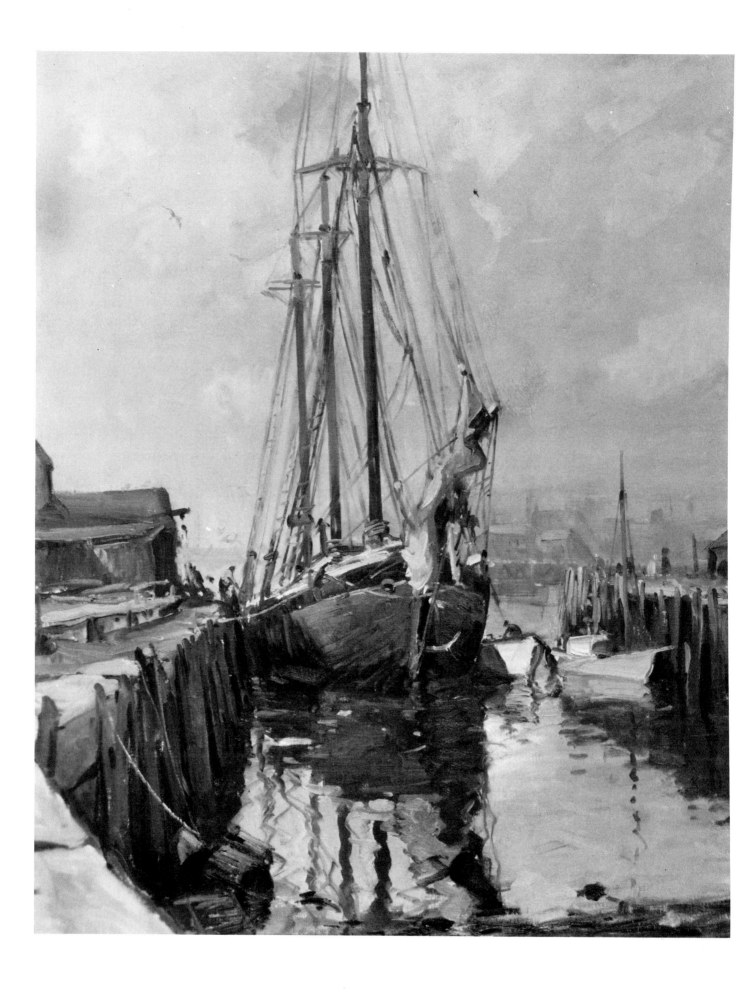

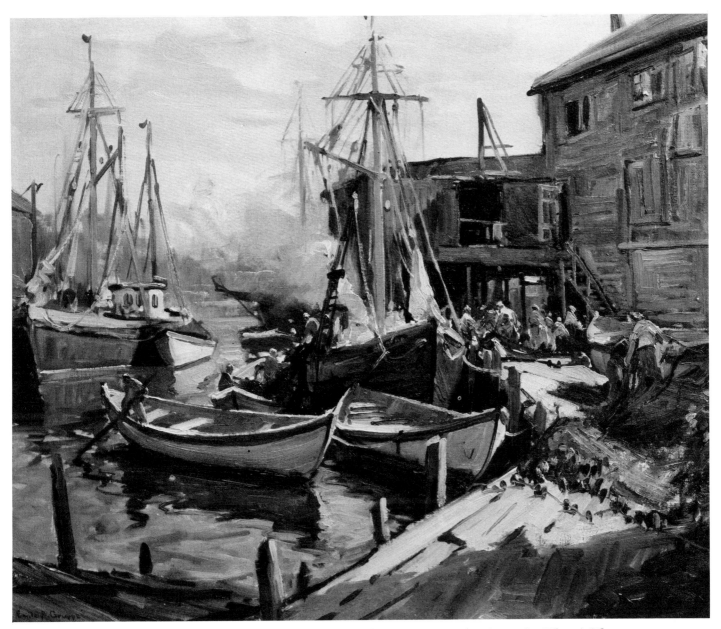

Plate 33. Old Salter. (Left) Oil on canvas, 40″x 50″. I painted this large canvas on the spot—later, there was a celebration at my having pulled it off. You can see that the small dory to the right of "Old Salter" is a brilliant white. A spot like that is always valuable in a painting; it completes the value range.

Plate 34. Busy Day at the Docks. (Above) Oil on canvas, 30″x 36″. The big mass on the right—buildings and boats— is balanced by the smaller mass on the left—the dragger and the single seine boat. The lower corners are blocked, keeping the viewer's eye in the painting. Notice that all the boats are tied to one another and to the wharf. Don't overlook this detail; if you do, the viewer will feel that your boats could float away at any minute!

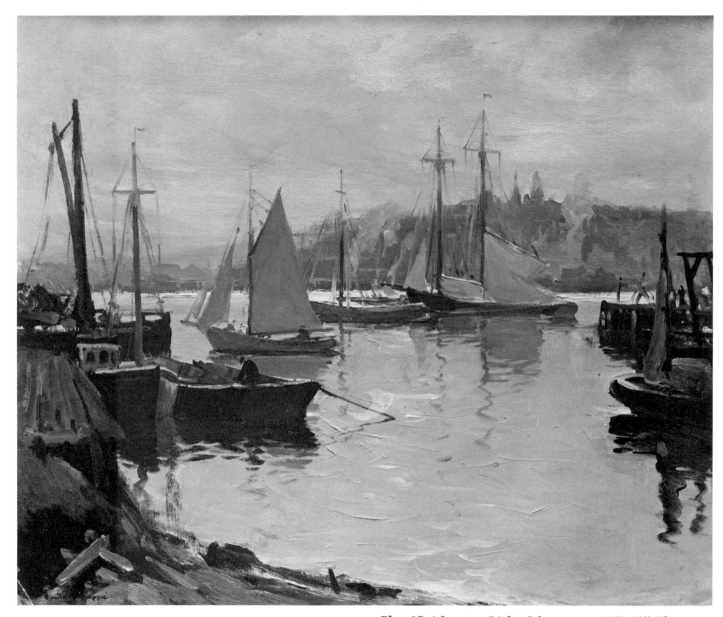

Plate 35. Afternoon Light. *Oil on canvas, 30"x 36". This is a good example of backlighting. The sun casts a glare on the water and throws all the foreground boats into silhouette. As in the previous pictures, I've kept the foreground dark— the background fades away almost completely. Remember that the only way you can get a three-dimensional effect in your paintings is by clearly defining your foreground, middleground, and distance.*

the buildings and men are all kept small. The reflections dominate the foreground. And I've pulled one—but only one—mast out of the top of the picture. That suggests how high it is.

Comparing Different Compositions

I'll end our discussion of the harbor by comparing two entirely different pictures—pictures that have different moods and use different compositional devices to create these moods.

Plate 34 shows a very busy harbor scene. Everything in the picture is designed to convey a sense of activity. Dynamic diagonal lines dominate the composition. There's loads of rigging, hoists, and pennants. Animated dots run through the design, from the floats on the net in the right-hand corner to the heads of the workmen and the pulleys that spot the sky. The only problem in a picture of this sort is that, if you don't watch out, it will appear too busy and the eye won't know what it's supposed to look at. I avoid that problem by keeping the main area of the picture—the building to the right and the boats near it—all one big mass. Squint at the picture and you'll see how it becomes a dark shape, broken by interesting areas of light.

Of equal interest is the way I planned an escape route out of the center of interest. You can work your way around the seine boat at the left and then out into the distance. If I'd made the background dark and full of houses, it would have acted like a wall, hemming in the viewer. The effect would have been claustrophobic. Now, despite all the activity and clutter of the foreground and middle distance, the eye has a chance to rest.

Plate 35 is a quite different sort of composition. Here I wanted to convey a feeling of quiet and restfulness, rather than one of activity. In contrast with Plate 34, a large part of this picture is empty. Instead of diagonal lines, the composition is dominated by restful verticals—masts, cranes, and even the puffs of smoke in the distance. Instead of being angled, the boats are mostly shown in profile; that makes them seem more static. And they're arranged so that the eye keeps moving in a lazy circle: from the foreground, up the dock on the left, across the connected series of boats, down the mass on the right, and then back up to the left again. Compare this with the restless way the eye moves through Plate 34. Both movements are appropriate to their subjects.

Mood

I hope these last two paintings show you that it doesn't matter how much or how little you put in a picture, as long as you make a clear statement and give the viewer a sense of your feeling towards your subject. Since I mentioned Mulhaupt at the beginning of the chapter, I'll mention him again now. There were painters in Gloucester in the old days who were more exact than he was—more "authentic" in that they got the shape of each boat exactly right. But many of these painters, as you looked at their work, might just as well have been painting a scene in England or Norway. Mulhaupt got the *smell* of Gloucester on canvas. He captured the *mood* of the place—and that's worth all the good drawing of a hundred lesser painters. He thought pictorially; he felt the potential in the scene before him. When you can do that, you've begun to be an artist. Otherwise, you might as well be a mechanical draftsman.

5 Landscapes

For me, the most interesting part of the landscape is the trees. There's a human quality to them. They're alive, and as they grow they tell us a story. So I want to spend most of this chapter talking about them—and getting you to take a real look at them.

The Earth

But first, I want to talk about the earth itself. Remember what I said earlier: when you draw the earth, try to capture its bulging, convex shape. It's the shape that counts; that shape suggests strength. Of course, there are always big and small valleys in the landscape, but you can't see them—the bulging forms cover them up.

The easiest way to make this point is to look at the most bulging area of earth I know: the Vermont countryside. I used to go painting up there with a friend who filled his pictures with humpy shapes. I'd glance over at what he was doing and think to myself that he'd never get away with it. But indoors, the pictures worked. He'd gotten the *feeling* of Vermont into them.

Plates 36 and 37 were painted in Vermont. In Plate 36, I was interested in the massive outcropping of rocks. The key to their character was their bulging shape—you can see how convex it is. I tried to keep these large shapes as simple as possible; that makes them more effective. So I worked them up with broad strokes of the palette knife. Figure 44 is a detail of the paint texture at the base of the main birch tree—you can see the interaction of the various strokes. Notice how rough everything is. Textures like that suggest the raggedness of nature. A forest is a forest, after all—and not a park!

In Plate 37, I applied the same idea to a more general view of the Vermont landscape; the foreground hillock, the hills in the distance, and the background mountains are all composed of large, rounded shapes. I've stressed this feeling by working the

Plate 36. Rocky Hillside. Oil on canvas, 25"x 30". Years after I painted this picture, I pulled it out of my closet and added the large center birch tree. The picture needed an upright element—everything else was bending to the right or the left. Now you have a standard and can gauge the angle of the neighboring trees.

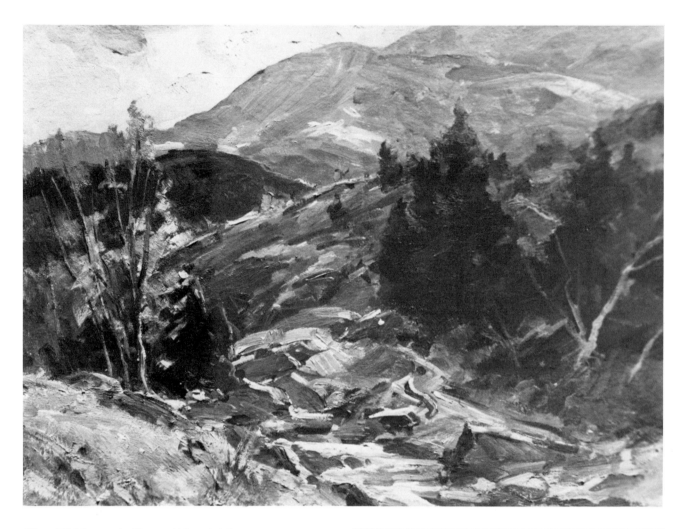

Plate 37. Mountain Slopes. (Above) *Oil on canvas, 30"x 36". Here, I'm interested in the large earth masses—so I've kept the trees small. The trees fan out to either side, directing the viewer's eye up the center hills and into the distant mountains.*

Figure 44. (Right) *Keep your landscape rough; it's a forest, not a park.*

mountain up and out of the frame. The viewer senses that there's space *beyond* the picture. He gets a strong feeling of bigness and height.

Plate 37 shows how one shape leads to another as the masses of earth build towards a peak. In Figure 45—a detail from a larger painting—you can see the clearings as they work their way up a mountain. There's no detail here—the suggestion of rounded shapes does all the work. Remember that a mountain doesn't fall to the earth like a wall—you have to show its growth. And that means you have to use the convex line.

Distance

The distances in Plate 37 are handled very simply. In Figure 46, I've isolated part of a larger picture so you can study the distant trees. I don't draw the spikey top of every pine. You may see them that way; but if that's how you painted them, they would look like a line of toy soldiers. Just make a dark mass and suggest a few individual trees. The viewer can imagine the rest. Don't draw them too well, either! If you do too good a job, the viewer will have a standard—and he'll expect them all to be drawn with equal care. You want the viewer to feel that there are masses of trees in the background—without his seeing every one.

Panoramas

Plate 37 verges on being a panorama—but I carefully stopped short of taking in all creation. There was a friend of mine, a fine landscape painter, who always worked on the top of a mountain. Looking down into the valley, he cleverly used the roads and rivers to lead the viewer into his pictures. I tried to follow him up those hills—but he always wore me out! I remember his joking about the farmboy who ran up to him breathlessly and said, "You're painting on the wrong spot, mister; up the road you can see *two whole miles* farther, b'jees!"

But you should remember that there's a danger to the panoramic view—even though a lot of people like it. You can include too much. And instead of a painting, you have a map. If I had to chose between painting a range of mountains or painting one or two trees, I'd rather paint the trees.

Trees

The discussion of panoramas, of course, brings me to my main subject. I've known some wonderful tree painters in my time—and all of them painted trees well because they had a strong feeling about them. One of my old instructors, for example, was a master

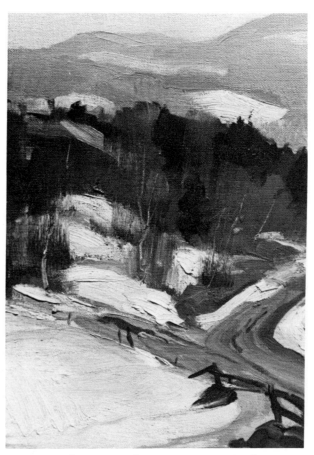

Figure 45. *Clearings work up into a mountain; the mountain doesn't fall straight to the earth.*

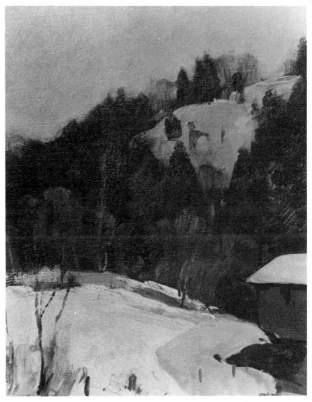

Figure 46. *Keep your distant tree masses simple.*

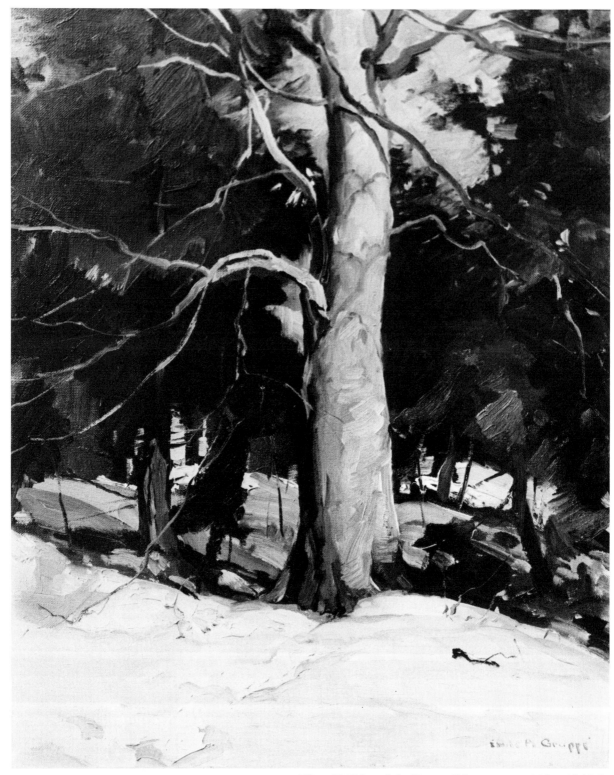

*Plate 38. **Edge of the Forest.** Oil on canvas, 36" x 30" (Collection Cape Ann Savings Bank, Gloucester, Massachusetts). The beech is in full sunlight with only a touch of shadow along the edge. The light tree is contrasted with the dark background. Attracted by the bright clearing in back of the pines, the viewer's eye is drawn deep into the picture.*

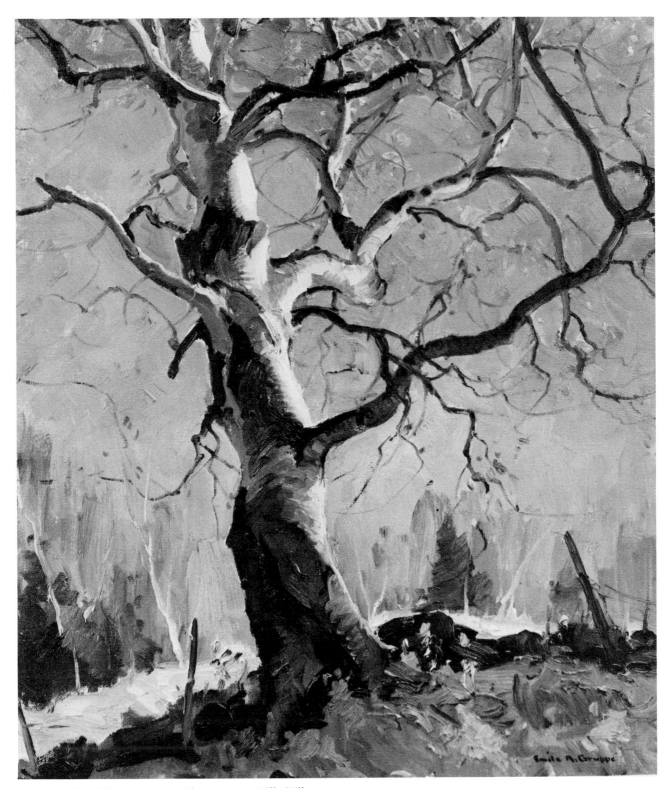

Plate 39. The Old Birch Tree. *Oil on canvas, 30″ x 25″.*
This time, the subject is in shadow with only a touch of
sunlight along the edge. The dark tree is contrasted
with the light background. Remember to keep your
trees either in sunlight or shade. From a distance,
areas half-light and half-dark cancel each other out.

at conveying the dignity and weight of a tree. He crowded them together on his canvas, emphasizing their big trunks and heavy limbs. They never grow that way in nature; they need more breathing space between them. But he took liberties with the site in order to get the impression he was after.

Observation

In order to have a feeling about trees, you should first learn to observe. Each variety has its own special personality. They're living things. So don't just paint "trees"—look at the tree in front of you and see how it grows. Note its characteristics, and, if it will help to make your point, exaggerate them. I recommend that you make careful, realistic studies outdoors—just for practice. Don't worry about composition; these are learning exercises. Save them and maybe someday you can use the information you've gathered.

Remember that a tree has anatomical structure just like the human body. The main branches grow out of the trunk and support the subordinate branches and twigs with their mass of foliage. Since this anatomy interests me, I most enjoy painting trees in the fall and winter. The foliage is off and you can see their structure and character. I'm never more frustrated—as my friends could tell you—than when I mistime my yearly trip to Vermont and arrive with the fall leaves still on the trees. Not only can't you see the trees' structure—but you can't see *through* them to the interesting rivers and mountains in the distance.

Growth

Plates 38 and 39 are two fall-winter studies. Plate 38 shows a beech at the edge of a clearing. Plate 39 is an old grandfather birch. Or maybe it's a grandmother; since the trunk splits into leg-like shapes, I've always called it my "Mae West tree." Look at these two plates while I suggest some of the questions you should ask when you go outdoors.

First of all, how does the tree stand? Is it straight, or does it lean? Does it twist? And if so, how? What kind of silhouette does it make against the background? Students always draw their trees too straight. Keep an s-shape in mind as you paint and *don't lose those curves.* One of the best compliments I ever got was when an old Vermont lumberman told me he'd never be able to get a plank out of the trees I painted. They twist too much! Remember: straight lines are uninteresting. Don't paint trees that would end up in that lumberman's mill!

The Trunk

Pay special attention to the trunk. What's its color—is it warm or cool? And its value—is it light or dark? Make a close study of its texture. Nothing could be more characteristic of a tree. Study its bark and decide what would be the most appropriate way to paint it, that is, what kind of stroke would best suggest the material. A beech tree, for example, has a smooth bark—it always reminds me of the material of old-fashioned opera gloves. For this you should use broad strokes that move diagonally across the tree in a crisscross pattern. By following the *shape* with the stroke, you accent the tree's smooth, rounded surface (Figure 47). A maple tree, on the other hand, has sharp, vertical rifts in the bark. Accent this verticality by making your strokes move in that direction (Figure 48). Put in a lot of crevices and break the whole area up. Make it look rough. The birch tree is between these two extremes. It has a smooth skin, but the bark is sensitive and breaks and peels easily. With that kind of bark, you can use a horizontal stroke, slightly curved to suggest the shape of the tree. Just slash the strokes on quickly and leave them (Figure 49). If some are a little longer than others, that's all right; where the stroke goes beyond the outline of the tree, it looks like the bark is peeling.

Roots

Pay close attention to the way the tree goes into the ground. If you want your tree to be convincing, it has to spread out as it nears the earth—not go straight into it like a telephone pole. That flare makes the tree look solid; you feel it can bear the weight of all those overhead branches. If you can see the roots, put them in. You can exaggerate them if you want; the eye likes the feeling of rootedness. Avoid, if possible, painting a picture of a tree with the trunk disappearing behind a bush. The tree will look like it's hanging in mid-air!

Branches

When you look at the branches, ask yourself how they grow. Do they grow in elegant curves, like the elm? Or do they have an angular, sharp movement, like the sycamore? Notice that branches act as a balancing device. If the trunk suddenly leans to the left, you'll find a branch suddenly shooting off to the right. That keeps the tree from falling over. This is particularly evident in Plate 39.

Remember, also, that branches go out in all directions from the trunk. Don't paint trees in profile,

Figure 47. *(Top left) The bark of a beech tree is smooth.*

Figure 48. *(Top right) The bark of a maple tree is full of rough, vertical rifts.*

Figure 49. *(Left) The bark of a birch tree grows across the trunk, frequently peeling and breaking off.*

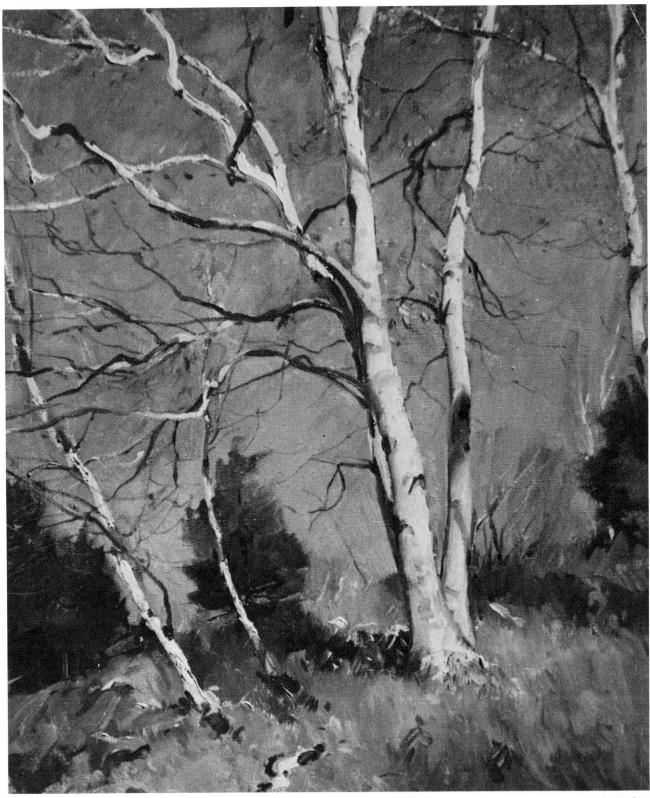

Plate 40. Hillside Birches. *Oil on canvas, 20″ x 24″. Dark accents on the birches—the branches and the "swallows" on the bark—help make them stand out. The trees spread in a star shape. And I've added variety by having just part of a tree snake into the picture on the far right.*

with the branches sticking out of the sides. That's a common student habit. To get depth in a tree, you have to have the branches coming toward you, moving away from you, and growing toward the sides. A good point to remember and look for is that branches coming toward you usually show their dark undersides—you're looking up at them and can't see where the sun hits them. Branches going away from you, on the other hand, show their top, sunlit sides and so are lighter. Get a lot of action into these branches; put a lot of wiggle in them. Vary the spaces between them, and try to avoid having them parallel one another. And notice how they're attached to the tree—they're not just stuck into it!

All these branches cast shadows—and you should look for them as they move across the trunk. Since the shadows follow the shape of the tree, you can use them to increase your sense of three-dimensional form (Figure 50). The amount of curve in these shadows appears to increase the higher they are on the trunk.

The Tree Screen

Another thing to look for is the way the branches cut the sky into a pattern. Plate 40 shows what I mean. This is a design based on the idea of a "tree screen"— much of the interest lies in the decorative design made by the branches against the sky. When you draw such branches, remember that they're seeking the sun. They reach toward the sky—and it's very important that you convey this feeling of reaching to the viewer. Exaggerate to make your point. Make the branches *longer* than they are and pull them *decisively* out of the canvas. Don't just have them kiss the top of the frame—or slowly fade out, so that the top of your picture looks like it's been bleached by the sun. Make them look like they're going someplace.

Foliage

If you're painting when the foliage is still on the trees, look to see what the leaves are like: are they big or small, long or short, narrow or wide, heavy or feathery? If you have an understanding of the basic structure of the tree—the branches and the trunk— you should know how to place the foliage. The main branches will determine both the size and shape of the leaf masses and the size of the skyholes between them. Remember that you portray the tree through its *masses* in summer time. Don't put in a lot of individual leaves; if you do, all you'll have is a bunch of flyspecks—spots, not foliage.

Figure 51 shows what I mean. It's a detail of a larger painting and suggests how I paint the foliage

Figure 50. *Use cast shadows to emphasize a tree's round shape.*

Figure 51. *Keep your masses of foliage simple, with individual leaves appearing only toward the edges.*

Figure 52. *Since skyholes cut down the amount of sunlight that comes through a tree, they're never as bright as the surrounding sky.*

on an apple tree. Notice that I put down areas of light and dark first. I keep the masses simple. And I apply the paint loosely. There's an old saying that a bird should be able to build a nest in a tree and fly to it without trouble. So keep your strokes free and easy, with enough variation in the mass to prevent it from looking like a dark, impenetrable wall. You can put a few individual leaves near the *edges* of your mass—just a flick of the brush here and there. That's where you see the leaves. But only put in a few!

Skyholes

A tree usually has four or five skyholes, with the largest of them close to the ground. That's where the branches are heaviest and the distances between them the most noticeable. As the branches divide and become more numerous, the mass closes up. Trees in the foreground have the most skyholes— that's because you can look up into them and see their branch structure. The skyholes in the distance aren't as noticeable. In both cases, whenever you see branches cutting across the holes, put them in. They accentuate the all-important anatomy of the tree.

Much of the character of a tree is determined by the skyholes. Larger and fewer skyholes are seen on a tree with heavy foliage—like a maple. But a tree like the birch has lacy foliage and many small skyholes. Each type calls for a different approach. When the foliage is heavy, I paint the big mass first and then work the skyholes into it. That keeps the holes dark, and prevents them from breaking up the mass. With a lacy tree, I paint the sky first and work the foliage into it. I'm interested in the way the sky shows through.

Refraction

Sometimes it looks as if the skyholes are lighter than the sky, but that's an optical illusion. They're in contrast to the dark surrounding foliage, and so appear light. In reality, they're *darker* than the rest of the sky. The branches and leaves obstruct the passage of light, creating the same refracted edges that we saw when we studied a ship's mast and rigging. In Figure 52, you can see the effect at work. The largest skyhole—to the immediate left of the steeple—is fairly light. But all the other skyholes are dark—the smaller they are, the darker they get. Compare the value of the largest one with the sky areas visible through the branches of the tree on the right. You have to paint the skyholes darker than the surrounding sky if you want them to look like part of the tree. Otherwise they jump out at you. Paint them the color of the rest of the sky, and the tree will look like it's pasted on the

canvas. It's almost impossible to make skyholes too dark.

Simplicity

I said earlier that I'd rather paint a couple of trees than a whole mountain range. And that kind of thinking applies to the trees themselves. For example, good pictures have been painted with a birch tree, a maple, and a beech sharing the viewer's attention. But I don't recommend it: there's always doubt in the viewer's mind as to what the subject is. Confusion is avoided if you stick to the same species, and then tell your story by having more than one example of that species in your picture. Two beeches tell more than one. You can show how the branches grow. You could contrast an old and young tree. You have a better chance to explore the character of your subject.

Three Stories

In Plate 41, we have two beech trees. The picture tells a story about the way branches move. I was interested in their long, flowing lines; and you can see how I've accented them by putting them against a nice, dark evergreen. Look at the twist of the limb on the upper part of the right-hand tree! An notice the horizontal movement of the branches near the bottom of the trees. Those branches can't go straight up—they have to work hard to escape the huge mass of foliage overhead. So they grow horizontally first, and then turn towards the sky. This picture is about the struggle of the lower branches for a place in the sun.

Plate 42 tell another story about beeches. In this case, the trees are closer together and the branches move differently. I've laid special stress on the younger trees as they move to escape the shadow of the large central one. Notice how the tree on the left, for example, has its main branches on the side *away* from the largest tree—that way, its leaves can get some sun. The principle line in this picture—the one that makes it work—is the long branch that hangs down in the center. That's a very characteristic movement for a beech, and I drew it exactly as I saw it, carefully following the branch as it twisted toward the earth. When you're in a beech grove, you constantly bump against such hanging branches.

Plate 43 is of birch trees, but again there's drama to their story. The largest and straightest tree is always the oldest. It had the land to itself and went right for the sun. But younger trees have a harder time. The kids don't like the Old Man and twist and turn to escape his shadow. Their struggle is what I never tire of painting.

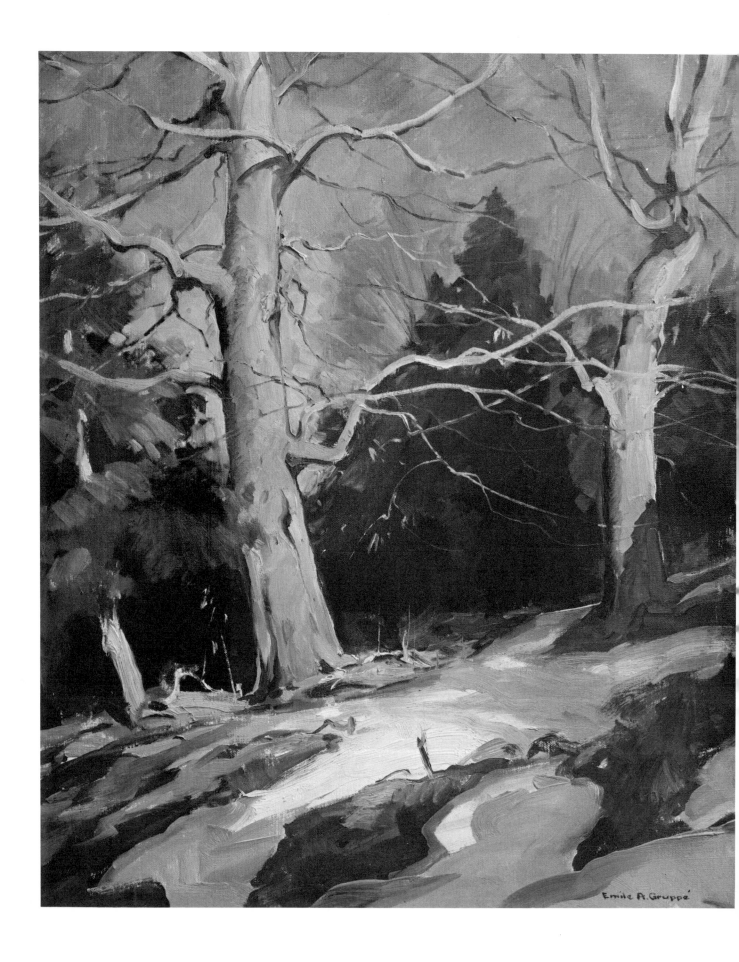

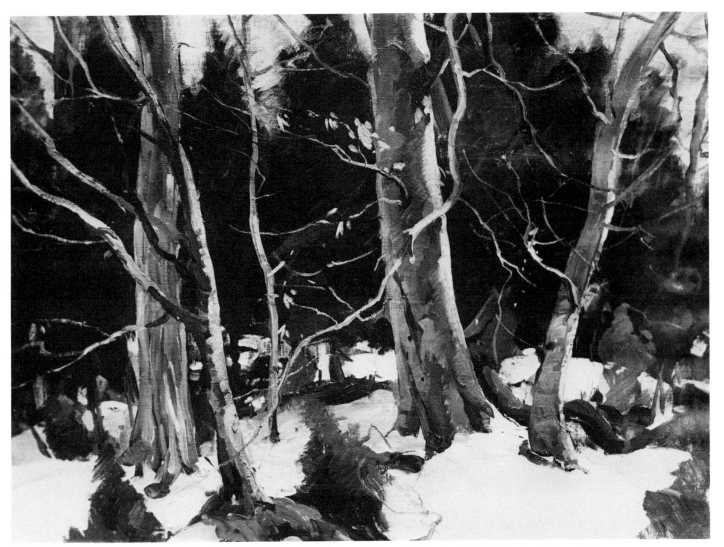

Plate 41. Beeches in Snow. *(Left) Oil on canvas, 30″x 25″. I'm interested here in the horizontal movement of the lower branches. The painting was done late in the afternoon—the raking light of the sun makes the side of the snow patch the lightest area in the picture. The dark sky accents bright spots.*

Plate 42. Beeches in the Woods. *(Above) Oil on canvas, 30″x 36″. Here, I've made use of the leaves that died on the tree in the summer—and so stay on all winter. They add interest to the dark masses, and the cluster near the top of the main tree breaks the vertical line of the trunk. Throughout the picture, I've broken my verticals, lessening their severity.*

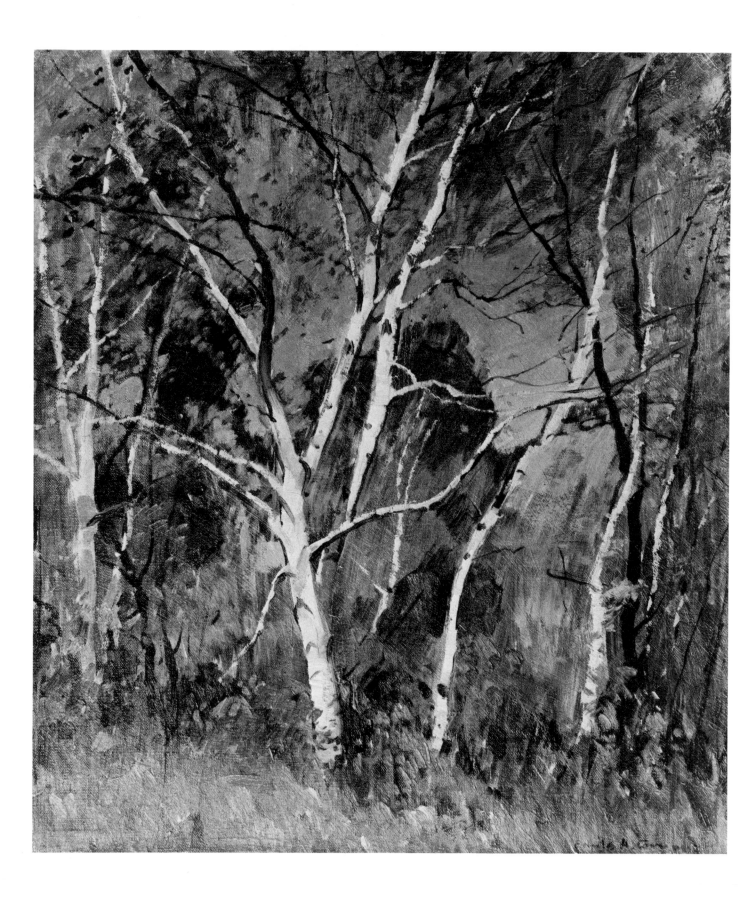

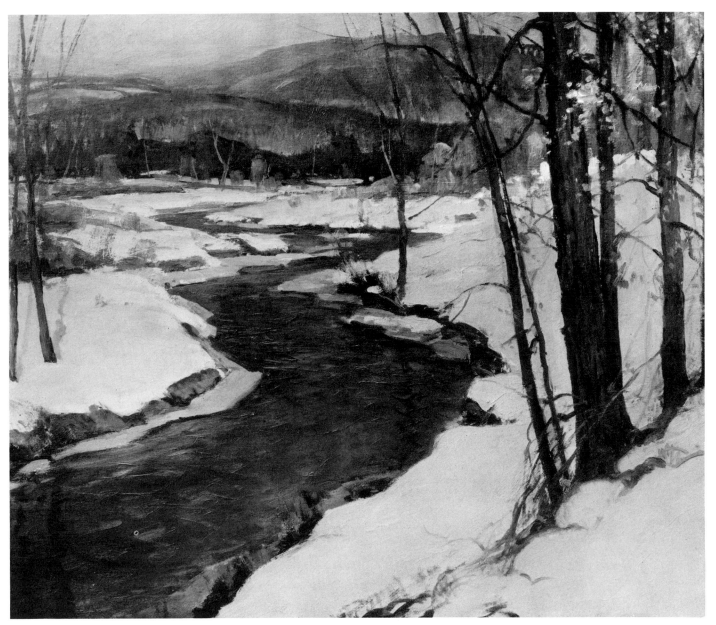

Plate 43. Hillside Birches. *(Left) Oil on canvas, 24"x 20".*
There's a lot going on in this picture, but it holds together.
Although leaves are all over the place, they're kept in
groups. You see them as masses first and feel their presence
without wanting to count them.

Plate 44. Meadow Brook. *(Above) Oil on canvas, 30"x 36".*
I've kept the horizon high in this picture so that the brook
dominates the canvas. Since the sky is relatively dark, the
snow has a chance to tell. The water reflects the dark sky
overhead.

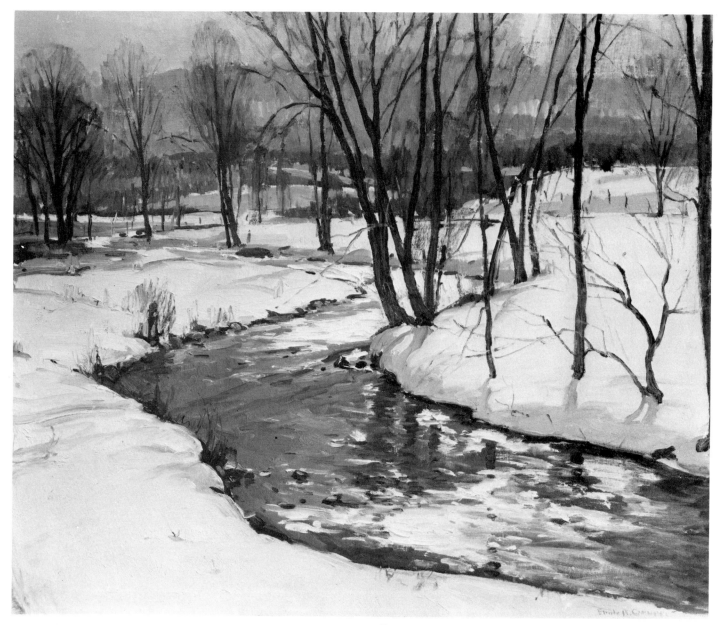

Plate 45. Sparkling Creek. Oil on canvas, 30"x 36". The large light area of snow on the left balances the dark area of trees on the right. It's large, close to us, and so gives the viewer a strong sense of foreground. The background is very simple: Just a few areas of value. It's a subordinate area and shouldn't be developed in detail.

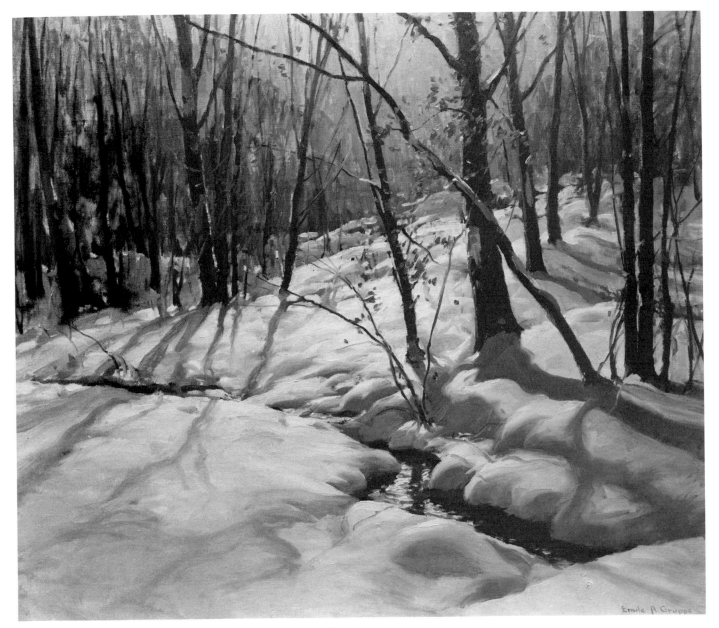

Plate 46. Tree Shadows. *Oil on canvas, 30"x 36". Since this is a fairly busy picture, I've kept a simple snow area on the left where the viewer's eye can rest. The leaves and the slanting tree help to break the vertical lines. The sun is directly in front of us—the shadows fan out to either side of the picture. Only near the center do they begin to come toward us.*

Plate 47. Jeffersonville Church. *Oil on canvas, 30″x 36″. The trees and people give scale to the church. Again, I've kept the sky and the snow relatively dark, so the strong afternoon light on the church will really tell. Notice that I pulled one tree right across the steeple—that breaks up the shape and makes it more interesting.*

Plate 48. Dusk. *Oil on canvas, 30″x 36″. I'm not too interested in real estate. Close-ups of buildings are really feats of draftsmanship—portraits. I prefer to use small buildings, just to give scale to the design. After this photo was taken, I added human interest to the scene by bringing smoke out of the chimney of the farmhouse and putting a small light in its window.*

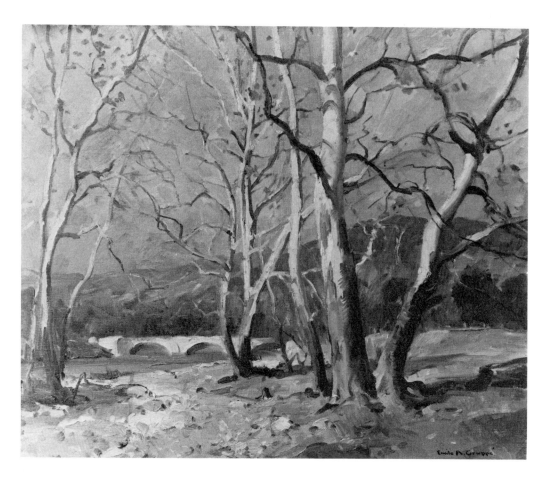

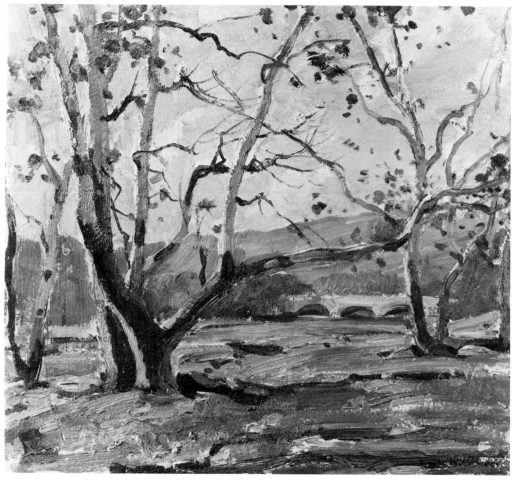

A Matter of Emphasis

I've told you trees should twist and turn. But should they *always* twist and turn? Remember that everything depends on what you want to emphasize. Look at Plate 44, for example. Why have I kept these trees straight? The answer's a simple one: in this picture, it's the twisting of the stream that interests me. And in order to *emphasize* its curved shape, I need to keep my trees nice and vertical. It's as if I were saying, "Look: this is a straight line. See how much the river bends!"

A similar principle is at work in Plates 45 and 46. Both subjects are backlit and there's a strong glare in the water—that glare is the brightest area in both pictures. In Plate 45, I want to stress the glare. It's my subject. So I reduce the trees in size and make the river big. In Plate 46, on the other hand, I'm interested in the trees and their shadows—so the river is only a small element in the design. In both pictures, the river helps to lead the eye of the viewer into the picture—but it's clearly the center of interest in one picture and a subsidiary element in the other.

Plates 47 and 48 further illustrate the importance of emphasis. In Plate 47, I'm interested in the church—it's a big building and dominates the canvas. The nearby trees are simply there to give scale. You see how small they look and immediately *feel* how large the church is. In Plate 48, I want just the opposite effect. The trees are now my subject and I want to emphasize their height and dignity. So I keep the houses small. They give scale, without overpowering the scene.

Mood

A site can have quite different aspects under different conditions—and a good site is nearly inexhaustible. Plates 49 and 50 were both painted along the Mohawk Trail; you can see the same bridge in the background of each. But notice how different the moods are.

Plate 49 was done in the afternoon. The light casts shadows but isn't strong. Notice that the effect is a *sober* one. The grayish light and the fairly straight trees both convey a feeling of dignity and propriety.

In Plate 50, I was struck by the *festive* look of the scene. The big sycamore leaves look like balloons. The light is crisp and sharp, and the trees twist gayly. The paint is thick and has a lively texture. And the big, round leaves dance all over the sky.

Conclusion

Remember when you're outdoors that you have to be open to the character of the site. I'm reminded of a friend of mine, a friend who painted marvelously sensitive tree studies—and who was so poor that he would scrape off masterpieces so he could reuse the canvas! I went into his studio one day and saw a large picture of some beech trees, with the light filtering down them. The subtlety of the piece took my breath away. I remember standing there in silence for a minute. Then I thought to myself, "This is God!" That's all I said. And that's all I needed to say.

Plate 49. Afternoon Sycamores. (Top left) Oil on canvas, 25"x 30". The small group of sycamores on the left balances the large group on the right. The smooth upper parts of the trunks are typical of the sycamore. Notice, in particular, the abrupt, angular way the branches move.

Plate 50. Morning Sycamores. (Bottom left) Oil on canvas, 18"x 20". Everything in this scene is crisp and lively. I've gotten perspective into the picture by making the trees in the background smaller than the principle group in the front—and I've pulled the design together by running a long branch right across the canvas.

Figure 53. *Here's a snapshot of the scene I painted in Plates 74 and 75.*

Now that we've discussed the various aspects of landscape and marine painting, I want to analyze a series of finished designs. Then I'll take you to a site and you can see how—over a period of two days—I tried to organize a composition, so that it more clearly expressed my feelings about my subject.

General Observations

But before I analyze specific pictures, I want to say a few things about design itself. I've mentioned some of these things before, but they're worth repeating. First of all—and this may seem obvious—you have to have a subject. You have to know *why* you want to paint a thing: what aspect of it interests you the most. In good design, it's *everything for one thing.*

Now, I remember a story that reinforces my point. It was back when I was studying with Charles Chapman. Harvey Dunn came in to have lunch with the teacher. There was a model dressed like an Indian, and I was working on a single figure in the corner of a huge canvas. I don't know what I was after—maybe I planned a massacre. Dunn came up, looked, and finally said to me, "What are you doing?" Then he grabbed my brush. "Here's an Indian!" And in no time he did a tremendous figure right in the middle of the canvas—feathers all over the place. I was speechless. Dunn went right to the point. He knew what he wanted to do and he did it—in a big way.

So you have to dope out what you want to do. Use your head. When you paint a picture, you make at least two thousand decisions. Be selective. You're like a film director. He comes on a set. "Strike that!" he says. "Get rid of this!" A stagehand may complain: "Wait, it took us weeks to build that stairway!" But out it goes for the good of the scene. You have to have the same ruthless attitude.

An Exercise

One way to start thinking about the most important question of all—"Why am I painting this?"—is to get a bunch of note cards. Take one and divide it into four boxes. You won't have room to do detail; there'll only be space enough for the main theme. Go outdoors and do four little sketches of a site. Let's say you have a view of a road, a field, a farm in the middle distance, and a mountain. In one box, emphasize the *mountain.* Make it the dominant element. Not much sky and just a suggestion of the farm and field. In another, let the *sky* dominate the scene; sub-

ordinate everything else. In the next, let the *field and road* fill the space, with hardly any mountain or farm. Lower the mountain if you want—or have it go out of the picture. And in the fourth box, draw the *farm*, with little mountain and little field or road.

Remember as you shift your emphasis around that you can't look *up* at the mountain and *down* at a field—not at the same time. So don't expect the viewer to do it. Choose one theme. Then the viewer knows what you're trying to say. He isn't confused, as he would be if you simply went out and painted *everything* in front of you, with equal emphasis on all the parts. That's a collection of objects—not a design.

Remember that nature may be perfect but she isn't always a good designer. You have to pick and choose. Make sure all the elements in the picture have a purpose and keep you masses simple and interconnected. That gives a picture "carrying power." The viewer understands your composition, and the farther he gets from it, the easier it is to "read." At juried shows, the unanimously accepted pictures are always those that are based on a simple light and dark pattern. John Carlson had a saying: "A good composition can be seen at a glance."

Counterpoint

By varying the lines in your picture, you can give it added life. In his still lifes, Cézanne always slanted the table so that it angled into the picture, drawing the viewer in and avoiding lines that parallel the frame. He also looked *down* on his subject, further emphasizing the leading diagonal lines. You can use his ideas in your own outdoor work. Just remember that perfectly straight lines are boring—look for the diagonals! They give your picture variety and vitality.

Cézanne also played line against line. If he had a lot of round fruit in a picture, he'd have a lot of sharp, triangular shapes in the background draperies. Those harsh lines *explained* the round ones and made the fruit seem more like fruit.

I mention these two aspects of design because many contemporary painters don't give much thought to them. Parallel lines dominate their pictures, and the eye doesn't have anything exciting to look at. There's just the scene—and that's that. But a good design—well, you can take a good design, throw it on the floor, and it will look interesting no matter how it lands. The spacing and spotting are what counts. Turn a picture upside down on your easel sometime and study it that way. Hang it upside down and look at it for a week. You'll probably see it a lot better!

The Importance of Finding a Subject

I'm starting with Plate 51 because it's a good example of how you *shouldn't* compose a picture. It has some good points, but there's enough material in it for four pictures. It's all over the place. The superimposed circles should explain what I mean. The big wharf building is a subject in itself—as are the two schooners in the background, the white seine boat in the foreground, and the stone pier directly in front of us. Everything is interesting, so nothing stands out. In addition, the background buildings are too dark. The painting needs a few roof shapes catching the light. That would break up the mass and make it more interesting.

In Plate 52, I've simplified things a bit. But the viewer is still confused. He asks himself if the mountain is the subject, or the wet ice, or the birch trees. I tried to emphasize the distance by framing it with trees. I fanned the trees out in a star-shaped pattern so as to avoid a lot of straight lines. But there's still too much of them. If I were doing the picture again, I'd play the trees down and put a decisive emphasis on the distant mountains.

In Plate 53, painted at the same spot as the preceding, I *got* what I was after. Now there's no doubt about the subject. The trees dominate the space; I've brought them up close and run them right out of the top of the picture. I've put a nice, dark evergreen right on the frame so the viewer know where he's standing, and I've used the other evergreens to bring out the sunlit trees. Without the dark background, the trees wouldn't have any punch.

Light and Dark Compositions

When we discussed trees, I suggested that it was best to have a tree either in full light with a little shadow, or in full shadow with a little light. Halves cancel each other out. The same principle applies to a design: either darks or lights should predominate.

In Plate 54, lighter values are the dominant element. Both the sky and the snow are light, with the row of dark trees forming a nice contrast to them. I was primarily interested in these dark trees—and the way the snow stuck to them immediately after a snowstorm. Notice that I've done everything possible to suggest the *height* of the trees. You're looking *up* at them to begin with, and the horizon line and distant hills are kept very low. That makes the trees look taller. I've kept the largest area of sky to the left, near the source of light. The eye naturally moves towards this large area, then follows the line of trees towards the right. Notice that I've made the trees

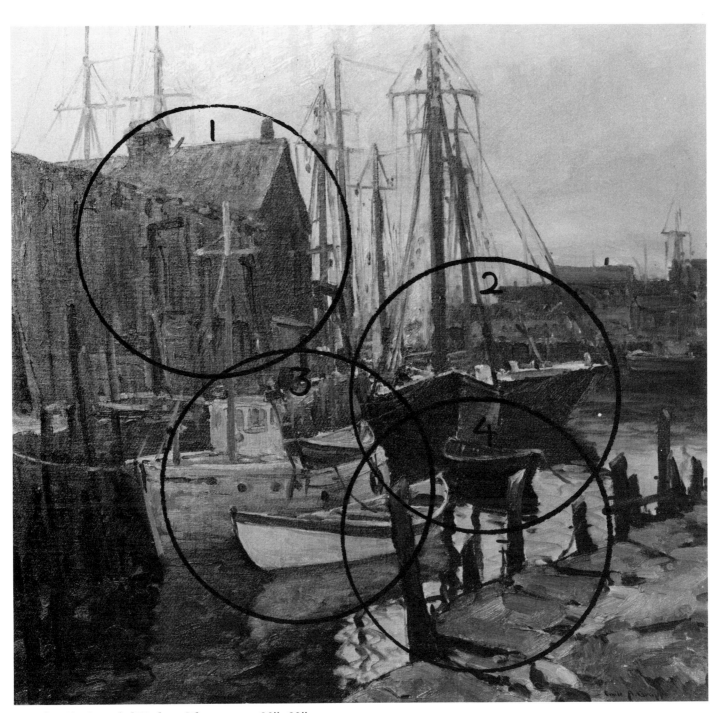

Plate 51. Crowded Harbor. Oil on canvas, 30″ x 32″.

*Plate 52. **Field Stream.** Oil on canvas, 25"x 30"*.

Plate 53. Interior. Oil on canvas, 30″x 36″.

Plate 54. After the Snowstorm. Oil on canvas, 25″x 30″.

smaller as they recede, and have subtly changed their value, lightening them as they go back. A few small saplings give scale: their slenderness and delicacy contrast to the massiveness of the other trees. In addition, the one straight sapling (near the center of the picture) gives you a standard to judge the crookedness of all the others.

In Plate 55, the design is mainly *dark*. But don't think it was necessarily this way when I arrived on the site. On the contrary: it was right after a storm and all the evergreens were heavy with snow. There was too much white. So I simply put down my large dark areas and then broke into them with snow patches where it seemed necessary. After all: how much snow do I need to make a point? And snow piled on pine trees tends to form repetitious, uninteresting patterns. Here, you can see a few branches hanging in convex lines. That suggests the *weight* of the snow; those few shapes tell the story.

Moving the Eye into the Picture

Having discussed perspective earlier, I'd like to show how I use it in two quite different designs. In Plate 56, I'm looking down a Gloucester street. The downward curve of the right side of the road matches the downward curve of the background trees—the two taper towards the left, forcing the eye down the road and around the distant corner. The tops of the trees on the right, the city hall in the middle, and the church steeples to the left all break the contour of the hill and prevent the eye from moving downwards at too breakneck a speed. The line is softened.

Now what I really want you to notice is the perspective in (1) the buildings and (2) the size of the objects. The linear perspective isn't perfect. That's the way it should be. Too many people are so proud of understanding perspective that they overdo it; everything looks like it was drawn with a ruler. This is an old city street and *irregularity* is part of its charm. Notice how the building on the right (directly above the nearest car) leans slightly *backward* when compared to the building on its left. That slight variation is one of the most important elements in the picture. It gives *character* to the scene. But a sloppy observer just wouldn't notice it.

As for the size of the objects, notice how I started with one big building on the right—and ended up with four or five little ones by the time we turn the corner. Many students would make all these buildings the same size. They draw them one at a time—and don't *relate* them to each other. Also notice the other perspective clues: a big car in the foreground, a small car, and a smaller one. A big person, a small

person, and a smaller one. Big windows up front and smaller ones in the distance. Detailed nearby buildings—and broadly-painted distant ones. Everything works to pull the viewer back into the picture.

Plate 57 is designed in a similar way. The river bed narrows like the road in Plate 56. The largest tree is on the bank nearest to us, and the trees get smaller as they recede. The largest area of snow is at our feet, and the areas get smaller as they go back into the picture. An especially important part of the design is the large, snow-covered rock in the lower left-hand corner. It's a nice, big shape and gives you a standard to judge all the smaller patches of snow up-river. Cover the rock with your hand and see how the picture suddenly looks much flatter; there's less feeling of distance.

Exaggeration

In Plate 58, I've tried to get a sense of depth by another means. There isn't any place in Gloucester where you can see the bird's-eye view illustrated here. I was actually standing on a spot just to the right of my signature. From that vantage point, all the distant wharves come together in a line at about my eye level. But a design like that is boring; the boats form a wall, keeping the eye from moving into the picture. So I used my imagination and raised myself into the air. Now the design is an interesting zigzag. The eye moves from the foreground float (which I greatly reduced in size) to the boats on the right. They, in turn, point towards the mass on the left. That large grouping of boats, buildings, and derricks slowly tapers back towards the right and the hazy horizon—the eye loses itself in infinity. Notice that since we're looking into the sun (you can see the shadows cast by the boats and the glare over the reflections), there are a lot of silhouettes. I kept these masses simple—a lot of details would have taken away from the effect.

Peaches and Cream

In Plate 59, I get the eye back into the picture by yet another means. The eye moves from the light seine boat and dragger near us to the large dark mass on the left. This mass balances the lighter one and attracts the eye. But notice how close it is to the frame. It's just big enough to serve its function. If it were bigger, it would become a subject in itself. And it would cut into the breathing space that I want to keep around my main boats. From the dark mass the eye moves into the distance, attracted by the light sail. That small light spot is extremely important. If

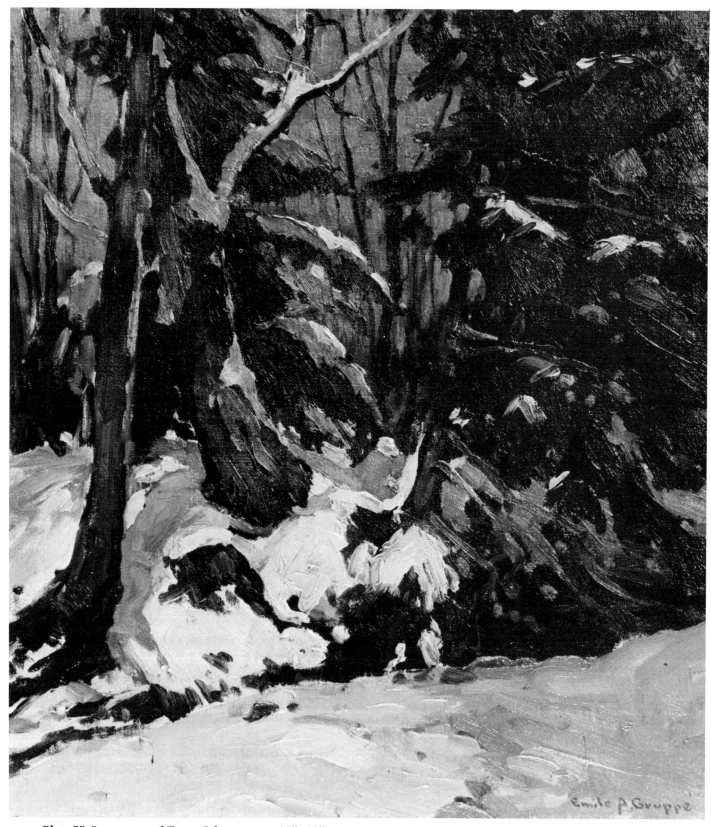

Plate 55. Snow-covered Trees. *Oil on canvas, 18″x 20″.*

Plate 56. Main Street, Gloucester. Oil on canvas. 20″ x 24″.

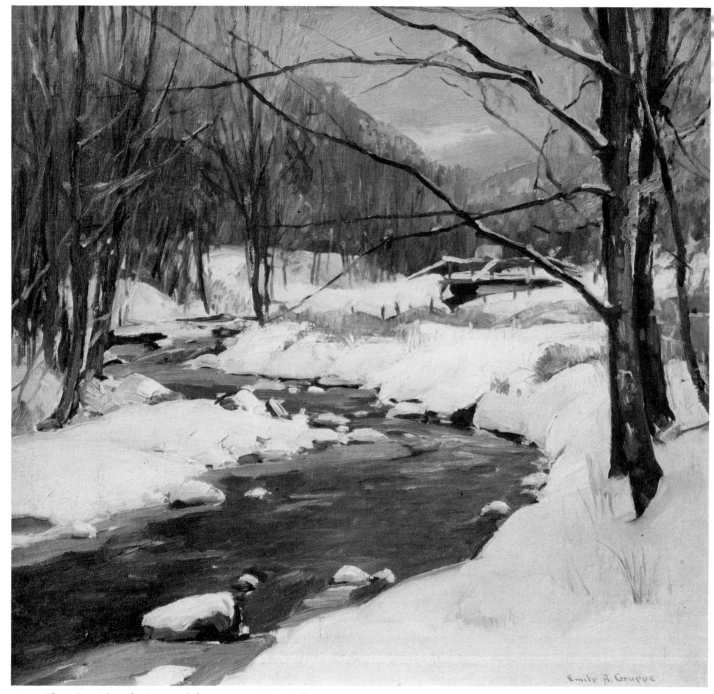

Plate 57. After the Storm. Oil on canvas, 20″ x 24″.

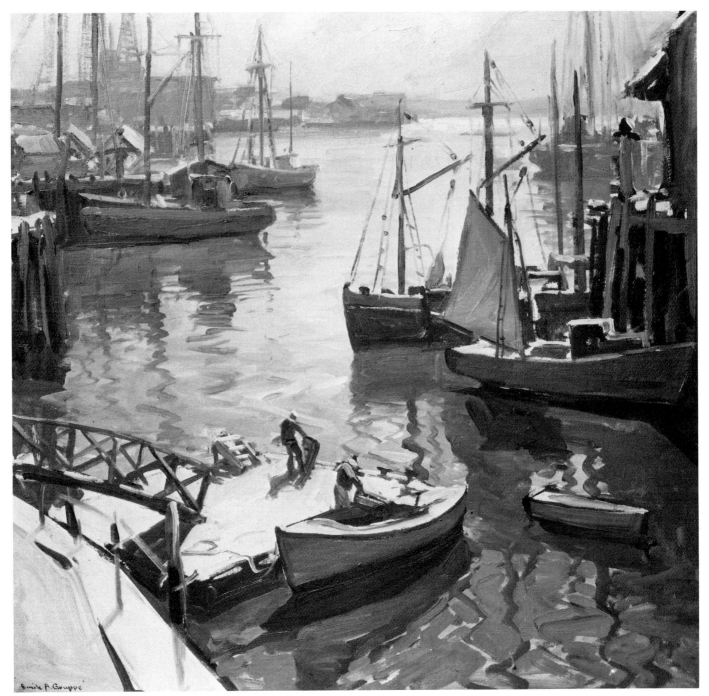

Plate 58. Town Landing. Oil on canvas, 30″ x 32″.

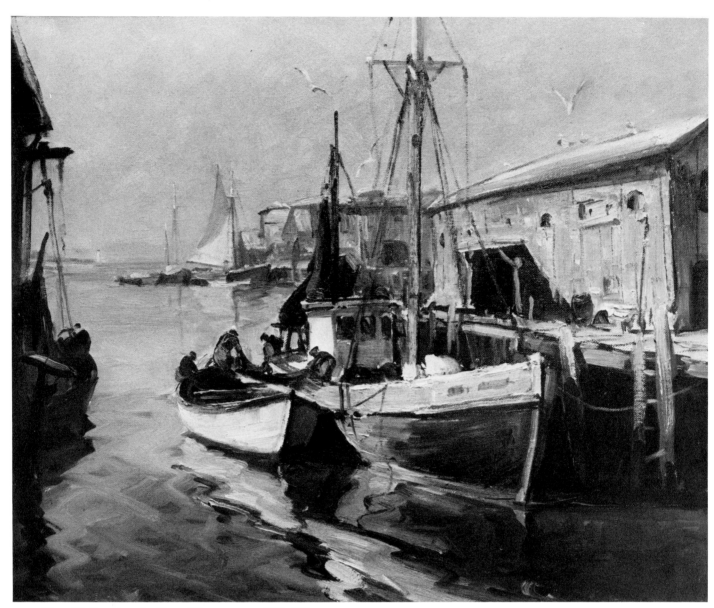

Plate 59. Stowing the Nets. *Oil on canvas, 25" x 30"*
(Collection Meriden Savings Back, Meriden, Connecticut).

you cover it up with your thumb, you can see how much less interesting the area is; the eye isn't tempted to go out and explore the background. With that spot, however, the eye takes time and looks around. That's the *dessert* of the picture, the peaches and cream. It's something for the viewer to enjoy, once he has gotten his fill of the main subject.

Emphasizing a Motif

In the next few plates, I want to show you how I was taken by a particular aspect of a subject and then designed the picture to bring that aspect out.

In Plate 60, I was struck by the size and dignity of the boat at dry dock. I liked the way it stood alone, with plenty of air around it. It looked very imposing. My problem was where to place it on the canvas for maximum effect. You can ask yourself the same question. What if it were placed higher? Cover the mast and see if the boat looks as imposing. It immediately loses much of jts dignified character. So I place the boat where I can show a good part of the mast. I run the rigging lines out of the top of the picture, keeping them far from the mast. If they looked as if they met the mast just outside the frame, the mast would look stubby and the viewer would get a cramped feeling. In order to make the ship more imposing, I've lowered the horizon line and added a small man to give scale. Then I've emphasized the dynamic, cutting bow by keeping it in strong light and throwing the rest in shadow.

The dark poles at the stern of the boat and the dark right-hand side of the bow make the ship and its scaffolding into a self-contained unit. Then the planks on the ground direct the eye into the distance and around the whole mass. On the right, part of a boat blocks the edge and keeps the eye in the picture. I'm stressing the feeling that you can go around the boat because it's an *important* quality of the scene—and I worked hard to get it!

Convex Shapes

In Plate 61, I'm trying for a different effect. Here I want a *high* horizon; I like the rolling hills and the way they move off into the distance. That means I have to stress the convex shapes of the earth. I have one, big, bulging shape behind the white house, then two or three bulging fields behind that—and way in the distance you can see two whole mountains. You can feel the way these forms slowly step back into the picture. I emphasize their downward slope by counterpointing it to the slope of the small hill in the lower left—a few foreground shrubs clarify the line.

To balance the painting's strong leftward move-

ment, I've placed my vertical elements, my darkest darks, and my lightest lights all to the right. The dark barn is an especially important element in the design because it attracts the eye and keeps the viewer from simply sliding out of the picture and breaking his leg. Of course, the dark also functions as a standard; it lets you know how light everything else is. Cover it up, and you'll see that the picture looks washed out.

Two Different Roads

In Plate 62, I'm interested in the road—I want to get you down it, around the tree, and up into the mountains. The road's sharp perspective pulls you strongly towards the left, a movement helped by the fact that all my large forms are also on the left. Then I block the corner with a tree in shadow—that keeps the eye in the picture. The light house in the distance attracts the eye, pulls it towards the right, and gets it moving into the mountains. A sapling on the far right, while not strong enough to compete with the big forms on the left, blocks the right-hand side of the picture and keeps your eye inside the frame.

In Plate 63, I was attracted to the way the road goes down and then up. The other elements in the picture. interested me, but not as much as the road. So I make the road big. The wall on the right points dramatically downward. Then, in the middle distance, I've emphasized the upward movement of the road by placing vertical elements next to it. The small saplings on the left and the evergreens on the right all point upward. Cover the evergreen with your hand, and you'll see that the upward movement of the road is not as pronounced. The evergreen also helps create a sense of recession. It's a strong dark and separates the foreground and background by overlapping them. Again, cover the evergreen and see how the areas merge together. The small farm on the left also helps define the space; the eye senses that there must be a lot of distance between it and the large, principal barn.

Foreground and Background

Plates 64 and 65 are paintings of the same spot, done at different times of the year. In Plate 64, I was interested in the breaking ice and the patches of snow on the wharf. Since the background didn't interest me, I played it down. I've suggested it with a few strokes, making the far distance just one big area of value. My brightest spots are all in the foreground—that keeps the eye where I want it.

In Plate 65, I've tried for an exactly opposite effect. I'm no longer interested in the foreground boat

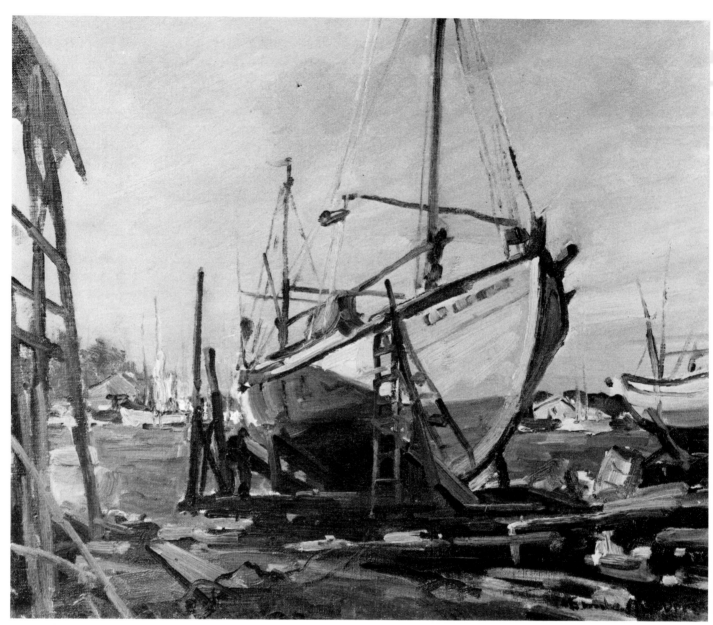

Plate. 60. ***On Dry Dock.*** *Oil on canvas, 20" x 24".*

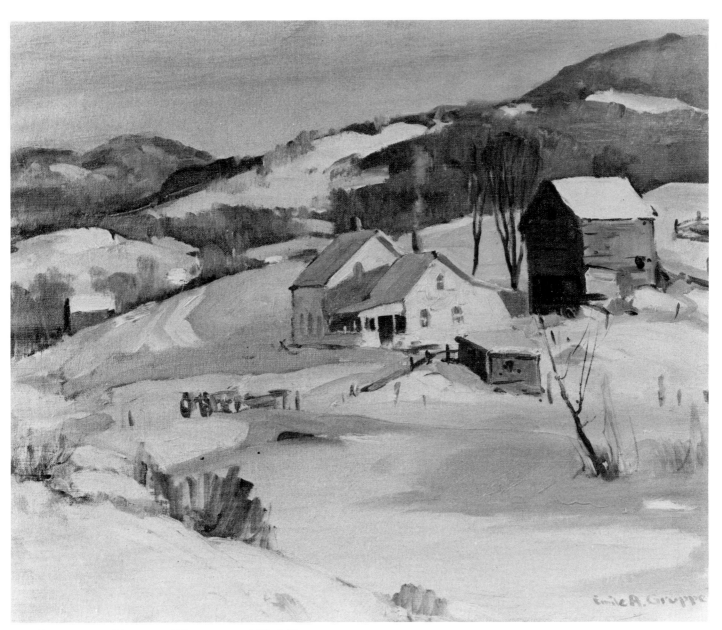

Plate 61. Late Afternoon. Oil on canvas, 20″x 24″.

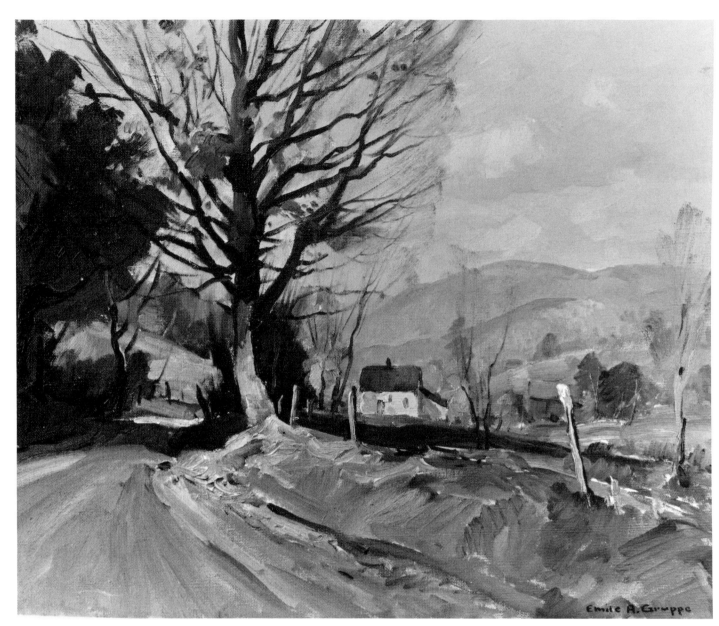

Plate 62. The Road to the Village. Oil on canvas, 20″ x 24″.

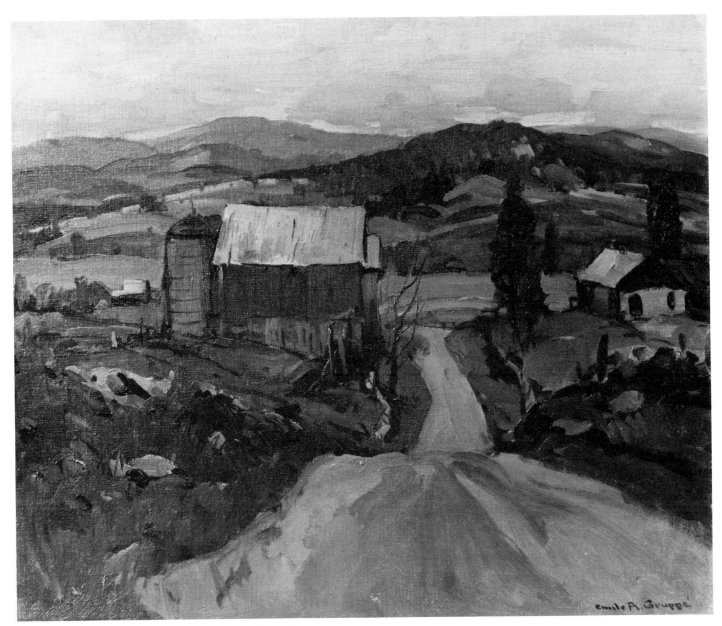

Plate 63. Vermont Hills. Oil on canvas, 20″ x 24″.

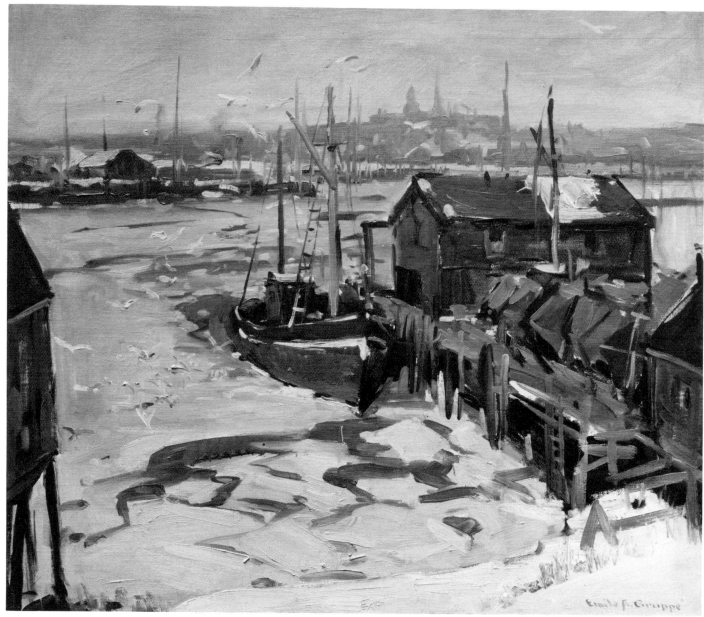

Plate 64. Breaking Ice. Oil on canvas, 25" x 30".

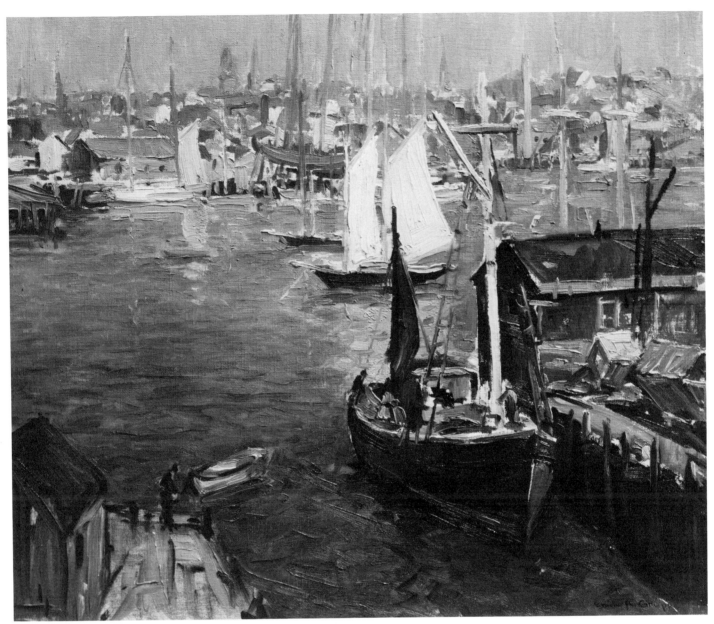

Plate 65. Looking Towards Town. Oil on canvas, 25"x 30".

and wharf, nor do I want to suggest the quiet and solitude of winter. Instead, I'm interested in the bustling activity of the harbor in the middle of summer. So I put all my bright spots in the distance. I make the distance big, so the eye goes to it—and I throw the foreground into shadow. The keynote for this picture is the "spotty" look of the two, big, white sails. I develop the whole background in a similar manner: a lot of quick daubs and dabs. The effect is a busy one and reflects the liveliness of the whole scene. The technique matches the subject—just as the completely flat distance in Plate 64 matches the mood of that picture. Notice, by the way, the little dory in the lower left of the picture. That small element plays an important part in the design. Not only does it point toward the large, dark boat, and thus begin to get you into the composition, but it also breaks up what would otherwise have been an unnecessarily large and uninteresting area of water.

Angles and Counterpoint

Plate 66 was painted at low tide and gave me a chance to look down on my subject. You can see how the strong diagonals lead the eye into the picture. As you go into the distance, the diagonals flatten out. The sail sums up the whole design: it's a study in angles. How many triangular shapes can you find? How many sharp edges and angles? The key to a picture of this sort is the execution. It's brisk and to the point. The sail is painted with the same authority as the rest of the picture: strokes are placed on the canvas and left there, with a minimum of touching up. As a result, the design has a crisp, dynamic quality that interests the eye.

Plate 67 is developed along the same lines. Many people, painting this subject, would work to get the architecture just right. But I'm not an architect. I'm interested in the angles and shapes of the houses, so there isn't a straight line in the whole picture. Although there's a lot happening in the design, it doesn't fall apart. I've kept all the darks and lights together; the buildings all form a big mass, while the lights slowly step their way up towards the church and then to the steeple, towering over everything. The largest building is in the foreground and the shapes get smaller as they go back. At the actual site, the covered bridge is farther to the left. But I brought it over and cut it into the side of the church. I didn't need a large, light area out there. And it gives me a more interesting shape.

Plate 68 carries the idea into a marine painting. The sea is of very little importance here—my subject is the way the rocks angle into the picture. So I keep the horizon high, the area of water small, and the sky dark—it doesn't attract attention and is a good foil to the light foam. I concentrate on the big masses, working light against dark so as to bring out the large, irregular shapes. Notice that there isn't a straight line anywhere. Everything tilts one way or the other. Parallel the shapes with your hand and try to *feel* how they angle their way into the picture. I have a special liking for pictures like this one—they have guts to them.

Contrasting Shapes

I don't want you to think a design has to be dominated by one kind of line. On the contrary, you can get great effects through meaningful contrast. When I began to paint Plate 69, for example, I was interested in the dancing quality of the apple tree. It seemed happy to be alive. But what gave me that feeling? I decided that the effect was caused by the way the tree's sinuous, curving branches contrasted with the sharp lines of the surrounding buildings. Notice the angles of the roofs, the sidewalk, the steps, and the spiky steeple of the church. Contrast makes the picture.

Liveliness of Handling

Plate 70 is a somber barnyard scene. Since the design is backlit, almost everything is in shadow. I've emphasized the silhouette of the barn by keeping it next to the lightest part of the sky. I don't want the eye to wander into the upper corners, so I block them with tree forms, lowering the value of the sky and making it less obtrusive. The shadow area is large and simple. Squint, and it all becomes one big mass. A few sunlit leaves emphasize the darkness—but *only a few*. You don't want to have too much of a good thing. You'll put down a few leaves, like the effect, and add a hundred. Then everything's lost.

So the picture has a sober strength. But why do I prefer Plate 71? Well, Plate 70 is too set. It's like a piece of architecture; there's no life to it. In Plate 71, on the other hand, the roof angles in all directions, the planks on the barn go every which way, and the trees twist and swirl. The road pulls you into the picture and then around the barn; while in Plate 70, the haystacks and trees keep you locked in the foreground. The walls of the barn move back and forth in Plate 71, the trees counterpoint each other, and there's a variety of interesting textures—the boards, the wet gravel road, the feathery branches of the trees. In short, the eye can play in Plate 71. It moves round and round the picture in a swooping, swirling

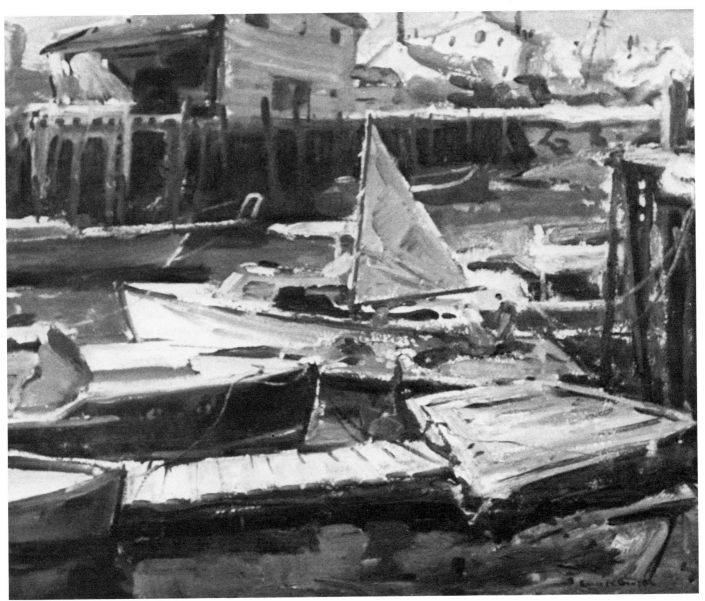

Plate 66. Lobster Fleet. *Oil on canvas, 30″ x 36″ (Collection Cape Ann Savings Bank, Gloucester, Massachusetts).*

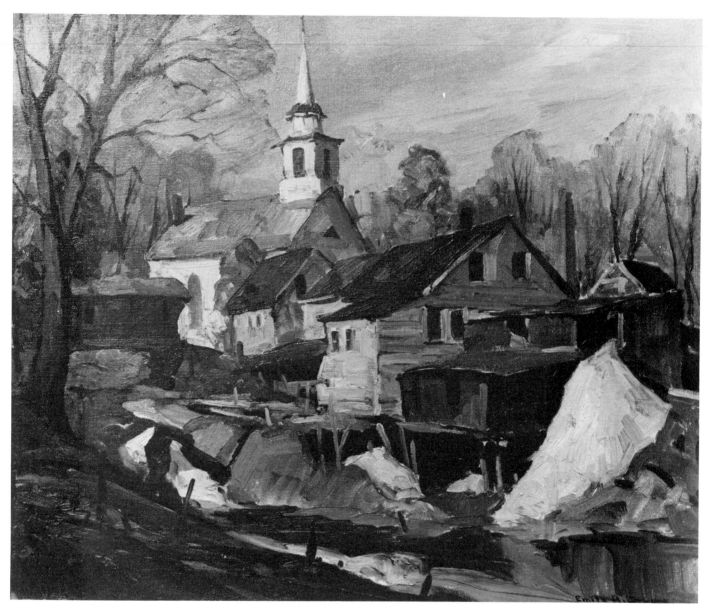

Plate 67. Old Saw Mill. Oil on canvas, 25" x 30".

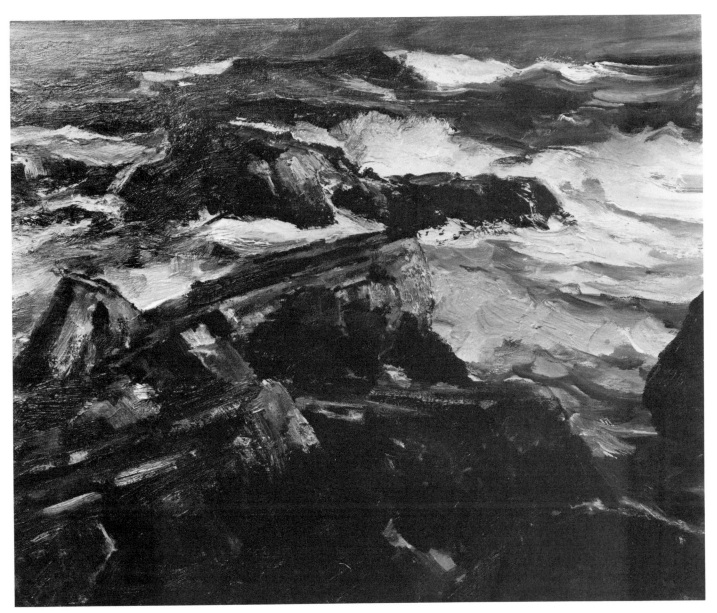

Plate 68. Angry Surf. Oil on canvas, 25″ x 30″.

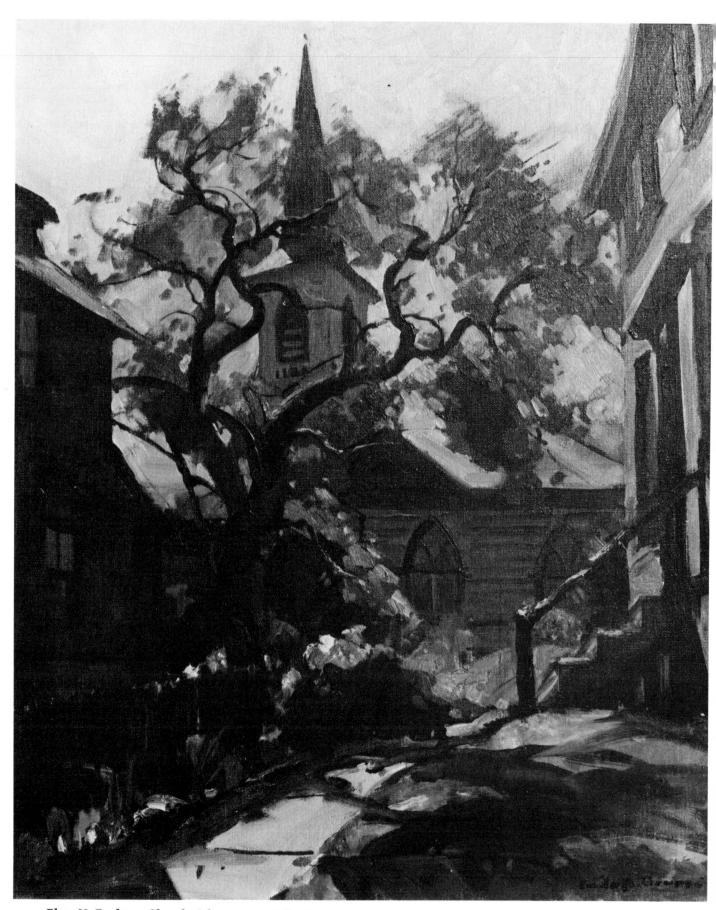

Plate 69. Rockport Church. Oil on canvas, 25″ x 30″.

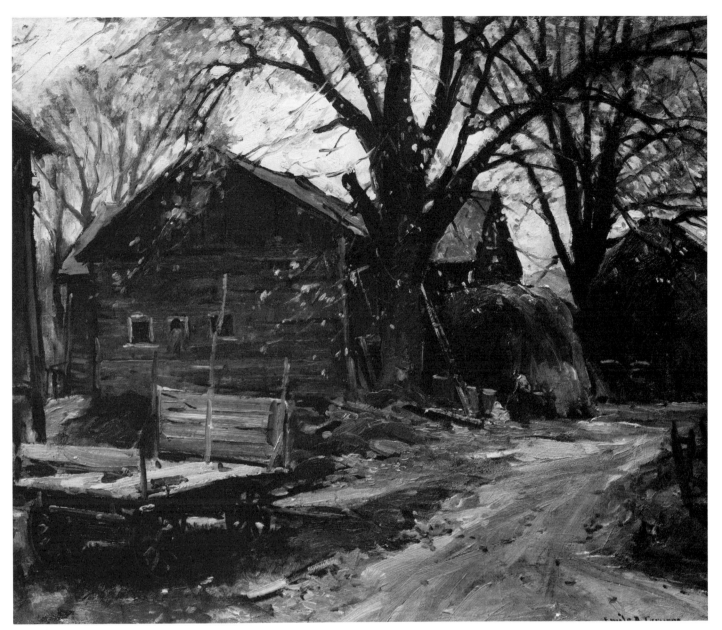

Plate 70. The Old Farm. Oil on canvas, 25"x 30".

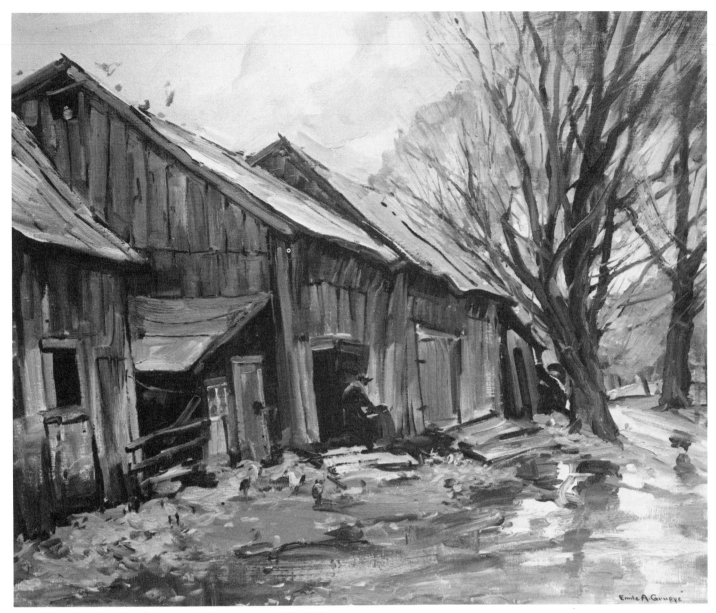

Plate 71. Wet Day, Vermont. Oil on canvas, 30" x 36".

motion. Plate 71 is entertaining—and to my mind a better painting.

Plates 72 and 73 present the same contrast. Plate 72 has its merits. The mass of the hill sets off the light trees, and I'm able to play the sparkling leaves effectively against this large dark. In addition, the sky is handled in a lively and interesting manner. So what bothers me about the painting?

Again, the trees are too straight. I painted them as they were. It's a record of the place—and not of my emotions. On the last day of classes in Woodstock, the instructor would show us a series of sketches that played down the *facts* we'd been learning all summer and emphasized how we should *feel* towards a subject. I can still remember a small picture of birch trees. They looked like nudes dancing on a hillside! *That's* the kind of feeling you should have in birch trees. And that's what I've tried to do in Plate 73. The trees counterpoint one another as they sway back and forth, and I've exaggerated the movement of the long, delicate branches. There's a vitality running through this picture that the other lacks.

Working Outdoors: Pigeon Cove

I'd like to take you out with me now, so you can see how I design on the spot. Figure 53 is a photograph of Pigeon Cove as it looks from the place where I set up to paint. If I'd painted it as it looked, I'd have a portrait of some buildings. But that wasn't what I was after. I wanted to get a sense of the place—of a protected cove with the ocean beyond. I felt this "protected" quality, but the problem was how to emphasize it by meaningful exaggeration.

The first day I went to the site, I raised myself in my mind's eye, reducing the buildings to a secondary position (Plate 74). Having raised the background so I could see it (I had to move a few feet to get a look at what was hidden by the foreground roofs), I exaggerated the size and shape of the distant bluffs. That created a large mass of rocks, building, and boats that tapers towards the oblong breakwater. The eye then picks up the distant headlands and moves back towards the left. In the photograph, you can see that the far distance is very straight. I wanted to get a sense of land and sea tapering off to infinity. So I reshaped the area to suit my purposes. You can also see that I've grouped all my boats. The effect at the site was too spotty; if I'd put all the isolated boats in, they'd have distracted the eye without serving any purpose. So out they go! I add some figures in the foreground to give scale—and the beached foreground boat points the viewer into the picture.

I liked the effect I got, so I went back to the place the next day to perfect the composition (Plate 75).

Now I've made the shacks even smaller, in order to emphasize the cove. I've also reduced the size of the breakwater—it's important, but I don't want it to be as dominant as it is at the actual site. I also increased the amount of distant ocean, so that I now have the breakwater and a bit of water above it, then a headland and water above it, and then the distance.

Mood

Before ending this section on design, I want to let mood have the last word. For if you don't get *feeling* into your work, all the design in the world isn't going to help it. Mood comes first, *before everything*! You have to think deeper than the line—and deeper than the object itself.

So I'm ending this chapter with two of my more "moody" pieces. Both utilize the straight, horizontal line—a line that suggests sadness, solitude, and death. I saw the site of Plate 76 out of the corner of my eye. I was driving along the road, glanced out the window, and came to a sudden halt: "That's it!" The loggers had just gone through a small valley. And all that was left were some broken branches, a few stumps, and the hill in the distance, scarred by piles of fallen trees. Again, the key to the picture is the gray day. There are no dancing highlights. And there's a sobriety to the horizontal clouds and the horizontal line where the hill and the flat ground meet. I've used the trees and shrubs to break the line of the hilltop. I don't want your eye to slide down it too quickly. Quick movements wouldn't fit the picture. I want the feeling of death and sadness to come first; everything in the picture has to contribute to that all-important mood.

Plate 77 is of a dead beech tree. I need to put detail in a picture like this in order to explain what's going on: the rotting wood, the old mushroom growing halfway up the trunk, the hole where a large branch used to be. It fell off years ago, so there's a jog in the tree without a branch to compensate for it. That severe break in the tree makes the picture. It's harsh rather than vital in character. Then the long horizontal lines of the clouds and the mountains add to the sense of solitude.

I hope you can see how the day enhanced the mood created by the tree. It was gray and overcast; there were a ramshackle barn and leafless trees in the distance; and there was that dark, muddy road. The more you paint outdoors, the more you'll notice that you can pass a site a hundred times without its affecting you. Then, on the hundred and first time—with the right light and atmospheric conditions—the spot comes to life. It suddenly *has* to be painted!

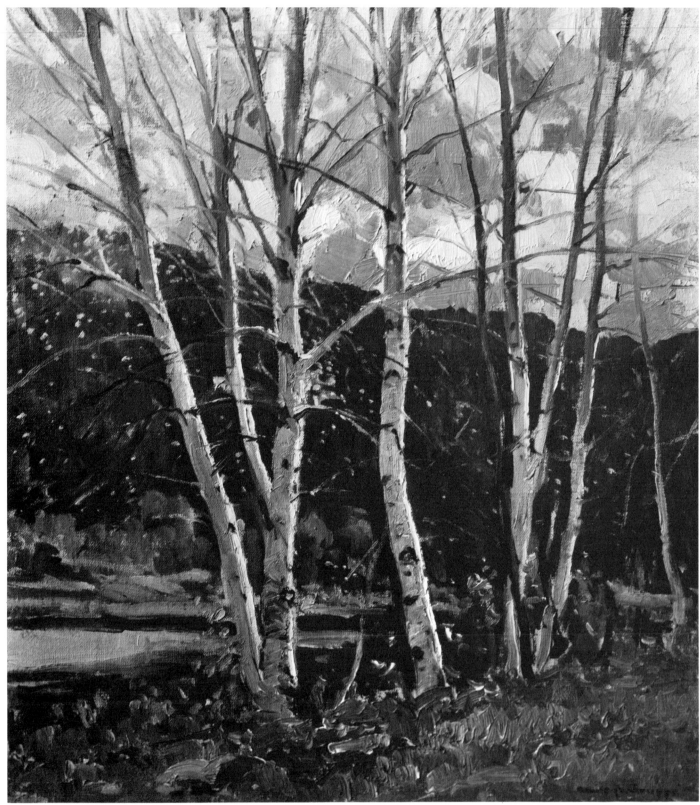

Plate 72. Birches. Oil on canvas, 18″ x 20″.

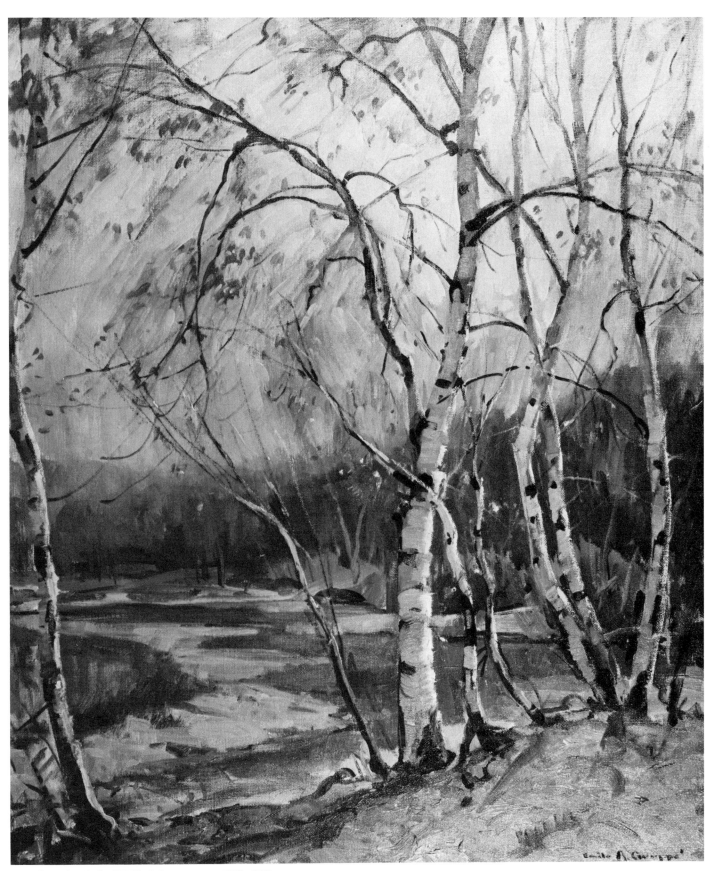

Plate 73. End of Fall. Oil on canvas, 25″ x 30″.

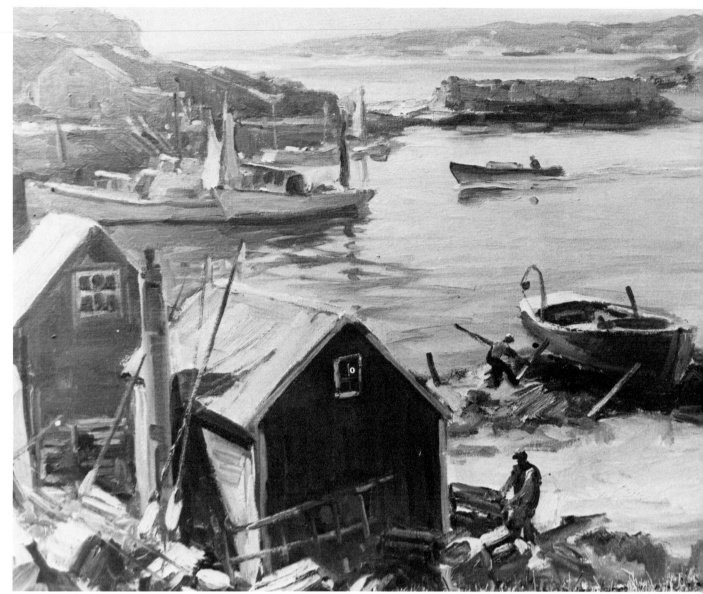

Plate 74. Lobster Harbor, No. 1. Oil on canvas, 25″ x 30″.

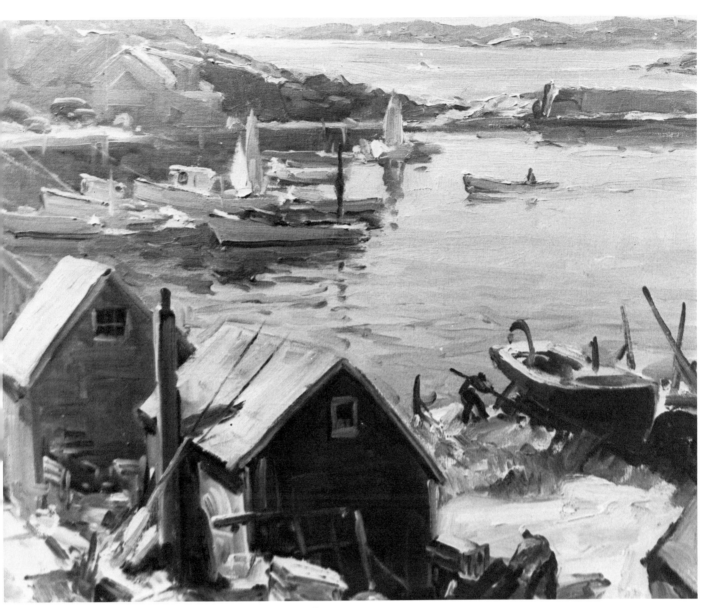

Plate 75. Lobster Harbor, No. 2. Oil on canvas, 25'x 30".

Plate 76. After Lumbering. Oil on canvas, 25" x 30".

*Plate 77. **Beginning of Winter.** Oil on canvas, 25″ x 30″.*

7 Lay-In and Development

If you'll only learn to *see* outdoors, you'll find that you make rapid progress. I know of no better and quicker way to learn values, color, and composition than outdoor painting. But you have to *get out and do it*. The studio can't prepare you for it. There's an "awkward beauty" in nature that has to be seen to be recorded (Plate 78). And you have to keep an open mind. Don't think that, well, I like sunny days, or I like overcast days. Every day has something valuable to offer if you'll just look for it.

Learning to See

I'm so familiar with some sites, after years of painting in the area, that I sometimes find myself painting from memory. I'm not really paying attention to the scene. And that's bad; because it's only outdoors that you can get the interesting, authentic bits that you'd never think of in the studio. Years ago, I had a deal with a gallery and had to turn out so many pictures a week. I was always thinking of the quota and so pushed everything around quick, working fast and not paying much attention to the scene. Well, one day I went out painting with a friend, got into trouble, and called him over for a quick critique. "What's the trouble here?" I asked him. He looked at the picture, then at the site. "Are you looking at what's in front of you? I don't see it in your canvas," he said to me. "Look at that rock down there with the water running around it. That's a whole story in itself. Put that in first and then I'll give you more advice." Well, I put it in—and that simple act of observation made me open my eyes to the whole scene. I was blind till then. And my friend knew it. He came over later and asked if I needed more help. I told him I didn't.

Avoiding the Peculiar

The only thing I'd warn you against is the unusual or peculiar subject. Nature will probably look odd

Plate 78. Tree Screen. Oil on canvas, 20″ x 24″. Outdoors, you see an awkward beauty that you'd never imagine in the studio. See how these trees bend and twist, making an interesting pattern against the sky. The three light birches are important. Since everything in the picture is fairly close in value, the whites give you a standard; you can gauge the darkness of everything else by them. Cover them up and see what happens.

enough when you get it down on canvas—don't make matters harder for yourself. Sunsets, for example, are too overpowering to paint—and they're impossible to live with. Once when I was down in Florida, a friend called me up and told me to run to the window. The marshes had sent a lot of salt into the air that day, and the color of the sky was a strange, bilious green. He thought it would make a good painting because it was a "phenomenon." I told him that if it looked odd out his window, it would look even odder framed and hanging on his wall. He finally took my word for it.

Drawing the Design

You can make or break a picture right at the beginning. The first lines you put down on the canvas are the most important, and you should keep correcting them until you get them right. That's why I recommend that you start with charcoal rather than paint. Use a nice, soft charcoal, so you can rub off mistakes easily with a rag. Some people fix their drawing with a spray, but that's not necessary. Just flick the canvas to get rid of the excess charcoal and then paint right over it. It will be absorbed by the paint—like the fly in your soup, it doesn't drink much. So don't worry.

Remember that you should begin by thinking in terms of *spaces* and *shapes*—not specific subjects. Try to avoid hitting center, or splitting the canvas in half, and vary the spaces between the vertical and horizontal elements. That will give the painting variety.

Place your subject with the first lines. Get that down first! That sounds obvious, but most students will inevitably start with a subsidiary part of the scene—a building, for example—and will become so fascinated by its details and so determined to get them right that before they know it they've filled the whole canvas and haven't room for their real subject.

The Lay-In

I believe in a fairly complete oil lay-in prior to actually applying the color. I use a purple for this, since it's a lively color and will look good, even if some ends up showing through. Of course, some people like to block in their painting with earth colors—burnt sienna, for example. But a color like that is dead—there's no life to it. And it dulls all the colors you eventually run over it.

When laying in my design, I concentrate on the large light and dark masses. That shows me how the

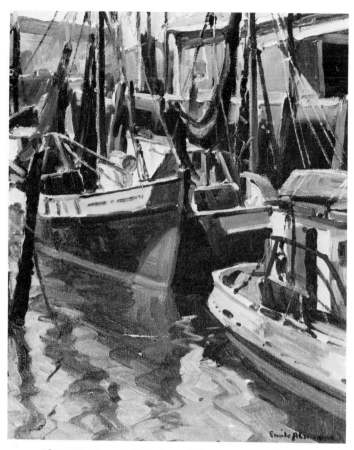

Plate 79. Crowded Harbor. Oil on canvas, 20" x 24". The shapes of the crowded boats make an arresting study in themselves. A picture like this is interesting, even when you turn it upside down.

final picture will look. And it's easy to make corrections in the shapes of these masses while using thin washes; it's difficult after you've put down a lot of paint. As you work with these washes, try to fill in the grain of the canvas. Too much canvas showing through makes it hard to judge your values. A dark area, with spots of clean canvas in it, tends to look gray from a distance. So fill things in!

We're not interested in careful drawing or "finish" at this stage. You can't do everything at once—you'll get confused—so for now just think of composition and values. Simplify the scene in front of you by squinting at it. That cuts down the amount of light that enters your eye, and you see things in simple light and dark masses. I always tell people that artists have crow's feet around their eyes because they spend most of their life squinting.

As you squint, determine which area is your darkest and which your lightest. This is a relative matter, of course—in some scenes, the area of dark may be very small. Just compare the masses in front of you. Is the side of a tree, say, lighter or darker than a shadow on a rock? When two objects are side by side, decide which is the darker. But always compare. When you look at one dark, try to keep your eye on all the other darks in the scene.

Hit your darks hard. You may even want to exaggerate them. The sooner you put down the darkest dark, the easier you'll be able to decide how strong to make the rest of your lights and darks. It gives you a standard. By keeping the dark low in key, you'll get good contrast and won't have to exaggerate your lights. Then, you'll have something in reserve when you put your highlights in.

As you lay in your big tonal areas, don't pay attention to the numerous shifts in value within a mass. The area will be filled with halftones and quarter-tones, but you could spend all day trying to record them. Just put it down, either light or dark. The simpler the better.

There's a simple exercise you can use to make yourself think in terms of big value areas. Get an 8" x 10" canvas and divide it into four quarters. Then do a picture looking: (1) into the light, (2) away from the light, (3) to your right, and (4) to your left. Do each sketch with as few strokes as possible—maybe only four or five. Just try to get the value relations right and don't worry about composition or making a good design.

Variety

Try to make your masses as interesting as you can. Vary their size, shape, and position. This sounds eas-

ier to do than it is. For, if like most students, you try mainly to copy exactly what's in front of you, you won't even think of this aspect of the painting process. I was going to call it the "abstract" part, but I hate that word. It's been used too long as an excuse for bad drawing. So let's just say that you should think of the objects in front of you as *shapes* first—shapes that can be made larger or smaller, depending on *what looks good on your canvas.*

Plate 79 shows you what I mean when I talk about the importance of shapes in a picture. This painting is a study made on the Gloucester docks, and I was particularly interested in the way the different shapes come together. Those shapes are my subject—not the boats. Study the picture and notice how the lines are all moving in different directions. The foreground building slants down; the background building goes in the opposite direction. The boats are at different angles. And then, among all the sharp lines, I have the concave, hanging lines of the nets. These concave lines help explain the other ones—it's comparable to the way a portrait painter emphasizes the *convex* shape of a sitter's shoulders by using a background drapery that hangs in *concave* folds.

Figure 54 is a detail from a larger composition. Again, study the shapes. Notice that the strokes all work up to the man and the anchor—the focal point. I've designed the area so that the lines all counterpoint one another. The lobsterpot on the lower right, for example, is extremely important. It's angled in a way that counterpoints the sharp line coming down from the anchor. It helps to define it. Block the pot with your finger and see what happens. Notice that I'm *not drawing specific objects* in this part of the painting. I'm trying to fill a space in an interesting manner, placing my strokes so as to make a good design. I'm not interested in the lobsterpot, as such; it's just a convenient shape. I *am* interested in the part it plays in the overall composition.

Drawing versus Painting

Charles W. Hawthorne was a great teacher: one trick was to make his students paint with a palette knife. That way, we couldn't draw objects carefully, even if we wanted to. Instead, we concentrated on placing the objects and getting their values right. He forced us to see things in a broad way. From years of teaching, I've discovered that nothing is as hard as trying to get a student to stop drawing things and to begin painting them; that is, to *stop* making outlines and coloring them, and to learn to work in big areas of value.

It's a hard task because students don't realize that

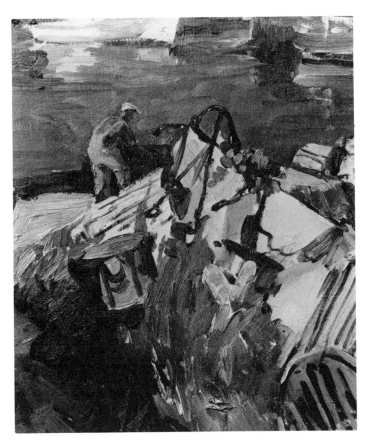

Figure 54. The shapes and brushstrokes in this detail of a larger painting all work up to a central point; the individual objects count less than the overall design.

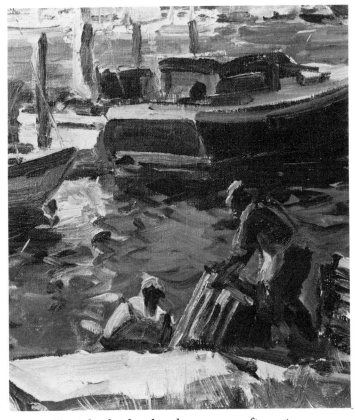

Figure 55. With a few brushstrokes, you can often get a better sense of a scene than you can with loads of detail.

Plate 80. Last Ray of Sunlight. Oil on canvas, 18" x 20". A sunlight effect in the late afternoon. Even after painting all day, I couldn't let this effect escape me.

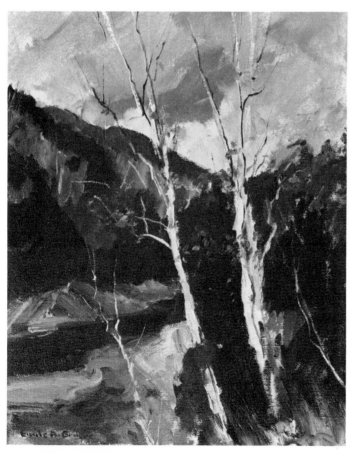

Plate 81. White Birches. Oil on canvas, 20" x 24". Having caught the drama of light against dark, I considered this sketch finished. There was nothing more to say.

drawing isn't the beginning and end of art. Of course, it's good to be able to draw—if you can control your hand, you're more likely to make interesting shapes. But I've known painters who used color and placed their objects in such an interesting way that you didn't notice they couldn't draw. Look at Cézanne's *Bathers.* The figures are way out of drawing. But he didn't *want* to spend time on them. He was interested in *grouping* them. And he made the groups so interesting that we aren't aware of anything else.

Application of Paint

How you use your brush is always a personal matter. But I like soupy paintings. I find that the more paint I have on, the better the painting. I tell students to paint like a millionaire. And if they're poor, I say well, save up, paint once a week, and *then* paint like a millionaire! Of course, I understand why they have trouble putting paint on. They're hesitant and tend to paint a picture the same way they might paint a house — smoothing out all the strokes. They have trouble drawing and they constantly go over the painting, correcting details. Maybe they'll stain the canvas blue, say, then work over it with a stain of orange, going back and forth till the two colors are mixed to a muddy gray.

But the aim of painting, if you work directly as I do, is to keep away from the flat, overly-worked surface. You want to put down a nice load of blue and then pull orange over it. That way, the paint layers interact; one color mixes with another, creating "broken color"—strands of mixed and unmixed paint. In addition, the brushstrokes have a chance to register. When you see the stroke, you sense that the painter is working with authority; it looks as if he means what he's doing.

Now when I tell you to paint in a thick, soupy way, I don't mean that you should just throw the paint on. There's a difference between slapping paint on and putting it in the right place. The stroke should bear some relation to the subject. Someone once told me that I didn't paint pictures: I wrote them. The brushstrokes were descriptive. And I'm convinced that it's really the way you describe a thing—the way your brush moves—that interests the viewer. He's interested in the scene, but he's *more* interested in getting a sense of the painter's personality.

Developments on the Canvas

You can paint with authority, but at the same time you shouldn't be too sure about how the picture is going to come out. You don't want to get yourself into a straitjacket. Be open to developments on the can-

vas. If you want to have a good time, work all over the place. Painting is supposed to be fun, after all. When it gets to be work, it shows in the picture. I used to worry about paintings and work on them, sometimes getting up in the middle of the night to fix a part here or there. I might spend a week doing that. And then, on the last day, I'd usually scrape everything off, leaving only the ghost of the work. I'd labored over it too much; my exhaustion showed in the canvas. I'd put the picture aside, and then on a later day, when I felt perky, I'd take it out and repaint it— *at one go*. That's the best way; the quicker the better.

Detail

Whenever I see a student putting a lot of detail in his work, I'm usually sure he's done most of his painting in the studio; that's where everything stands still. You can take your time. But outdoors things are constantly changing and you can't waste time on the bits and pieces of the scene. At best, you have about three hours in the early morning and three hours in the late afternoon when the light is fairly consistent. So three hours is the maximum amount of time you can spend on your painting. You can't do much detail in that time. And, besides, most people can't draw well enough to do detail anyway. So why bother? There's nothing worse than a picture full of flyspecks!

There's also another reason for not finishing anything: if you spend a lot of time on one part, and then move on to something else, you may discover—as the picture nears completion—that the carefully-finished part needs to be changed. It may conflict in some way with the rest of the composition. But you'll hate to touch it—you'll think about the labor it cost you, rather than the needs of the painting.

Even more important, perhaps, than all these practical considerations, is the fact that you have more fun when you don't finish anything. You get a chance to express your personality. Let's say I'm painting a bunch of boats in the distance—a jumble of draggers, dories, masts, and warehouses. I don't worry about every detail. I just brush in a few big masses, masses that suggest what I'm after. Then I leave it alone. I go work on some other part of the picture. By the time I get back to the spot, my eye has rested and the spot looks *new* to me. It will suggest ideas. Then I can pull out what shapes I like.

Look at Figure 55. It's a closeup of a small part of a much larger painting, but I like it better than the original. It's less cluttered—and more suggestive. I want you to notice how loosely I've painted both the men in the foreground and the objects in the far distance. The men don't have eyes, or noses, or fingers. I just suggest a characteristic shape: a curved stroke

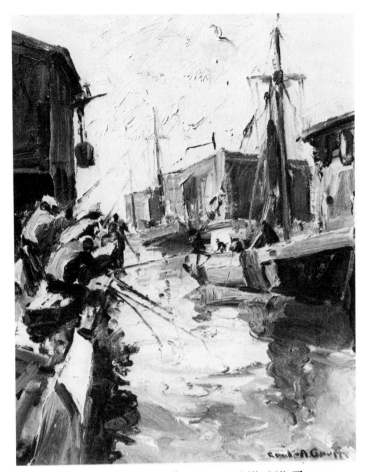

Plate 82. Smelt Fishermen. *Oil on canvas, 16" x 20". The sketchy vitality of the piece matches the activity of the scene.*

for a hat or the rolled sleeve of a shirt; a semicircular shape for the shoulders; a dark spot for the head. Remember that even if I put in all the features, the head would still only be a dark spot from five feet away. So I don't bother. The background is similarly handled. I was after the *texture* of the distance: the dots and dabs that you see out there, not the individual boats, sails, and buildings. You'll notice that the farther away you get from this illustration, the more finished it looks. Since it's painted broadly, it has a lot of carrying power.

Accidentals

The more suggestive the picture is to you, the painter, the more fun it is to work on. Talent, I think, is largely knowing how to take advantage of "accidentals"—those loose spots that suggest ideas to you. At the same time, however, I think that some modernists go wrong when they rely exclusively on accident—dripping paint or letting worms wriggle over the canvas. Painting isn't all accident. It's skill. You look for the accidental, but you *use* it so it ends up working for you.

The Power of Suggestion

Not only are loosely-handled pictures more fun to paint—they're also a lot more fun to look at. They take advantage of the power of suggestion. Sometimes the power of suggestion is so strong that a half-completed impression of a scene will look far more like the place than a version that nails everything down, that shows every clapboard and every shingle. Suggestions are always more interesting than hard facts. They let the viewer play a part in the picture. His eye is given something to do. This is the place, I think, where painting becomes most like poetry. A poet tries to say the *most* he can with as *few* words as possible. Similarly, the artist uses a few strokes—well-placed—to suggest a whole world.

If you finish like a photograph, on the other hand, the picture has as much personality as a photograph. But look at Robert Henri's portraits: a stroke for the eye, a couple for the mouth, a big swatch of color for the cheek. That's painting! There's personality in work like that.

Finish

It's not too much to say that once the lay-in is complete, the composition fairly well established, and the color and values suggested, the picture is prac-

tically done. You can bring it forward to almost any stage of completion, depending on your personality. A modernist would leave it rough—and it would look almost cubistic. A banker would put a name on everything.

Plates 80, 81, and 82 should indicate what I mean. They're all quick sketches, done in less than an hour apiece. Plate 80 was done very late in the afternoon. I had been painting all day and was riding home when I noticed how the late afternoon sun was hitting one pine while throwing all the rest into shadow. What an effect! I kept my darkest shadows near the highlights—to give them punch—and then stained the other shadow areas. The white of the canvas shines through them, giving the area a luminous quality. You can see some tree trunks in among the shadows, just like you can see a spoon in a cup of coffee. I got the effect I wanted—and stopped. There was no need to "finish" it. You should ask yourself: if I go any farther, am I likely to help the picture or hurt it? Will detail add anything to what I've already said?

In Plate 81, I again stopped once I said what I wanted to say: light trees against a dark, dramatic background. The design probably looks familiar; I did it the day before painting *Vermont*, on page 55. This sketch was really an exploration of an unfamiliar site. I was so taken by the result, that I went back the next day with a much larger canvas.

Plate 82 is a sketch made down on the wharf. There's a vitality running through it that would have been lost if I had carried the piece any further. Now, everything hangs together. The action of the men, moving around and jiggling their poles, is suggested by the action of the stroke. The heavy, active paint texture is suited to the subject.

The Greater Art

For me, expressing the theme with as few strokes as possible is the greater art. I don't mean you should count your strokes. If you do that, you'll be worried about technique more than substance, about how you say a thing rather than what you're saying. But look at Whistler, if you want an example of what I'm getting at. I remember a picture of his: a man in a dark coat. And on that coat, you can see one button catching the light. Close up, that button is only one quick stroke. But when you get away from it, you would swear you could see the buttonhole, thread, and everything. Whistler could make one stroke say a lot.

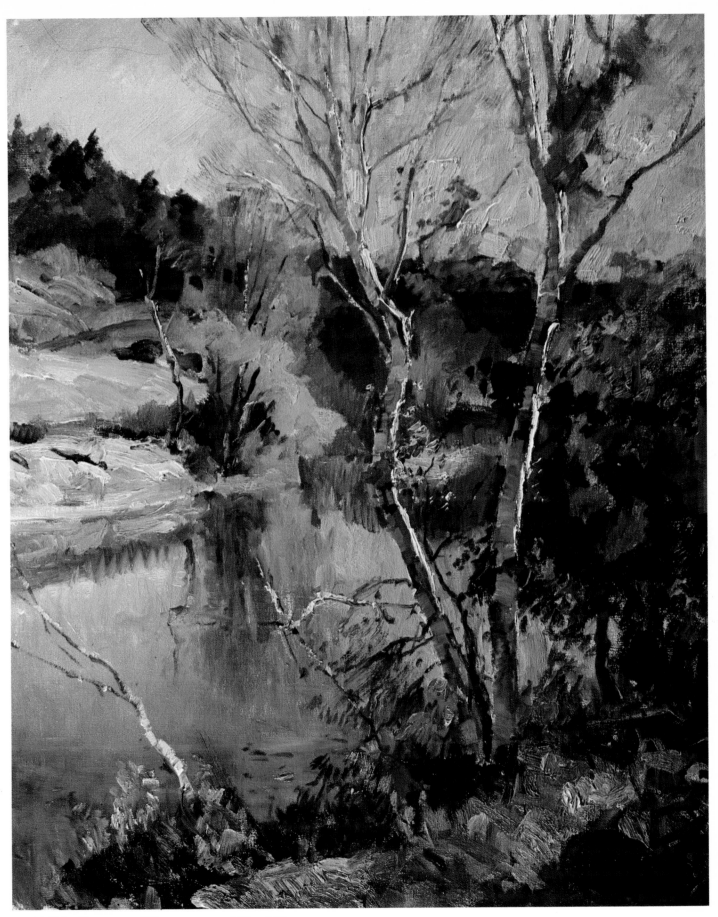

Fall in Vermont. *Oil on canvas, 36" x 30".*

Demonstration 1
HARBOR SCENE

1. I make one dragger bigger than the other and exaggerate the crookedness of the pier to add interest to the composition. I also vary the spaces between the masts and tip all the verticals slightly so they won't all be parallel—and thus monotonous.

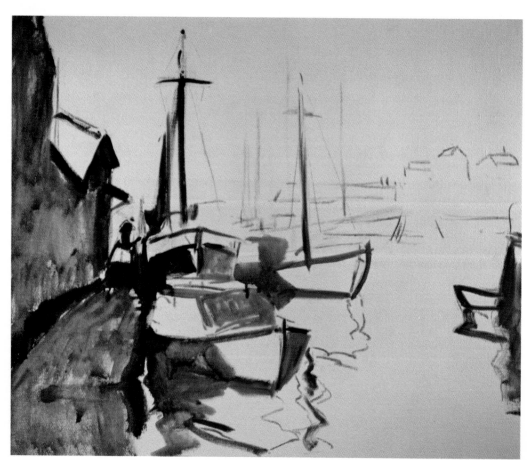

2. Here I cover the large areas of the canvas, laying in the darks first. I keep the shapes simple and paint thinly. The wash will dry quickly and leave a nice surface to work on. I frame the lights so they'll register and make the shadow on the foreground lobster boat dark. Students always make a white boat in shadow much too light; things in shadow must pertain to the shadow.

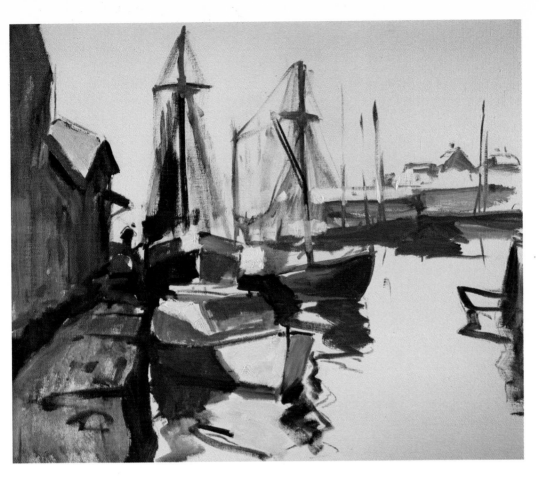

3. *Here I've created a nice halftone around the mast. It looks like it's surrounded by atmosphere and not just pasted on the canvas. I add green to the painting, counteracting the purple so I don't go colorblind. The bluish shadows contrast with the warm colors of the sunlit areas. Now that I've established the design and placed the warm and cool masses, I've done all the hard work. Anybody could add the finishing touches.*

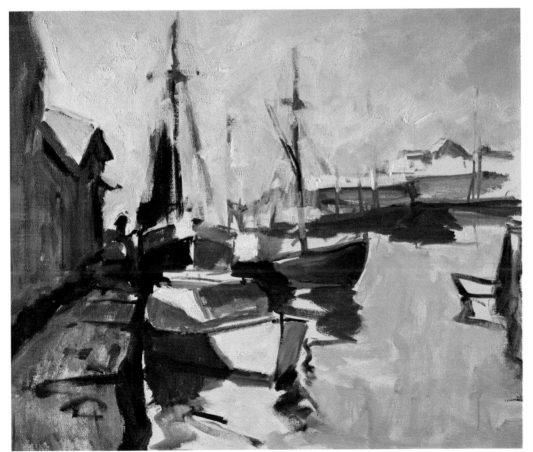

4. *See how light you can make the sky and still get away with it! First, I establish the sky's warmth. It's yellow toward the source of light (on the right) and becomes less warm as you move to the left. I bring the reds right down into the water, darkening them a little in the foreground where it reflects the darker sky tones overhead. I paint right over my edges, creating interesting halftones.*

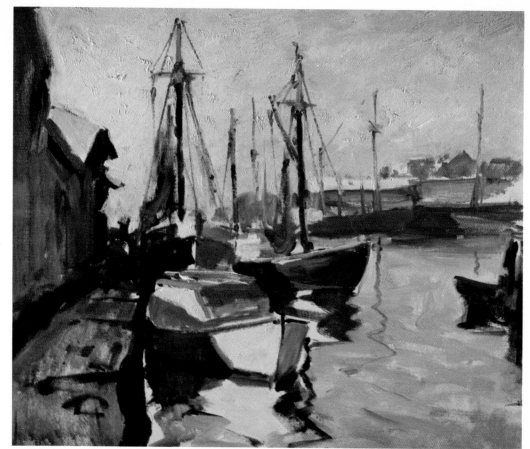

5. *The tiniest touch of blue and—bang!—I've cooled my warm sky. I lay cool color into the sky and water with a large brush, keeping the paint juicy and not overmixing. The sky color is reflected darker in the water. Ultramarine blue makes the shadow sides of clouds in a red sky. In the distance, atmospheric perspective takes the yellow out of the buildings and turns them purple. The orange trim on the boat accents its role as a foreground element.*

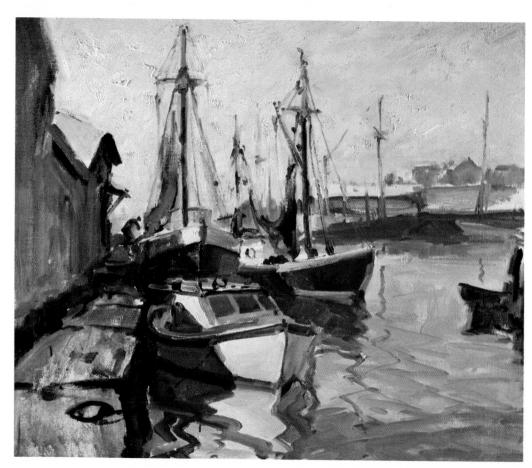

6. *The center dragger's color looked too much like the ocean, so I added a raw green that looks like paint out of a can. The light red waterline accents the dragger's darkness. I make the pattern along the pier more interesting by cutting down the size of the lobster boat's cabin. The side of the boat facing the pier is dark, but the blue sky reflects into the sides facing the harbor.*

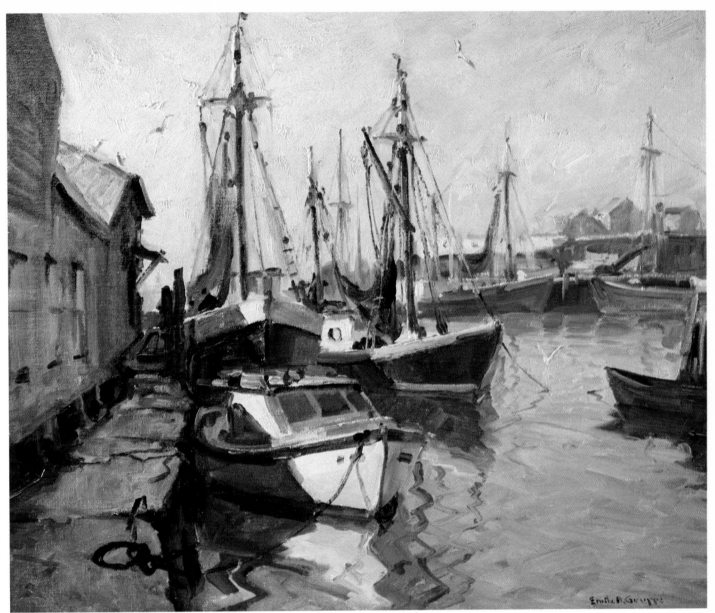

7. Gloucester Harbor. *Oil on canvas, 25" x 30". I finish up
the background buildings a little, being careful not to let
highlights pop out. Remember, these buildings are a mile
away. I also check to see that the masts are dark against the
sky—highlights here would just confuse the picture. I give
the pier a rough, granite texture, and add blue where it
catches a reflection from the sky. The man is eliminated;
instead, I use two pilings in perspective to help pull the
viewer's eye into the picture. I put in some seagulls to give
the harbor life, using lemon yellow and white (as in the
crosstrees on the masts) so you can see them against the
sky. I make the water simpler and softer. Then I move the
dory so it points more forcefully into the picture, and add a
rope from the dragger to the dory to help tie the composition
together.*

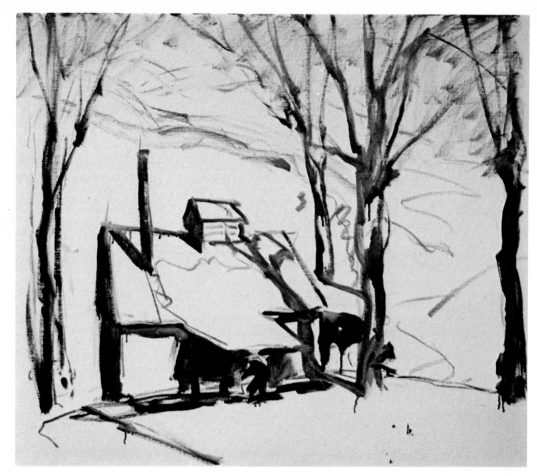

1. *As in the first demonstration, I drew a charcoal sketch, then blocked it in. I've counterpointed the upward movement of the foreground bank against the downward movement of the distant mountains. The S-shaped road connects foreground and background. The whole story of the picture is in the movement up the bank, down the valley, and then around into the distance. I keep all my darks dark. I brush in the branches, trying to get movement in them and putting down a halftone (like the one around the masts in the previous demonstration).*

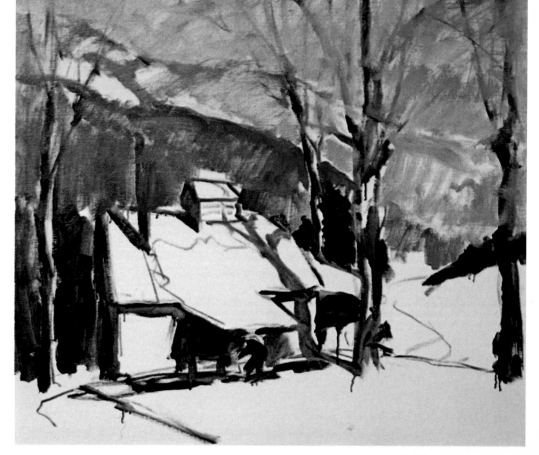

2. *I begin to block in the main masses, silhouetting the sugar house against a rich dark. I put down a red for the sky. Then I work for a sense of recession in the background. The trees nearest to us have the most red in them. As we look into the distance, they look much bluer. I don't use many colors at this point: that would confuse matters. I keep something in reserve for the later stages of the work.*

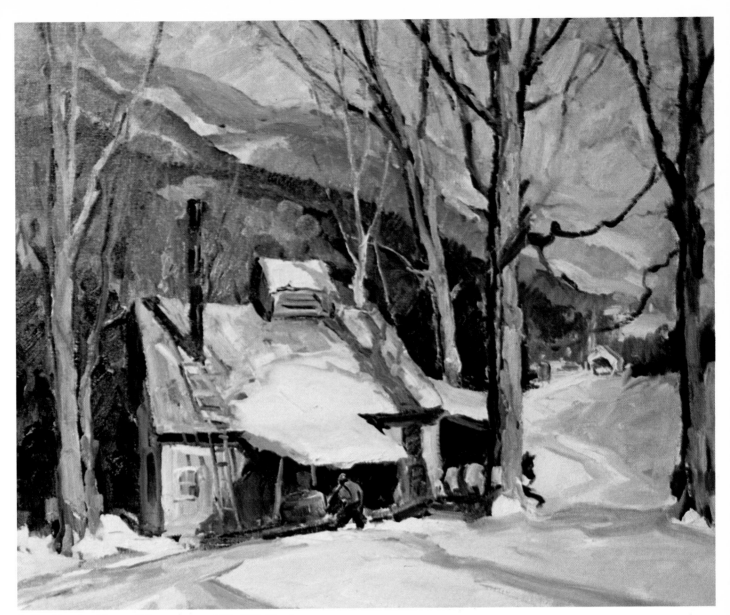

3. The Road to Town. *Oil on canvas, 25″ x 30″. The foreground shadows on the snow lead the viewer's eye to the sugar house. Some green over the purple underpainting creates a stand of dark pines. The white birch directly behind the sugar house acts as a standard, letting the eye know how dark the background mass is. The line of mountains keeps getting higher—and humpier and humpier as they recede. I want you to get a feeling of Vermont's rolling hills. I run some blue-green over the sky to suggest the morning light. The distance is wrapped in atmosphere so the viewer has room to breathe. He's pulled into the picture and the distant village gives him something to look at. Notice the dark branch on the largest tree. That's very important: pulled across the hazy distance, it pushes everything back.*

Conclusion

(Above) Here's a closeup of how I built up my paint texture. Notice how a dark area sets off the workman. In the painting, I used a similar dark to accent the backs of the horses—then I made the head of one horse dark against the light snow. Always think in terms of light against dark and dark against light.

(Right) Here's a closeup of trees and the distant village. I've gotten a grayish look to my trees by using the complements: an orangey red underpainting is partially covered by a greenish overpainting. The interaction of the colors creates a vibrant gray.

Years ago, when I was young and didn't know any better, I told a friend that I could draw better than Renoir. He nodded. He even admitted that maybe I could. But could I use color like Renoir? Could I get the same feeling of roundness in my forms? I thought about that and decided I couldn't. There's more to art than being able to draw.

Drawing is part of the how of painting. It's a matter of technique. But I want you to worry more about *why* you do a thing and less about *how* you do it. Cézanne's followers turned his insights into a method. They saw his patterns—and nothing else. But when you paint, don't be tied to a system. If you want to use a broad stroke, use it. If you want to put a dot someplace, then put it down. Don't rely on tricks or "sleight of hand."

Remember, too, that there's no set way to develop a picture. You can have a lot in a painting (Plate 83), or you can have very little (Plate 84). You can study the texture of your subject—the dots and dashes that give it character and life. Or you can work in broad areas of tone—searching for a quiet and sober mood. Everything depends on what you see in the scene. Try not to have favorite subjects. Keep your eyes open. Look around. And paint when something clicks in your head—when you hear something say, "That's it!"

Study

There's an old saying that it takes a painter to make a painter. And it's probably true. When I was younger, I used to be accused of painting like my teacher. And maybe I did; after all, I believed in him. I studied everybody's work in those days, looking and taking in everything that was said to me. I absorbed it all like twenty dollars worth of blue blotting paper. I even got to the stage where I could do fairly good imitations of other men's styles. But there's always a point in a painter's career when he has to stop and go in reverse for a minute. You have to sit down and ask yourself how you're going to use your technique. When you go outdoors, don't think, "How would Emile Gruppé handle this subject?" Ask yourself what *you* want to do with it!

Also remember that I can't really teach you anything. In the long run, you have to teach yourself. Up in Woodstock, when I was an assistant instructor, I talked and talked about refraction. But it was only when a student came running in with a wet canvas and told me excitedly about *his* discovery of refraction that I knew he had gotten the message.

Personality

The Tower of Babel story has a good moral. You can never reach perfection, no matter how hard you try. And given the nature of oil paints, you could never make a "copy" of nature. But sometimes the *suggestion* of nature's perfection is more interesting than the thing itself. When you work with the power of suggestion, you give the viewer nature—and some of your own personality, too. That's why I don't want you to paint boats, or trees, or waves—I want you to *suggest* them. I'm interested in your response to a subject, your impression. Painting is like story-telling—no two people will tell a story the same way. That's what makes art interesting.

It takes years—maybe even a lifetime—to learn to see in a simple way. You have to be as old as the hills, sometimes, before you really understand what art is all about. Emil Carlsen, on his deathbed, said he wished he could paint without paint. He wanted to get closer and closer to the essentials. And that's what you should do. If you remember nothing else that I tell you, remember this: Learn to look for the essentials and you'll discover that both painting *and* life are simpler than most people suppose.

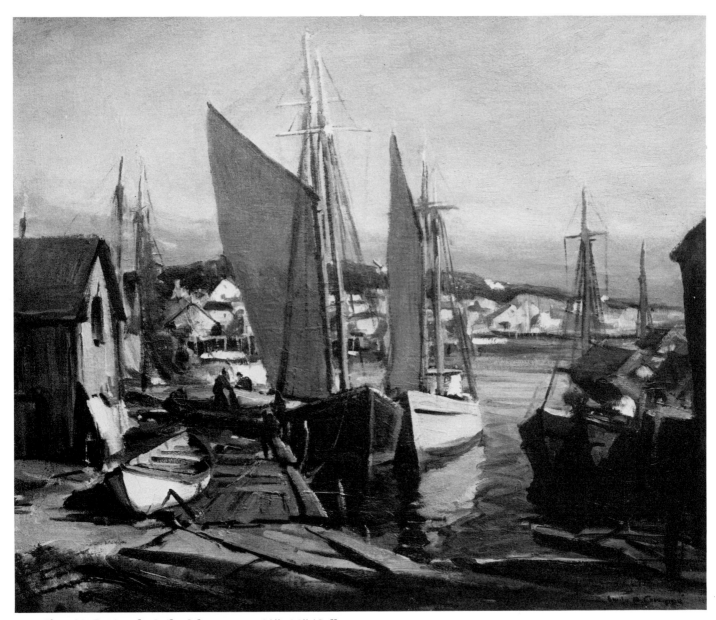

Plate 83. Drying the Sails. *Oil on canvas, 30"x 36" (Collection Gloucester Cooperative Savings Bank, Gloucester, Massachusetts). Notice how the surrounding elements lead your eye toward the sunlit boat with the drying sail. The white dory points in that direction, as does the wound net on the right-hand wharf. More important, the tops of the sails are angled toward the boat—and the roof of the right-hand building also points inward.*

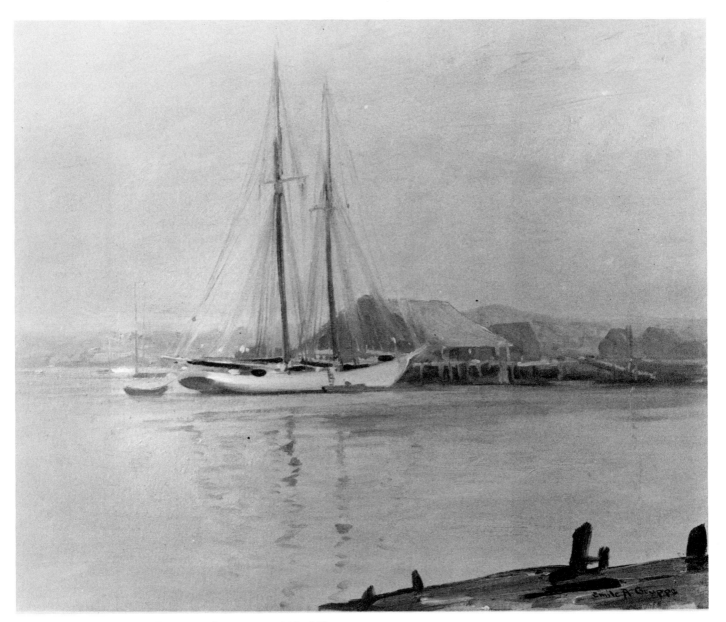

Plate 84. Gloucester Schooner. *Oil on canvas, 20″ x 24″.*
The dark foreground wharf serves two functions in this
very simple design: it gives you a place to stand, so you
don't feel as if you're walking on water; and its darkness
pushes the schooner far into the background—you sense the
space between it and you.

PHOTO CREDITS:

Peter A. Juley and Son
225 West 57th Street
New York, New York 10019

Peter Katsoulas
187 Concord Street
Gloucester, Massachusetts 01930

George Faddis
RD 5 Box 262
New Castle, Pennsylvania 16105

Charles Movalli
237 Western Avenue
Gloucester, Massachusetts 01930

Bibliography

Bates, Kenneth. *Robert Brackman, His Art and Teaching*. Noank, Connecticut: Noank Publishing Studio, 1951.

Bridgman, George. *Life Drawing*. New York: Dover Publications, 1961.

Hawthorne, Charles. *Hawthorne on Painting*. New York: Dover Publications, 1960.

Henri, Robert. *The Art Spirit*. Philadelphia: J. P. Lippencott Co., 1930.

Karolevitz, Robert. *The Prairie is My Garden, The Story of Harvey Dunn*. Aberdeen, South Dakota: North Plains Press, 1969.

Shaw-Sparrow, Walter. *Frank Brangwyn and His Work*. Boston: The Page Co., 1915.

Above all, I recommend the book written by my principal instructor while I was a student at Woodstock. This man taught me more than any other teacher in my life.

Carlson, John F. *Landscape Painting*. New York: Dover Publications, 1974.

Index

Edited by Claire Hardiman
Designed by James Craig and Bob Fillie